# THE BIOLOGICAL
# ORIGINS OF ART

**Recent Titles in
Human Evolution, Behavior, and Intelligence**

# THE BIOLOGICAL ORIGINS OF ART

Nancy E. Aiken

Human Evolution, Behavior, and Intelligence
Seymour W. Itzkoff, Series Editor

 PRAEGER

Westport, Connecticut
London

**Library of Congress Cataloging-in-Publication Data**

Aiken, Nancy.
    The biological origins of art / Nancy E. Aiken.
        p.        cm. — (Human evolution, behavior, and intelligence, ISSN
    1063–2158)
    Includes bibliographical references and index.
    ISBN 0–275–95901–5 (alk. paper)
    1. Art—Psychological aspects.    2. Creation (Literary, artistic,
etc.)    3. Aesthetics.    I. Title.    II. Series.
N71.A39    1998
701'.15—dc21            97–42064

British Library Cataloguing in Publication Data is available.

Library of Congress Catalog Card Number: 97–42064
ISBN: 0–275–95901–5
ISSN: 1063–2158

First published in 1998

Praeger Publishers, 88 Post Road West, Westport, CT 06881
An imprint of Greenwood Publishing Group, Inc.

Printed in the United States of America

**Copyright Acknowledgments**

The author and publisher gratefully acknowledge permission to reprint the following:

Robert Frost, "Stopping by Woods on a Snowy Evening": From THE POETRY OF
ROBERT FROST EDITED BY EDWARD CONNERY LATHEM, Copyright 1951 by Rob-
ert Frost, Copyright 1923, © 1969 by Henry Holt and Company, Inc. Reprinted by
permission of Henry Holt and Company, Inc., the Estate of Robert Frost, Edward
Connery Latham, and Jonathan Cape.

Figure 7.4: Rudolf Arnheim, *Art and Visual Perception: A Psychology of the Creative Eye.
The New Version* (Berkeley and Los Angeles: University of California Press, 1965), 375.
Copyright © 1974 The Regents of the University of California. Used by permission of The
Regents of the University of California and the University of California Press.

# Contents

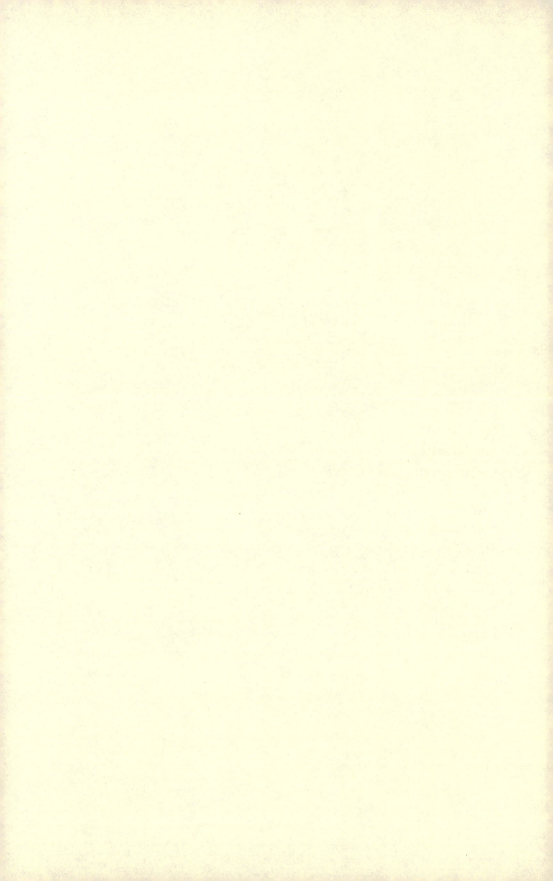

# *Figures*

# Preface

The germ of my thesis was brought to life several years ago when, as an artist, I stopped painting one day to ask, "Why do I paint?" I have hardly painted since that day. Instead, I have spent all available time with books and ideas instead of paint and paper. I hope that the years thus spent have produced the equal of one good painting.

In order to pursue answers to my original question and others that quickly followed: Why do people make art? What is so compelling about art? How does art evoke profound responses in its observers? I followed a course of interdisciplinary studies designed to help me find answers to these questions at Ohio University in Athens, Ohio. The one question that eventually became the problem I hoped to answer was the following: How does art evoke emotion? The disciplines that I hoped would help me find an answer were philosophy (aesthetics), psychology (cognitive and developmental), neuroethology, and fine arts. Not only do I think I have found a viable and even a testable answer to how art evokes emotion, but in the solution to that problem are answers to why we make art and why art is so compelling. In fact, the origins of art may be attributable to the emotional effects evoked by art behavior.

My sincere thanks to my early mentor, retired philosophy professor Warren Ruchti, retired art professor Erik Forrest, philosophy professor H. Gene Blocker, and neuroscience professors Ellengene Peterson and Michael Rowe. My special thanks goes to psychology professor Gary Schumacher. Thank you to zoology professors Jerome Rovner and Gerald Svendsen and to history professor Robert Whaley, who

have supported my ideas since my first questions years ago. Thank you to my friend, plant biologist T. Lee Gregg, who has been a wonderful sounding board. She also introduced me to the hallucination articles discussed in Chapter 9. Thanks to another friend, Mary Lautzenheiser, who read this manuscript, made many helpful suggestions, and prepared the figures for publication. Thank you to the members of the European Sociobiological Society for their support and for listening attentively while I read a paper at the First International Conference on Sociobiology and the Arts in 1993 and another one at their Conference on Sociobiology and Politics in 1996. It was at that last meeting that Seymour Itzkoff offered to show my work to Praeger. I am most grateful for this opportunity accorded me by Professor Itzkoff and by Praeger.

# Chapter 1

# Big Questions

Making and appreciating art are ancient human behaviors. Hominids may have decorated their bodies with red ochre and black manganese more than 100 thousand years ago. *Homo sapiens* demonstrated mature artistic style in Paleolithic paintings and sculptures 32 thousand years ago. Making—and, by implication, appreciating—art are of obvious importance to us, since practically all cultures in all times have practiced this ancient behavior. Elements of art are everywhere: in our dress, shelters, vehicles, furniture, utensils, monuments, advertising, entertainment, and rituals. Unlike language, however, which is another pervasive and ancient human behavior and is necessary for human communication, art is considered to be a superfluous activity. Art is the icing on the cake of culture; it is nice but not necessary.

If art were just nice but not necessary, it seems odd that art has persisted as a human behavior. If art were just a nicety like a favor at a dinner party, it seems illogical that it would be so pervasive in human cultures across time and space. Why does art persist? Other questions quickly come to mind: Why do people make art? Why do people enjoy art? What purpose does art serve? These are big questions. Do they have answers?

The traditional approach to these and other big questions does not answer them adequately. Past attempts at answering these questions have either taken for granted that art began with body painting, Paleolithic cave paintings, and decorated tools in an attempt to somehow magically insure successful hunts, or that a mysterious creative drive that seeks beauty is at the root of art. These traditional views of art

and art making and appreciation do not deal satisfactorily with the big questions. Most twentieth-century human beings are no longer concerned with successful hunts, and we seldom perform magical rites. Our search for beauty in art has been turned inside out by twentieth-century art, which sometimes seems to search for ugliness, horror, and disgust rather than beauty. These traditional approaches to what art is, why we make art, why we enjoy art, and what purpose art serves fail, on at least one count, because they are not inclusive of all art for all time. I concur with Ellen Dissanayake, who wrote,

One who wishes afresh to consider the relationship between art and life can begin by rejecting such extreme or naive views. On the one hand, respecting the unique properties of human achievements, we will not call bird song and spiderwebs "art." Nor will we reduce art to one primordial antecedent—such as play or toolmaking or body decoration. At the same time, being biologically and anthropologically informed, we will not be inclined to assert that art is an essence inhering in objects or a phenomenon that, occurring for its own sake, is unrelated to vital concerns.[1]

## AN ETHOLOGICAL VIEWPOINT OFFERS
## NEW OPTIONS FOR ANSWERS

It is time to exchange the traditional viewpoint of aesthetics with an ethological viewpoint and, in so doing, view art as a behavior. Ethology studies behavior from the viewpoint of evolution, asking questions such as "Why has this behavior persisted in this species?" and "What purpose has this behavior?" This, then, allows us to study art as animal behaviorists would study other behaviors, which, in turn, opens new avenues of approach to these and other big questions. Viewing art as a human behavior molded by evolutionary forces allows a fresh look at art and, thus, offers an opportunity to investigate and, possibly, learn more about ourselves and why we do the things we do.

This approach has been taken before, in the writings of Ellen Dissanayake, in some speculative writings from the late nineteenth century, and in the experimental and speculative work of Richard Coss. Dissanayake discarded the Kantian view of art as nonutilitarian, since the evidence points to another conclusion, and, instead, adopted the ethological view which provided a conclusion to fit the evidence. That is, since virtually everyone of every culture and time either partakes of or performs art, it must have some utility. The Kantian view of the value of art rejects any utility, but an ethological view fully admits a utility. An ethological view of art asks what role art has in increasing fitness (which means how art helps people survive and reproduce), and Dissanayake defines art in terms of what she has concluded is its ethological value. She writes, "The manufacture or expression of what

are commonly called 'the arts,' [is] based on a universal inherited propensity in human nature to make some objects and activities special." She defends this thesis with a compelling argument based on social needs. Moreover, she provides not only a precedent for an ethological framework for my argument, but a statement of authoritative evidence when she writes, "The primordial sources of aesthetic experience can be said to inhere in reflexive general responses to biologically significant stimuli."[2] My theory, based on an ethological view of art, proceeds in this direction of biologically significant stimuli. This is, I propose, how otherwise mundane items are made into the special things we call art.

### Answers to Big Questions

I propose that part of the emotional response to art results from reflexive reactions to certain configurations of line, shape, color, and sound, and that these reflexive emotional responses to certain visual and auditory images provide the rationale for the origin of art. Again, a precedent is found. This time it is found in the writings of nineteenth-century scholars who extended the biological evolutionary theory of Darwin to behavior. Grant Allen, in particular, writing in 1877, contributed a seminal book, *Physiological Aesthetics*, in which he attempted to relate physiological responses and aesthetic responses.[3] Many years later, in 1984, another writer made similar assertions; M. S. Lindauer produced an article on an old and nearly forgotten subject, physiognomy, which he defines as the power of a stimulus to evoke meaning and feeling. Certain configurations, such as pointed shapes or curved shapes, have, it seems, the power to evoke specific meaning and feeling, according to Lindauer. These, Lindauer claims, are the basis for what artists call expressiveness in art. The expressiveness, Lindauer writes, is found in the artworks, and observers simply react to the colors and forms which are the expressiveness.[4]

Assuming that certain configurations, such as pointed shapes, for example, actually have the power to evoke specific responses in observers, then many implications and questions immediately arise. One obvious implication is that, if this were so, it explains the universal interest in art and how some works of art seem to have universal appeal. That is, if certain configurations evoke specific responses in human beings, then all members of the species must be capable of responding in the same way to these configurations. Thus, artworks containing sharp points, for example, would evoke similar responses in all humans. English philosopher David Hume, writing his famous essay on taste in art in 1757, asserted the relativity of responses to art but failed to account for what a later philosopher/psychologist, J. Sully,

pointed out: All humans seem to have an aesthetic sense or an ability to appreciate the beautiful.[5] That is, though it is obvious that human beings display great variation in taste, the fact that we all seem to respond to art points to some universality.

Another implication of a reflexive response to certain configurations used in art is that a utilitarian argument for the occurrence of art or for its ultimate nature is provided. If one looks at art from an ethological viewpoint, it makes no sense to say art has no purpose. Any behavior that has persisted since the dawn of our species must, if behaviors are considered from an evolutionary perspective, have utilitarian value and purpose.

A major question arises from this theory. How does it work? That is, how do these configurations evoke specific responses in human beings? That is the subject of most of the chapters which follow, and psychologist Richard Coss actually provided an answer in the 1960s. Coss, thinking as an ethologist, theorized that the predator visual cues, which, through natural selection, evoke appropriate responses in prey animals (e.g., great excitement in preparation for fight or flight), could be used in art to evoke similar responses. Coss did not provide an aesthetic framework for his argument nor did he ask the big questions asked by Dissanayake, but he did show how art can universally evoke emotion by the use of ethological releasers. Coss analyzed various visual configurations which might be releasers of fear or excitement in humans. These included the curves formed by a snake's body and the crouch of a large predator cat, the angled and pointed outline of a spider's legs and the talons of a predator bird, and the concentric patterns found on many moths' wings (which animal behaviorists call eye spots). Thus, the groundwork was laid for an explanation of how certain configurations of line, shape, color, and sound can evoke specific emotional responses in human beings.[6]

## BASIC DEFINITIONS

### Emotion and Aesthetic Response

Aesthetic response traditionally has been difficult to define. I define it in terms of emotional response, but emotion is another elusive term. Other related terms—such as arousal, motivation, and drive—overlap, confound, and confuse definitions of emotion. Psychologist G. R. Levin provides the most useful definition of emotion that I have found. Levin writes, "Each emotional reaction has three parts. There is (1) physiological arousal (as in changes in brain waves, blood chemistry, and heart rate), (2) behavior (smiling, running, talking, and so on), and (3) cognition (understanding or interpreting the situation, as in

thinking 'This is great!')."[7] Using Levin's three-part definition of emotion, it might be possible to say that art (1) arouses physiological events in observers, which (2) may not make them run away but might cause tingles down their spines, and (3) probably will result in a comment, such as "I like that music!" Aesthetic response, I submit, is actually a particular kind of emotional response.

Not all aesthetic response is evoked by art. Natural objects and occurrences, such as wonderful sporting accomplishments, can and do evoke aesthetic response. Moreover, aesthetic response can be refined and modified by observers' knowledge of the specific stimuli evoking the response. For example, a firm grounding in classical music will likely enhance the response to a fine performance of a Chopin sonata. However, the basic response is not thwarted for the uneducated. For example, observers who are acquainted with literary devices will notice that the wolf in the film *Dances with Wolves* serves as a metaphor for the Indian as a people and for their way of life. The title of the film reinforces the metaphor by referring literally to a specific episode in the film in which the lead character "dances" with the wolf, but also metaphorically to the relationship between the white man (the lead character) and the Indians with whom he came to live. However, persons who are ignorant of the use of metaphor or who are not practiced enough to detect its use can respond aesthetically to this film for its beauty, spectacle, and story. Consequently, aesthetic response is a kind of emotional response, and emotional response is composed of physiological response, behavior, and cognition. See Chapter 2 for a more complete discussion of aesthetic response.

### Ethological Releasers

In the 1930s, Konrad Lorenz and Niko Tinbergen formulated the theoretical basis for the new discipline of ethology, which is the study of behavior from an evolutionary point of view. Behaviors, they figured, could be viewed in the same way that anatomical changes were viewed by evolutionary theory; that is, behaviors are shaped by the adaptive value that they have or how they contribute to the survival of the behaving organisms. Behaviors that result in the survival of the animal long enough for it to mate and insure the survival of its young tend to survive; behaviors that are maladaptive or result in early destruction of the organism before it can procreate and raise young do not survive evolutionary change.

The basic unit of behavior, the founders of ethology theorized, was the *fixed action pattern*. The fixed action pattern was the end result of a reflex triggered by a releasing or triggering stimulus. The whole process was termed the *releaser–internal releasing mechanism–fixed action pattern*. The releaser could be some simple environmental stimulus,

such as the sudden movement of an object within an organism's field of vision. This would trigger an internal releasing mechanism or reflex arc, which would start the fixed action pattern. The fixed action pattern was a predictable behavioral or motor pattern that would run to completion without further sensory feedback. An example is the "C-start" escape behavior seen in goldfish. Once the appropriate mechanism is stimulated, a goldfish will make a quick turn away from the threatening stimulus which results in the body of the fish forming the shape of a C. When the fish has thus turned itself away from the stimulus (such as a sudden noise or movement), it swims away, effecting an escape from what could be a predator fish or some other danger. Once the C-start begins, all of the subsequent behavior pattern is relatively fixed; the C-start is thus fairly stereotyped in appearance and it continues (i.e., all muscular actions take place) without sensory feedback (i.e., whether the stimulus was actually a danger).[8]

Lorenz and Tinbergen viewed behavior as built of these basic units which are reflexive in nature and subject to evolutionary forces. Their theory encountered some problems, however. First, people were loathe to accept the idea that behavior, especially human behavior, was biologically based and subject to evolutionary change, just as they had been loathe to accept Darwin's assertions that we may have evolved from creatures who were less than human. Second, neurobiological technique was not adequate at the time to provide evidence for the actual existence of internal releasing mechanisms. Third, Lorenz and Tinbergen primarily described behavior and performed few controlled experiments. Fourth, they and others used the fixed action pattern to refer to such complex and plastic behaviors as mating rituals and parental caretaking activities. Their credibility became reduced since it was difficult for others to see how a behavior described as fixed could be used to describe flexible behaviors such as these.

Many years have passed. People are still loathe to accept the idea that their behavior could result from evolutionary forces, but techniques of neuroscience have improved so that internal releasing mechanisms are traceable, controlled experiments have demonstrated the viability of the original theory, and the basic unit of behavior as described by Lorenz and Tinbergen can be demonstrated to provide the building blocks of complex behaviors, such as catching prey and even, perhaps, parental caretaking.

## THE ARGUMENT FOR A
## BIOLOGICAL ORIGIN OF ART

In the discussion that follows, I hope to overcome some of the concerns about human behavior being shaped by evolutionary forces. I try to demonstrate that human behavior is shaped, molded, or constrained by

our biological makeup, but is not set or predetermined in the sense that our behavior is made automatic by our nervous system. I also explain how recent research has demonstrated the viability of the original notion of a unit of behavior shaped by evolutionary forces, but that this old releaser–internal releasing mechanism–fixed action pattern is much more complex than Lorenz and Tinbergen imagined. I explain and clarify and define this concept in light of the recent research. Also, as an extended example, I describe a particular kind of reflexive behavior, the defense reaction, in order to demonstrate that (1) the defense reaction is part of human behavior, (2) the defense reaction is reflexive in nature, (3) emotion is part of the defense reaction, and (4) some of the same natural stimuli which trigger defense reactions in human beings are used in art to trigger emotional responses which are part of the defense reaction and which are evaluated by us as aesthetic response. I then discuss various stimuli which probably are used in art to trigger the emotional portion of the defense reaction, and some stimuli which may trigger other emotional responses. Finally, I offer answers to the big questions posed at the beginning of this chapter.

Consequently, I argue that aesthetic response consists of many behaviors, including behaviors that are part of a reflexive response to specific stimuli. When one responds aesthetically to a painting, a song, or a sunset, part of that response may, but not necessarily does, include a reflexive response which is triggered by some configuration of line, shape, color, or sound in the painting, song, or sunset. This biologically built-in response, common to the human species, accounts for the universal qualities of aesthetic appreciation. It accounts for our appreciation of art from other times and cultures, because the releasing stimuli have not changed over many thousands, and possibly even millions, of years, and we have not yet evolved away from our reflexive ties to them. It also accounts for what may well be the ultimate purpose and origin of art: manipulation of the behavior of others in order to gain reproductive advantage.

## NOTES

1. Ellen Dissanayake, *What Is Art For?* (Seattle and London: University of Washington Press, 1988), x.

2. The quotes are from page 107 and page 150, respectively, of Dissanayake, *What Is Art For?* Her more recent book, *Homo Aestheticus: Where Art Comes From and Why* (New York: The Free Press, 1992), further amplifies these views.

3. Grant Allen, *Physiological Aesthetics* (New York: D. Appleton, 1877).

4. M. S. Lindauer, "Physiognomy and Art: Approaches from Above, Below, and Sideways," *Visual Arts Research* 10 (1984): 52–65. Though Lindauer discussed the notion of the stimulus creating the response, he failed to develop it adequately.

5. J. Sully, *Illusions: A Psychological Study* (New York: D. Appleton, 1888), 213–217. David Hume's 1757 essay, "Of the Standard of Taste," can be found in K. Aschenbrenner and A. Isenberg, eds., *Aesthetic Theories: Studies in the Philosophy of Art* (Englewood Cliffs, N.J.: Prentice-Hall, 1965), 107–119.

6. Coss's research into visual configurations which evoke emotion is found in R. G. Coss, *Mood Provoking Visual Stimuli: Their Origins and Applications* (Los Angeles: University of California Industrial Design Graduate Program, 1965). His ideas linking these visual configurations with ethological releasers used in art are found in R. G. Coss, "The Ethological Command in Art," *Leonardo* 1 (1968): 273–287.

7. This quote appears on page 231 of G. R. Levin, *Child Psychology* (Monterey, Calif.: Brooks/Cole, 1983). Neuroscientists have recently found evidence that supports Levin's definition. See the work of Joseph LeDoux, which is described later in this book.

8. Many of the points presented here regarding ethological theory can be found in Konrad Lorenz, "Part and Parcel in Animal and Human Societies: A Methodological Discussion," in *Studies in Animal and Human Behaviour*, vol. 2, trans. R. Martin (Cambridge: Harvard University Press, 1971). Lorenz's original work was published in 1950. More discussion is found in Niko Tinbergen, *The Study of Instinct* (Oxford, England: Clarendon, 1951), and Niko Tinbergen, *The Herring Gull's World* (New York: Basic Books, 1961).

## SELECTED BIBLIOGRAPHY

Coss, R. G. *Mood Provoking Visual Stimuli: Their Origins and Applications.* Los Angeles: University of California Industrial Design Graduate Program, 1965.

———. "The Ethological Command in Art." *Leonardo* 1 (1968): 273–287.

Dissanayake, Ellen. *What Is Art For?* Seattle and London: University of Washington Press, 1988.

———. *Homo Aestheticus: Where Art Comes From and Why.* New York: The Free Press, 1992.

Lorenz, Konrad. "Part and Parcel in Animal and Human Societies: A Methodological Discussion." In *Studies in Animal and Human Behaviour.* Vol. 2, trans. R. Martin. Cambridge: Harvard University Press, 1971.

Tinbergen, Niko. *The Study of Instinct.* Oxford, England: Clarendon, 1951.

# Chapter 2

# Emotional Response to Art

Aesthetics is the branch of philosophy that inquires into the nature of art. Aestheticians ask, "What is art?" and "What is the purpose of art?" Philosophers who have taken global approaches to their philosophic ponderings have always included aesthetics in their writings (e.g., Plato, Aristotle, Hegel, Kant, Schiller, and Spencer). Consequently, most of the literature in aesthetics is by philosophers whose concerns are extremely diverse and whose thrust is the worldview. Some exceptions to this rule exist, of course, notably the aesthetic ponderings of Roger Fry and Leo Tolstoy, one a mediocre painter and the other a great novelist. Other artists and critics have contributed to aesthetic literature, but the outline of mainstream aesthetics relies mostly upon the work of philosophers who saw aesthetics as a part of a whole worldview. On the other hand, as an artist, my concern is with aesthetics and not with ethics, epistemology, or other philosophical domains. Moreover, unlike many philosophers, I am concerned with what actually is rather than what ought to be. I am not concerned with *ideal* beauty; I am interested in what actually happens, in terms of physiology and cognition, when we respond to art. Consequently, after a brief review of classical aesthetics, I hope to offer a fairly thorough examination of aesthetic response in order to clarify what is meant by it and what actually occurs when someone responds to art. This clarification and explanation will, I hope, provide a background for the argument to come, which explains how a biological mechanism can be involved in evoking emotion in response to art.

## CLASSICAL AESTHETICS

The study of the nature of art by philosophers has traditionally taken the form of attempts to define art, state its purposes, and describe it. Classical studies of the nature of art revolve around three areas: (1) art as the imitation of reality, (2) art as form, and (3) art as expression. The notion that art is the imitation of reality began with Plato's *Republic*, in which Plato wrote that art should imitate the ideal of any object, or what that object ought to be. For the Greeks, this meant sculpting and painting beautiful objects, especially people, in a realistic manner. Artists in the Western world tended to follow suit, more or less, until modern art questioned this restricted definition of art. Art defined as form was a reaction to art defined as representation or imitation of reality. In the early part of this century, Clive Bell suggested that the nature of art is found in its formal structure. Combinations of colors and shapes which he and his cohort, Roger Fry, called "significant form" define art, they argued. The representation of real objects had, to Bell and Fry, no consequence in the nature of the observer's response to art. The observer, they indicated, responds to significant form.[1] Tolstoy and Ducasse, as the more modern proponents of art as the expression of emotion, argued that the defining characteristic of art is its expression of or evocation of emotion. This notion dates back to the Greeks, with Aristotle's idea that art provides a catharsis of the emotions. It was a particularly popular idea during the Romantic period and has continued to provoke interest.[2] Other theories also have been proposed as to the nature of art, but these—art as the imitation of reality, art as form, and art as expression—provide the nucleus of aesthetic theory.

Modern philosophers are still concerned with the classical problems of art, but often confront them via discussions concerning a clarification of what art is. One of the tasks of philosophy is to define and clarify, but in the case of art no consensus has been reached on a definition, so a clarification of ideas about art is a more useful approach. Nevertheless, philosophers have tried to define art. Ideas for a definition of art range from no definition possible to anything that is said to be art is art. Most aestheticians have attempted to list qualifications for a work of art, but these attempts have never been without exception.[3] Yet we all seem to have some notion of when we are confronted by art or, at least, we think we do. Art is part of all of our lives, yet we are unable to articulate just what it is or what it does. We seldom question why we have it or make it, but we know we enjoy it because it stimulates us, makes us think, excites us, and entertains us. These are the common beliefs that philosophers have struggled to analyze, define, and clarify since Plato.

Working within the modern framework of clarifying what is art, I have devised a means of clarification based on what I consider to be

the essentials for the existence of art. In other words, to have a work of art at all, four essentials are needed: (1) the artist who makes the work, (2) the work itself, (3) the observer of the work, and (4) the value the observer places on the work. The following discussion is built around these four requirements for the existence of a work of art with the hope of clarifying one aspect of art: what is meant by aesthetic response. Perhaps some other aspects of what art is will be made clearer also by this discussion.

## FOUR REQUIREMENTS OF A WORK OF ART

### The Artist

Common belief holds that an artist is an adult human who is creative and possesses the talent for technically reproducing his or her ideas. Attempts to define art in terms of the maker or artist have revolved around the artist's intention, which cannot be known with certainty by the observer who must describe the intention.[4] Aside from discussions of the artist's intentions, theories of art have basically not had the artist at their centers. Because of the relative lack of literature and importance to my main points, I leave this requirement for art undeveloped. The artist is, nevertheless and obviously, an indispensable requirement for art to exist. The pertinent question from an ethologist's standpoint is "Why make art?" From an evolutionary point of view, the artist must stand to gain reproductively. The artist will be discussed in the last chapter, briefly, in terms of evolutionary fitness.

### The Work of Art

Attempts to define art in terms of the work of art itself have helped to clarify what is meant by art. Discussions of the nature of art which use the work of art itself as the focal point generally involve the purpose, form, and expression of the work of art.

*Purpose*   Art is often designed to be decorative, to entertain, to tell a story, to aid spiritual instruction or devotion, or to protect against evil or desecration. A full listing of purposes is probably not possible, and, if it were, it would not be adequate to define art or to clarify what is meant by art. Non-art could just as well fulfill any or all of these purposes. What separates art from non-art will be explained as we proceed through this chapter.[5]

*Form*   The form of artworks can be described in terms of external form (i.e., sculpture, painting, poetry, music, etc.), and internal form (i.e., structure). Examples of internal formal structure include iambic pentameter in poetry and major keys in music.

The external form of the piece does not necessarily prescribe it as art. A tract house can roughly be described as architecture, but it is not commonly held to be art. A painting on black velvet for sale by the side of the road is, indeed, a painting, but is it art? What about islands wrapped in pink sheeting or the performance artist spattering himself with his own blood? Since these fail to fall into the classical formal categories, are they art? External and internal forms of art change so we cannot list the different forms to which we know and expect all future art to conform.

*Expression*    Art has often been defined as expressive of emotion. Of course, an inanimate object cannot feel or express emotion. The emotion is felt by the observer when he or she is experiencing the work of art. The so-called problem of expression in aesthetic theory has focused on how the emotion is evoked by the work of art. The problem of expression, as defined by nineteenth-century aesthetician George Santayana, is how the feeling gets into the work of art. That is, Santayana, in attempting to get at what is happening when one enjoys a work of art, chose to divide the problem into art object (first term) and feeling (second term), with the observer implicit.

Then Santayana asked, "How does the second term get into the first term?" Twentieth-century aesthetician Vincent Tomas answered Santayana's question in this way: Since we respond aesthetically not only to works of art, but also to natural things such as red roses and the songs of birds, man-made artworks must include bits of these natural things. That is, the artist selects things from nature that are already charged with *feeling import* with which to build the work of art.[6] The feeling import for response to some natural things and to art seemingly is the same. Compare the tingle down the spine experienced in response to the opening clarinet run in Gershwin's *Rhapsody in Blue* to the tingle down the spine experienced in response to a scream of terror. Tomas called these emotionally charged things used by artists *bits of nature*. Another twentieth-century aesthetician, Peter Mew, further suggests that not only does art evoke emotional response in the observer, it also shapes it. That is, art specifies or dictates the feeling felt by the observer, be it sadness, happiness, anxiety, or disgust.[7] This argument is fruitful because Tomas has suggested the possibility that some bits of nature in works of art evoke the emotion in the observer. Attempting to discover what these bits of nature are and how and why they evoke emotion in observers of art may help to clarify what we mean by art.

### The Observer

The third requirement for having art is an observer. The observer is human. In the past several years scientists have demonstrated that

chimpanzees and even elephants put brush to paper and apparently find it rewarding to do so.[8] However, as far as I know, no one has demonstrated that these creatures respond to their paintings or anyone else's paintings for the sake of the painting. Animals other than humans have not been observed pondering their own creations. Since, at this time, observers of art can safely be described as human, we can assume for the moment that one thing observers of art have in common is their humanity. Observers of art are also individuals, however, and therefore respond to stimuli with individual differences.

Observers bring cultural baggage with them when they attend to art. They could be New Guinea bushmen or New York art critics; the baggage is very different for each. Moreover, observers within the same culture have different backgrounds which influence their preparation for attending to art. Some will be artists; some will have read about and experienced many pieces of art; some will have experienced only television, movies, popular music, and paintings displayed in department stores. Motivation is also important; observers may not be particularly motivated to respond to art when presented with works of art. Their attention may be elsewhere; perhaps they are eating dinner or working on the assembly line. Observers, though they are human and possess universal human qualities, are also individuals with many individual differences.

### Value

The fourth requirement for having a work of art is the value placed upon it by the observer. When a person responds appropriately to a work of art, he or she is said to be responding aesthetically. When a person articulates his or her aesthetic response, he or she often evaluates the work of art. That is, evaluation of art is how observers articulate their aesthetic response. The articulation nearly always includes a description of how the art made the viewer feel and the consequent value placed on the work based on the feeling. The feeling may be vague and the articulation may be only "that painting is good." On the other hand, the work may have aroused feelings, associations, and ideas which are expounded at some length by the viewer. Professional and amateur art critics are often more practiced at articulating their aesthetic responses and, therefore, usually offer more detailed and penetrating appraisals of works of art than do other members of society.

So, in order to have a work of art there must be an artist who makes the work of art and an observer who evaluates the work of art. The artist and the observer each perform an action. In order for the observer to evaluate a work of art, he or she must respond to the work of art. This response is usually called *aesthetic response*.

## AESTHETIC RESPONSE

Assuming that the observer is motivated to attend to a particular work of art and has the cultural and educational background required by the work of art (some art requires little or no preparation), he or she will respond to the work of art with what is generally called an aesthetic response. This is a response to a work of art that is usually articulated in terms of a feeling felt by the observer and/or an evaluation of the work of art that is observed. Similar responses occur in the presence of natural objects such as sunsets and vistas.[9]

C. C. Pratt suggested that aesthetic responses differ from "real" feelings, such as grief in response to the death of someone close or fear of an impending collision with a car.[10] I disagree. Consider Tchaikovsky's *Swan Lake* ballet: Portions of the music are evocative of feelings of sadness, and the feelings seem quite real. The emotion evoked by a work of art may be just as real as an emotion evoked by a "real" event or object. The difference is not in the quality or specificity of the emotion but in the knowledge that what is evoking the response is, after all, only a ballet and not a real-life event. The sadness from hearing the music from *Swan Lake* is real sadness, but it evaporates quickly. The sadness felt over the death of a friend does not fade quickly. Another example makes the difference between response to art and response to real-life situations more tangible. The excitement evoked by an Alfred Hitchcock thriller seems real at the time: Palms sweat; heart rate increases; on the screen the dagger rises, ready to strike, and we gasp. We know, however, that the cause of this excitement is only a film. We realize that we are not in any personal danger. The palms dry out; the heart slows. We comment that Hitchcock certainly made exciting films. In real life, seeing a dagger about to fall into one's own chest would be more excitement than anyone would care to endure. Where the film is stimulating, the real thing is terminal. Nonetheless, in both cases the palms sweat and the heart beats faster.

Philosophers of art have used the term *disinterestedness* to describe aesthetic response.[11] The supposition is that since art objects are not useful or not real (i.e., a painting of a can of soup is not a can of soup; it cannot be opened and the contents cannot be eaten), the response to art objects is different from the response to the real object that it might depict. Certainly, an observer of an Andy Warhol painting of a can of soup may respond aesthetically to that painting. The same observer, when confronted by a real can of soup at lunchtime, will no doubt respond differently to the can of soup than he or she did to the painting. The observer of Warhol's painting of a can of soup may feel surprise or astonishment; the observer of a real can of soup may just feel hungry. The two soup cans are not equatable. One is depicted in a

painting, the other is really filled with soup. One might evoke astonishment, the other might evoke feelings of anticipation associated with hunger. The feelings are real, they are just different.

If, rather than disinterest, aesthetic response is characterized by the same qualities which characterize what we usually call emotional response (i.e., sadness really is felt when observing a painting that evokes sadness), then is there no difference between aesthetic response and emotional response? There can be a difference in the stimulus which provokes the response. Aesthetic response occurs in the presence of a work of art or something that projects similar qualities to those projected by art. Emotional response can occur in response to stimuli that have no other art-like qualities (e.g., seeing someone hit by a car). Categorically, aesthetic response is contained in emotional response, but not all emotional responses are aesthetic responses. Also, while the quality of the response is the same for aesthetic response and emotional response, the quantity of response may be different. That is, sadness provoked by art-like qualities will probably not be as intense or as long-lived as sadness provoked by the death of a friend.

### Four Ways Aesthetic Response Is Evoked

If aesthetic response is contained in the category of emotional response, what is it about the stimuli that differentiates between an emotional response in general and an aesthetic response specifically? Note that it is not simply the difference between man-made art and real-life events. One can respond aesthetically to sunsets and birdsong, for example. On the other hand, one can have no aesthetic response to a painting or a symphony. D. B. Stout wrote that anthropologists who studied the ways people in many different cultures respond to art agree on four ways that aesthetic response is evoked (see Figure 2.1).

First, aesthetic response can be evoked through associations, which are usually personal emotional attachments to particular objects depicted or sounds produced. Sometimes we would apply the term nostalgic to the associations which evoke fond memories. Sometimes the associations are shared by other members of the culture (e.g., Americans generally associate patriotic feelings with the sound of "The Star-Spangled Banner"), or associations may be more universal (e.g., the color yellow is often associated within our culture and by individuals in other cultures with cheerfulness).[12] The aesthetic response occurs due to the emotional attachment to the associated memory or concept that is evoked by the work of art or the life event. Later, we shall see that this is accomplished via classical conditioning.

Second, aesthetic response can be evoked by the depiction of emotionally charged events or persons or supernatural entities. The huge

**Figure 2.1**
**How Emotion Is Evoked by Art**

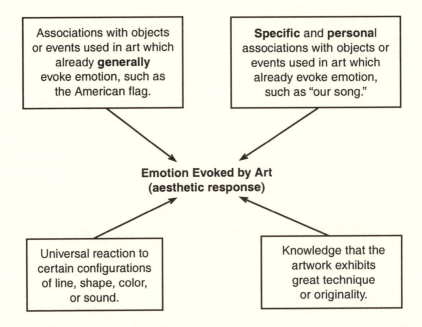

*Note*: Not all aesthetic response is evoked by art. Natural occurrences such as sunsets can also evoke aesthetic response, and for the same reasons. Also, all four of the contributors are not necessary to evoke aesthetic response.

portraits of Communist leaders hung in Moscow's Red Square were emotionally charged with patriotism, revolutionary fervor, heroism, and idealism. Their heroic proportions no doubt aided their emotional impact. The reputation of the object being observed (or the reputation of the artist who created the object being observed) can also lead to an aesthetic response. The awesomeness attached to such works as the Sistine ceiling and the *Mona Lisa* contributes to their aesthetic impact. Again, this is accomplished by classical conditioning.

Third, aesthetic response can be evoked by masterfulness of technique or a unique approach. Execution so skillful as to be extraordinary, a new approach, or a new idea never fails to thrill or astound. The precision of the Radio City Rockettes is amazing, and the Sears Tower is an engineering marvel.

Fourth, aesthetic response can be evoked by particular combinations of line, shape, color, and sound. These combinations are what, I think, Tomas refers to as bits of nature. They are the items charged with feeling import that are evocative of emotion regardless of per-

sonal memories or cultural influences. They are natural stimulators of emotional response. Sharp, angular shapes are evocative of uneasy feelings. Rounded, dull shapes evoke feelings of comfort and security. Harsh colors are grating to feelings of comfort. Soft, warm colors are pleasant. Shrill sounds are stressful.[13]

The first three of these four ways aesthetic response is evoked are dependent on personal memories, knowledge of cultural conventions, knowledge of art history, or other items. For example, if we had never heard of the *Mona Lisa*, we might not find the painting so compelling. These are relative ways of appreciating art or natural wonders. That is, the aesthetic response produced is relative to the memories and knowledge of the observer.

The fourth way is a universal way in which aesthetic response is evoked, in that it depends not on memories and knowledge but on stimulus–response packages built into the human animal. Certain combinations of line, shape, color, and sound reliably evoke specific responses, given adequate circumstances. Combinations of line, shape, color, or sound come equipped with response patterns in preprogrammed packages. Thus, as Peter Mew suggested, art shapes the emotion felt.

Aesthetic response, then, is emotional response to certain kinds of stimuli, but not to all stimuli that evoke emotional response. A parent's death certainly causes emotional response, but it is not aesthetic response. A play about failure and death, such as *Death of a Salesman* by Arthur Miller, evokes aesthetic response. Aesthetic response is emotional response, but not all emotional response is aesthetic response.

### Constraints on Aesthetic Response

There are constraints on aesthetic response. We are all aware that a particular work of art can and does evoke different responses from different people and no response at all from others. As discussed, three of the ways people respond aesthetically are dependent on personal memories and cultural knowledge. These ways certainly contribute to variable responses, but there are also other ways in which aesthetic response is constrained.

*Observer's Preparation*   Responses to art vary due to the observer's preparation. That is, people within a culture are variously prepared to appreciate postmodern art, for example. Large portions of the American population enjoy landscape painting but are confused by styles such as pop art and abstract expressionism, while people in other cultures may not appreciate a landscape painting. By the same token, Americans, as a rule, are not prepared to appreciate a Zambian carving in the same way a Zambian is prepared to appreciate it. Americans are not generally aware of the cultural associations which influence

the aesthetic response of the Zambian who is appreciating the art of his or her own culture. Americans can appreciate the Zambian carving, however, for its particular combinations of line and mass or shape.

*Motivation*    Another constraint on aesthetic response is the motivation or attention of the observer. If the observer is not interested in or unable to attend to the art object, there is no aesthetic response. However, art is quite often successful at overcoming inattention. The "1812 Overture" effectively uses the famous cannon shot to regain any attention which may have been lost during the preceding portions of the overture. Size is an attention getter; there is no way to miss the abstract expressionists' oversized canvases. Action is another attention getter; the Native American sand painter or the performance artist on the street hardly fail to draw a crowd.

*Individual Sensitivities*    Another constraint on aesthetic response is individual sensitivities. Each of us is a bit different; each of us responds a bit differently. Just as people have different body types and different tolerances to disease and stress, people vary in their responses to emotional and aesthetic stimuli.

*Personal Biases*    Another constraint on aesthetic response is personal biases. For strictly personal reasons, an observer may dislike a particular style of painting, for example. People are apt to say they dislike a painter's work because they read that the painter was a drug-addicted homosexual. They may even extend their dislike of that painter's work to all work that reminds them of that painter's work.

To sum up this analysis of aesthetic response, then, what happens when people respond to art is total involvement with the work of art for at least a very brief moment. It is an emotional response of the same quality as emotional responses evoked by real-life events or our own thoughts. It may not be very intense, since we are aware that the evocator of our emotional response is really only a work of art and not a real-life event. It may be difficult to describe the emotion felt in response to a work of art, since more than one emotion may be aroused, the intensity level may be very low, or, as will be discussed, the response may not enter our conscious thoughts. Aesthetic response is evoked by certain kinds of stimuli. A partial list of the kinds of stimuli evocative of aesthetic response includes three kinds which are shaped by culture and individual differences and one kind which occurs in a universal form. The effect of the stimuli on observers of art is constrained by several things, including the observer's preparation, motivation, individual sensitivities, and personal biases.

## VALUE FOR WESTERN OBSERVERS

Often, observers evaluate artwork as "good" or "bad." Good art will meet certain expectations, many of which are individually or cul-

turally based. Bad art usually fails to meet these expectations or offends the observer in some way. The offense may be very personal and, therefore, the observer's opinion of the work, colored as it is by this offense, will be unreliable. For example, as part of the plot in the feature film *Punchline*, one character delivers a comedy monologue in a contest to choose the best comedian. The monologue contains elements of art: It has form and structure, it exhibits good craftsmanship or technique, it is original and unique, and it contains a message. However, it offends three out of the five judges who attend to it because (as an integral part of the routine) the comedian slanders the judges at the outset of the monologue. Other comedians who also attend the performance are upset, since they, the unslandered cohorts, understand the unreliability of the critics' decisions.

### Good Art and the Art World

Notwithstanding personal offenses, art, to most critics and discerning observers of the Western world, needs to meet certain requirements to be called good art. It first needs to fall into the category of things we call art. That is, it must be something that we think might be art in that it is presented as art by the art world.[14] Aesthetician George Dickie suggested that a definition of art could be based on this first criterion.[15] As a definition, it is a tautology: This is art because the art world says it is art. Where does this leave observers of art who are not nominally members of the art world? Are we unable to determine what is art and whether or not it is good or bad? Clement Greenberg, the New York art critic who packaged action painting as good art, was asked by an art student how one could tell if an artwork were good. Greenberg answered, "If you have to ask, I can't tell you."[16] That, of course, is not the kind of question any self-respecting art student should ask, and the exchange indicates that the student is expected to know the difference between good and bad art. What is more, not only is the art student expected to know good art, he or she should not expect any guidelines for discerning good art from bad. Art students are on the fringe of the art world and, as such, are supposed to be able to make decent evaluations of art. The opinions of nonmembers of the art world are not expected to be good evaluations. Consequently, Greenberg did not need to answer the question. If you are part of the art world, you already know what is good art, and if you are not part of the art world, it does not matter if you know or not. The bottom line is that, though all people can and do evaluate art, those whose opinions are most highly valued are members of the art world. Therefore, the first test a hope-to-be-art object needs to pass is to be accepted as a work of art by the art world.

Acceptance of an artwork by the art world means that the artwork is made public. If Newton had never made his notions about gravity

public, we might have waited one hundred more years for someone to "discover" gravity. Like an experiment that is never published, a painting unrecognized as art by the art world in its own culture and time is not written about and not discussed. That does not remove its value as art to an observer. The situation might best be described as similar to the old question, "Does a tree falling in the forest make a sound if no one is there to hear it?" The crash produces sound waves, but if no observer is there to receive them and contemplate the meaning of the crash, the event is lost to human experience. In the same way, if no one from the art world accepts the painting as art, then it is lost, no matter how highly it might be valued by non-artworld observers or could be valued by the art world. Occasionally, paintings are discovered in an attic that were not noticed by the art world at the time of their creation. After their discovery, they become valued by the art world, which announces their discovery and value to the remainder of society. Recognized artists' work falls in and out of favor; for example, El Greco's paintings were considered to be more strange than good by the art world of his time. El Greco's work, however, unlike the work of the painter who put his work in the attic, was recognized and discussed as art in his time. The non-artworld observer, then, can and does evaluate art, but his or her evaluation generally is not of interest to those in the art world or on its fringes. It is the art world that first must accept a work as art before further determination can be made as to its relative goodness. This does not mean that art not accepted as such by the art world is non-art or bad art, though it certainly may be just that; it only means that the work is unrecognized by the art world. Its value to an observer is not affected, but its potential audience is definitely affected. Works not recognized as art by the art world are like trees falling alone in the forest; they are just not seen or heard.

Though Clement Greenberg really could not provide the art student with a guide to good art, he could have discussed ways critics evaluate art in Western culture. Consciously or unconsciously, critics set forth requirements for good art. Having absorbed about thirty years of reading reviews and evaluating art, I suggest that the following list, though it may not be complete, provides guideposts to good art in the Western art world.

First, a work of art should be technically adequate to do what it set out to do. For example, a wrapped island that has its wrapping come apart before the photographs are taken is a technical failure. A superrealist painting that portrays a poorly drawn figure is a technical failure and is, then, bad art.

Second, a work of art must be coherent to be good art. It must make sense on its own terms. A play that ends in what appears to be the middle lacks coherency. A film that leaves characters and plot twists

turally based. Bad art usually fails to meet these expectations or offends the observer in some way. The offense may be very personal and, therefore, the observer's opinion of the work, colored as it is by this offense, will be unreliable. For example, as part of the plot in the feature film *Punchline*, one character delivers a comedy monologue in a contest to choose the best comedian. The monologue contains elements of art: It has form and structure, it exhibits good craftsmanship or technique, it is original and unique, and it contains a message. However, it offends three out of the five judges who attend to it because (as an integral part of the routine) the comedian slanders the judges at the outset of the monologue. Other comedians who also attend the performance are upset, since they, the unslandered cohorts, understand the unreliability of the critics' decisions.

## Good Art and the Art World

Notwithstanding personal offenses, art, to most critics and discerning observers of the Western world, needs to meet certain requirements to be called good art. It first needs to fall into the category of things we call art. That is, it must be something that we think might be art in that it is presented as art by the art world.[14] Aesthetician George Dickie suggested that a definition of art could be based on this first criterion.[15] As a definition, it is a tautology: This is art because the art world says it is art. Where does this leave observers of art who are not nominally members of the art world? Are we unable to determine what is art and whether or not it is good or bad? Clement Greenberg, the New York art critic who packaged action painting as good art, was asked by an art student how one could tell if an artwork were good. Greenberg answered, "If you have to ask, I can't tell you."[16] That, of course, is not the kind of question any self-respecting art student should ask, and the exchange indicates that the student is expected to know the difference between good and bad art. What is more, not only is the art student expected to know good art, he or she should not expect any guidelines for discerning good art from bad. Art students are on the fringe of the art world and, as such, are supposed to be able to make decent evaluations of art. The opinions of nonmembers of the art world are not expected to be good evaluations. Consequently, Greenberg did not need to answer the question. If you are part of the art world, you already know what is good art, and if you are not part of the art world, it does not matter if you know or not. The bottom line is that, though all people can and do evaluate art, those whose opinions are most highly valued are members of the art world. Therefore, the first test a hope-to-be-art object needs to pass is to be accepted as a work of art by the art world.

Acceptance of an artwork by the art world means that the artwork is made public. If Newton had never made his notions about gravity

public, we might have waited one hundred more years for someone to "discover" gravity. Like an experiment that is never published, a painting unrecognized as art by the art world in its own culture and time is not written about and not discussed. That does not remove its value as art to an observer. The situation might best be described as similar to the old question, "Does a tree falling in the forest make a sound if no one is there to hear it?" The crash produces sound waves, but if no observer is there to receive them and contemplate the meaning of the crash, the event is lost to human experience. In the same way, if no one from the art world accepts the painting as art, then it is lost, no matter how highly it might be valued by non-artworld observers or could be valued by the art world. Occasionally, paintings are discovered in an attic that were not noticed by the art world at the time of their creation. After their discovery, they become valued by the art world, which announces their discovery and value to the remainder of society. Recognized artists' work falls in and out of favor; for example, El Greco's paintings were considered to be more strange than good by the art world of his time. El Greco's work, however, unlike the work of the painter who put his work in the attic, was recognized and discussed as art in his time. The non-artworld observer, then, can and does evaluate art, but his or her evaluation generally is not of interest to those in the art world or on its fringes. It is the art world that first must accept a work as art before further determination can be made as to its relative goodness. This does not mean that art not accepted as such by the art world is non-art or bad art, though it certainly may be just that; it only means that the work is unrecognized by the art world. Its value to an observer is not affected, but its potential audience is definitely affected. Works not recognized as art by the art world are like trees falling alone in the forest; they are just not seen or heard.

Though Clement Greenberg really could not provide the art student with a guide to good art, he could have discussed ways critics evaluate art in Western culture. Consciously or unconsciously, critics set forth requirements for good art. Having absorbed about thirty years of reading reviews and evaluating art, I suggest that the following list, though it may not be complete, provides guideposts to good art in the Western art world.

First, a work of art should be technically adequate to do what it set out to do. For example, a wrapped island that has its wrapping come apart before the photographs are taken is a technical failure. A superrealist painting that portrays a poorly drawn figure is a technical failure and is, then, bad art.

Second, a work of art must be coherent to be good art. It must make sense on its own terms. A play that ends in what appears to be the middle lacks coherency. A film that leaves characters and plot twists

dangling lacks coherency. It must make sense. For example, the Talking Heads, a popular music group, made a film of their live performances entitled *Stop Making Sense*. It is an example of an artist's reaction to the notion that art must make sense. No matter how bizarre or incoherent it seems, the film makes sense as a reaction to the belief held by the art world that art should make sense.

Third, a work of art must be cohesive. All parts need to make sense together. It is often said of a praised work that it has no extraneous parts; everything works together, nothing could be added and nothing left out. That is cohesiveness. For example, what if Picasso's *Guernica* sported a realistically painted reclining nude in one corner? The whole painting would lose its power and force because of this inconsistency. The nineteenth-century add-on steeple stuck in the middle of the roof of Notre Dame in Paris ruins the architectural cohesiveness of the building because it does not match the original structure. Notre Dame is coherent because it makes sense as a building, but it is not cohesive because all its parts do not go together.

Fourth, a work of art must be original and unique. An exact copy of a good painting is not a good painting but a fraud. Art that is derivative of other art has less value than original art.

Fifth, a work of art must have meaning. Meaning is often interpreted by art critics as the message or statement made by the work of art. There are at least two major types of meaning in works of art. First is the type generally associated with the assertion of a message or statement, and it can be described by comparing literal and figurative meanings.

*Literal and Figurative Meanings*    Robert Frost's "Stopping by Woods on a Snowy Evening" is often used as the exemplar to distinguish literal from figurative meaning. Literally, the poem is about a person who stops his horse by some dark woods on a snowy night but decides not to linger since his destination is still miles away. Figuratively, the poem seems to be about a person contemplating the peacefulness of death but who decides, rather, to try to finish the work he has set out to accomplish in his lifetime. The "dark woods" reads as a metaphor for death and the "miles to go" as a metaphor for work unfinished.

> Whose woods these are I think I know.
> His house is in the village though;
> He will not see me stopping here
> To watch his woods fill up with snow.
>
> My little horse must think it queer
> To stop without a farmhouse near
> Between the woods and frozen lake
> The darkest evening of the year.

He gives his harness bells a shake
To ask if there is some mistake.
The only other sound's the sweep
Of easy wind and downy flake.

The woods are lovely, dark and deep,
But I have promises to keep,
And miles to go before I sleep,
And miles to go before I sleep.[17]

Frost's poem has meaning for us because we can relate to the notion of being tired and wanting to quit but, instead, of picking ourselves up and forging ahead. We may contemplate our similar experiences. The poem changes us just a little because we consider the meaning in terms of our own experiences.

Another example helped encourage a reappraisal of our country's role in international affairs. During the Vietnam War, Jimi Hendrix gave a solo electric guitar performance of the "Star-Spangled Banner" at Woodstock, New York. Literally, he was playing a tune which is a symbol of the United States. The way he played the tune, however, turned the guitar into bombing and strafing war planes. Through the metaphor of the sounds, we imagine our American planes destroying thousands of soldiers and civilians. The message is clear: We are guilty of murder. Hendrix's use of the "Star-Spangled Banner" implicates us all in the destruction because we all have sung it and consider it a symbol of our people; it stands for *us*.

*Emotional Meaning*    Another type of meaning in art is emotional meaning. Robert Frost's poem does not leave us with just a message, it also evokes a feeling or mood in us. Death, it seems to say, is peaceful. Perhaps, though, we become depressed at the thought of our own death. Perhaps the poem stirs some other feeling, such as hope, since the person in the poem does choose to continue his life and his work. The Hendrix piece can hardly help but to stir feelings of horror and guilt and, maybe, anger. In both cases, the statements are clear and our associations with or ideas about the statements shape our feelings about the messages.

Emotional meaning can be shaped or evoked in other ways by works of art. Frost's poem and Hendrix's tune shape emotional meaning in ways other than through feelings associated with the messages. The sounds themselves aid and abet the same feelings evoked by the associations of ideas and memories. Frost's poem contains several open vowel sounds which ring full and round, or (put into emotional terms) content and peaceful. In the second two stanzas Frost also uses alliteration of the *s* sound, which softly hushes and calms our fears of death. Hendrix, on the other hand, sears our senses. His guitar shrieks and howls and we hear the agony of the dying. These associations are sub-

tly connected to the statements made. The artists use the media (language sounds and musical sounds) to underscore the emotion conveyed by the message or statement. This use of the media and the profound quality of the messages presented by the Frost poem and the Hendrix tune make these highly valuable works of art.

In summary, good art in late twentieth-century Western culture is typified, first of all, by work that is considered art by the art world. Beyond that prerequisite, the work should have other qualities. These qualities include (1) technical adequacy, (2) coherency, (3) cohesiveness, (4) originality and/or uniqueness, and (5) meaning. It is now necessary to determine if these qualities are shared aesthetic standards in other cultures, since art seems to be appreciated by all peoples.

## VALUE FOR NON-WESTERNERS

If, in the Western art world, we highly value technique, a unique approach, coherency, cohesiveness, and meaning, what do art worlds in other cultures value? A former curator of the Cleveland Museum of Art, Thomas Munro, provides a comparative look at the philosophies of art in some other "advanced" cultures. Munro wrote that, early on, Japanese, Indian, Chinese, and Western aestheticians assumed a didactic, moral, and social purpose for at least two of the arts, drama and poetry, but "long experience with didactic art showed that high moral aims were not enough; aesthetic power was also necessary."[18] Aesthetic power seems to entail what, generally, the Indians call *rasa* and what Westerners call emotions evoked by art or aesthetic feelings. These emotional states evoked by art may arise from what the Japanese call *yugen*, which describes a "vague, indefinite symbolism" and which is similar to the Chinese ideal of "spirit resonance" in painting. Spirit resonance is explained as "psychic forces within the artist and communicated by him to the work of art."[19] Thus, aestheticians in cultures as diverse as the Japanese, the Chinese, the Indian, and the Western all seem to be describing the emotional effect of art.

Technique is important in other cultures, as evidenced by the fact that the earliest Indian writings in aesthetics were on technique and the Chinese expend inordinate amounts of space in their aesthetic writings on brushwork technique. Technical skill may be the African's major criterion for evaluating the traditional art of Africa. For example, among the Chokwe, skillful technique was necessary in order that a piece be taken seriously. Generally, traditional African cultures stress technical skill rather than personal expression.[20]

Coherency, cohesiveness, and meaning may well be very important to the value of art in other cultures as they are to Western art. One famous and highly influential theory of Chinese literature, that of Lu

Chi, written about A.D. 302, notes, "He who intends to convince the mind values cogency." Furthermore, and paralleling my statements about how literal and figurative meaning must work together, Lu Chi wrote, "Lyric poetry traces emotions daintily; dirges are tense and mournful; admonitions are clear-cut and vigorous." Liu Hsieh (A.D. 465–522) elaborated the literary ideals of Lu Chi in *The Literary Mind and the Carving of Dragons*. It treats topics such as unity in variety, which "presents the essence of the classical ideal in art, aesthetics, ethics, and politics in every advanced civilization, East and West."[21] The phrase "unity in variety" seems to sum up the concepts of coherency, cohesiveness, and the various kinds of meaning which have been described.

Though this is an extremely brief and superficial look at aesthetics in other cultures, it is suggestive of general similarities in ideals. My general assessment, which may indeed be hasty, is that criteria for good art may be fairly constant across cultures when cultural conventions are stripped away, and the criteria may be quite similar to that which I have outlined. Regardless of culture, the quality of aesthetic response is likely determined by similar basic values. Cultural attributes overlay these basic values and can shape the aesthetic response. However, some emotional response evoked by art may be universal and relatively unaffected by cultural overlays. Works of art which evoke emotional response across cultures have been valued by peoples ancient and modern, "advanced" and "primitive" (e.g., African masks, prehistoric cave paintings, the Venus of Willendorf, the clay guards for the first Chinese emperor). The key to this universal aspect of art—how these works of art can evoke emotional responses across culture and time—is deeply imbedded in the emotional meanings of the works of art.

## THE KEY TO UNIVERSAL EMOTIONAL MEANING

This analysis of art is built around the four requirements necessary to art's existance: (1) the artist who produces the work of art, (2) the work itself, (3) the observer of the work, and (4) the value the observer places on the work. I hope it has somewhat clarified what is meant by art and, especially, aesthetic response. It is important to understand how one responds to art. The values which result from our responses to art, and which, in the end, make a work of art good or worthwhile, seem to be basic values crossculturally. Among these values is meaning, and one kind of meaning is emotional meaning. Returning to D. B. Stout, we are reminded that, in his assessment, emotional response to art is evoked in four major ways: (1) through symbols that arouse associations, (2) through the depiction of emotionally charged events, persons, or supernatural entities, (3) through superior technical execution or a unique solution to a problem, and (4) through "particular combinations of line, mass, and color, etc., that seem capable of arous-

ing emotions in themselves." The first three of these ways art evokes emotions can be roughly categorized as associations; that is, they all require connections to other experiences in the life of the responder, either through some individual juxtaposition of emotion with a significant event or through some cultural meaning. Even a unique solution to a problem or technical expertise requires the responder to be aware of technique and of other solutions to the problem, otherwise the responder would not recognize the solution as unique or the technique as masterful and respond emotionally. The emotional impact created by these first three depend on comparisons and relationships, even though they may not be consciously recognized as such by the responder. Their emotional effect depends on learned responses or classically conditioned responses. The fourth way emotion is evoked by art does not depend on comparisons and relationships in the same sense as the first three ways emotion is evoked by art. The emotional effect depends on unlearned responses or unconditioned responses. The emotional effect is independent of the cultural background and individual experiences of the responder.

How can this be? Drawing conclusions from the thinking of Vincent Tomas, the work of D. B. Stout, and my personal observations, I contend that the only requirement necessary of the responder to respond appropriately to the particular configurations of line, shape, color, or sound is that of being a reasonably healthy, normal human being. It seems, then, natural to look to the nature of the being for an explanation for how these configurations can evoke emotional response. The basis of the response must be innate. The basis of the response is, I propose, what psychologists call an *unconditioned reflex*. An unconditioned reflex involves a particular behavior which occurs normally to a particular stimulus; it is reliable and predictable.

As I hope I have made clear in the discussion on constraints on aesthetic response, reliable and predictable responses may be inhibited or modified by other kinds of stimuli and by individual motivation. Consequently, it is possible for many shades and varieties of emotion to be evoked by one work of art. Nevertheless, if all of these other stimuli and motivation factors are stripped away, it is possible to argue that particular configurations of line, shape, color, and sound within the work of art can evoke particular emotions in responders regardless of their personal experiences. It is possible to argue that these particular configurations used in works of art are the stimuli for unconditioned reflexes which may result in the behavior we call aesthetic response. The next chapter explains and gives examples of ways human behavior is constrained in general by biological adaptations. The emphasis is not on predetermined, automatic behavior, but, rather, on how reflexive behavior can be flexible and how emotional response is constrained by evolutionary adaptation.

## NOTES

1. The notion of significant form as outlined in Clive Bell, *Art* (1913; reprint, New York: Capricorn, 1958), and Roger Fry, *Vision and Design* (New York: Brentano's, 1924), precedes Lorenz and Tinbergen's descriptions of releasers–internal releasing mechanisms–fixed action patterns. Yet they theorized some connection between the particular configurations of line, shape, and color and the response of the viewer. Their motivation for attempting this definition of art was the necessity of accounting for Cubism and other abstract works of early twentieth-century artists. They realized that the old Platonic aesthetics could not account for modern art; therefore, another way of defining art was needed.

2. Aristotle's *Poetics* introduced the idea of defining art in terms of the expression of emotion. Many philosophers, critics, and artists have discussed art in terms of expressing emotion ever since. George Santayana, *The Sense of Beauty: Being the Outlines of Aesthetic Theory* (New York: Scribner's, 1896), asked the crucial question, "How does art express emotion?" Leo Tolstoy, the great novelist, pondered art as expression in *What Is Art?* (Philadelphia: Henry Altemus, 1898). C. J. Ducasse discussed the problem, after modern art posed new problems for old ideas, in "Art and the Language of the Emotions," *Journal of Aesthetics and Art Criticism* 23 (1964): 109–112.

3. Morris Weitz wrote in "The Role of Theory in Esthetics," *Journal of Aesthetics and Art Criticism* 15 (1956): 27–35, that a list of qualifications that would define art could never be conclusive, and, moreover, any attempts to define art would be hopeless. However, George Dickie, *Art and the Aesthetic* (Ithaca, N.Y.: Cornell University Press, 1974), took the opposite tack, and proposed that anything we call art is art.

4. In general, philosophers agree that it is impossible to know the intention of the artist. Certainly, artists discuss their works and their intentions, but, as we all know, people often fail to fully disclose their intentions or are unable to articulate their intentions. Artists are no different, and may be less apt to be able to reveal their intentions regarding their artworks. Consequently, it is considered a fallacy to say you know the artist's intention. See W. K. Wimsatt and M. C. Beardsley, "The Intentional Fallacy," *Sewanee Review* 15 (1946): 468–488. However, artists may be getting better at discussing their works. Also, as Nan Stalnaker, "Intention and Interpretation: Manet's *Luncheon in the Studio*," *Journal of Aesthetics and Art Criticism* 54 (1996): 121–134, points out, Wimsatt and Beardsley offered no viable alternative to subjective intentionalism; they only argued against discussing a work of art in terms of the artist's intentions. This argument without solution provided a background for deconstructionism, which holds that any interpretation of a work of art is as good as any other interpretation—rather like George Dickie's pronouncement that anything we call art is art. Stalnaker offers not only a thoughtful discussion of the so-called intentional fallacy, but also a viable alternative which may circumvent the fallacy.

5. David Novitz "Disputes about Art," *Journal of Aesthetics and Art Criticism* 54 (1996): 153–163, provides an informative discussion on defining art. He remarks on attempts at defining art in terms of classification and function, and comes to the conclusion that such attempts in the end involve social and

moral issues which have little to do with "metaphysical questions about the essential nature of art" (p. 162). He determines that the function of art is to make us feel at home in our world; art is a way of reinforcing our society's cultural boundaries. Art can question those values by making us feel insecure or uncertain, and that is also part of its function. Novitz's ideas are very close to those of Ellen Dissanayake, who argues convincingly for a social purpose for art in our prehistory. See Ellen Dissanayake, *What Is Art For?* (Seattle: University of Washington Press, 1988), and Ellen Dissanayake, *Homo Aestheticus: Where Art Comes From and Why* (New York: The Free Press, 1992). While Novitz discusses purpose in art from the viewpoint of mainstream aesthetics, Dissanayake takes an ethological viewpoint. Nevertheless, they seem to find common ground in a social purpose. Moreover, while Dissanayake tends to feel this social purpose may be lost to us, Novitz argues that, indeed, it is not lost. As far as using purpose to define art, however, all appear to agree that art cannot be defined in terms of purpose (this would be proximate purpose in ethological terms), nor can it be defined in terms of classification.

6. Santayana, *Sense of Beauty*, and Vincent Tomas, "The Concept of Expression in Art," in *Philosophy Looks at the Arts*, ed. J. Margolis (New York: Scribner's, 1962). A debt in Tomas's analysis is owed to Susanne Langer, *Feeling and Form* (New York: Scribner's, 1953), who initiated the notion of "feeling import" in art.

7. Peter Mew, "The Expression of Emotion in Music," *British Journal of Aesthetics* 25 (1985): 33–41.

8. Desmond Morris describes drawing and painting by a chimpanzee in *The Biology of Art* (New York: Knopf, 1962). J. Ehmann describes his experiences with an "artistic" elephant in "The Elephant as Artist," *National Wildife* 25 (1987): 26–28.

9. My definition of aesthetic response is a common-sense, intuitive definition. Mainstream aesthetics, the academic discipline, still hangs onto Kant's definition of aesthetic response, which regards the response to an object of art as a judgment of beauty based on disinterest. Kant did not differentiate between beauty in objects of art and in nature. Kant did feel that aesthetic responses are universally valid. See Immanuel Kant, *Critique of Judgment*, trans. J. M. Bernard (New York: Hafner, 1951). However, the term "disinterest" has posed many problems for subsequent philosophers. Disinterest seems counterintuitive when describing what occurs when observing art. Other words jump to mind: fascination, excitment, awe, and enrapture. Kant's use of the word disinterest was not descriptive of any emotional response but was intended to convey the notion that art is enjoyed on its own terms. Art, he thought, has no purpose. The interest we show in art is without regard for any utility—thus, he used the term disinterest. Kant's notions about art have been battered severely in this century. For an example, see Arthur C. Danto, "From Aesthetics to Art Criticism and Back," *Journal of Aesthetics and Art Criticism* 54 (1996): 105–115. Danto suggests one look at evolutionary psychology as an alternative to Kant, but most aestheticians offer no alternative. This book offers an alternative based on evolutionary theory.

10. C. C. Pratt, "The Design of Music," *Journal of Aesthetics and Art Criticism* 12 (1954): 289–300.

11.  See Note 9.

12.  This association is described in J. Nolt, "Expression and Emotion," *British Journal of Aesthetics* 21 (1981): 139–150.

13.  D. B. Stout, "Aesthetics in 'Primitive Societies,'" in *Art and Aesthetics in Primitive Societies*, ed. C. F. Jopling (1956; reprint, New York: Dutton, 1971).

14.  The art world is an amalgamation of artists, critics, gallery owners, theater owners, collectors, and so on, but who is in the art world and who is out is determined by those within. Art world members do not carry cards to identify them as such, but a publishing critic or an exhibiting artist is definitely part of the art world. Gallery owners and collectors may have more power than critics and artists, since they control the economics of art. However, just who is in and who is out of the art world is a nebulous affair. Nevertheless, the opinions about art that count in the Western world are those generated by or accepted by this group of people.

15.  Dickie, *Art and the Aesthetic*.

16.  Clement Greenberg, presentation at Ohio University, Athens, Ohio, winter 1984–1985.

17.  Robert Frost, "Stopping by Woods on a Snowy Evening," in *The Poetry of Robert Frost*, ed. Edward Connery Lathem (New York: Henry Holt and Company, 1951).

18.  Thomas Munro, *Oriental Aesthetics* (Cleveland: Press of Western Reserve University, 1965), 47.

19.  Ibid., 46, 51.

20.  See ibid. for a discussion of Indian and Chinese emphasis on technique. For African art in general, see R. Sieber, "The Aesthetics of Traditional African Art," in *Art and Aesthetics in Primitive Societies*, ed. C. F. Jopling (1956; reprint, New York: Dutton, 1971), 127–131. For Chokwe appreciation of technique, see D. J. Crowley, "An African Aesthetic," *Journal of Aesthetics and Art Criticism* 24 (1966): 519–524.

21.  Munro, *Oriental Aesthetics*, 61–62.

## SELECTED BIBLIOGRAPHY

Danto, Arthur C. "From Aesthetics to Art Criticism and Back." *Journal of Aesthetics and Art Criticism* 54 (1996): 105–115.

Stout, D. B. "Aesthetics in 'Primitive Societies.'" In *Art and Aesthetics in Primitive Societies*, ed. C. F. Jopling, 1956. Reprint, New York: Dutton, 1971.

Tomas, Vincent. "The Concept of Expression in Art." In *Philosophy Looks at the Arts*, ed. J. Margolis. New York: Scribner's, 1962.

*Chapter 3*

---

# *Biological Constraints on Human Behavior*

Certain configurations of line, shape, color, and sound evoke emotional responses in observers of art. This occurs not because of the observer's learned associations with the configurations, but because of unconditioned reflexes. That is, each configuration is a stimulus which triggers a neural mechanism in the observer under adequate conditions and which, in turn, causes a particular behavior to be performed by the observer. In the case of observers of art, the behavior consists of autonomic nervous system changes that are described by the observers as emotional or aesthetic responses. In order to argue this thesis, I will first demonstrate that research points to human behavior being constrained by our biological makeup. For example, we cannot see ultraviolet light because our photoreceptors do not capture ultraviolet wavelengths, not because we prefer not to see ultraviolet light. In this way our biologically constrained visual apparatus affects what we see. In the same way, what we hear and what we know are also constrained by our biology.

Second, I will demonstrate that one of these biological constraints, the releaser–response package, can have the flexibility necessary to be considered a part of the human behavioral repertoire. That is, we generally equate reflexive behavior with inflexible and fixed behavior, but reflexive behavior can be modified by inhibition and other factors so that this kind of behavior can be rather plastic. Even though this reflexive behavior which I call the releaser–response package is, on the surface, quite unlike the knee-jerk, it is nevertheless based on the reflex arc. It maintains a certain unity but, at the same time, allows for great variety in behavior.

Third, I will discuss a particular releaser–response package: the defense reaction. The discussion will necessarily begin with an attempt to describe the defense reaction. In so doing, it will be seen that the defense reaction is actually many behaviors all serving a common purpose: defense or self-protection. Concomitant with the overt behaviors often associated with defense are autonomic nervous system responses which we interpret as part of emotional response. These emotional responses are described by us as various intensities of fear: apprehension, uneasiness, anxiety, fear, horror. It will be seen that humans participate in this behavior, the defense reaction.

Fourth, I will assert that the natural stimuli which evoke the various intensities of fear are used in art to evoke the same emotions. (Though other natural stimuli, which evoke other emotions, may be used in art to evoke those emotions, this discussion is devoted primarily to those that evoke fear in its various intensities.) In this way, I argue that particular configurations of line, shape, color, and sound, which are natural stimuli or releasers, evoke emotional response in observers of art. This chapter begins this argument by discussing biological constraints on human behavior. The intent is to demonstrate that human behavior is shaped by our biological makeup in order to provide the basis for the discussion of the releaser–response package in the next chapter.

## BIOLOGICAL CONSTRAINTS

Over the past several years, psychologists have arrived at the opinion that knowledge can be dependent on biological parameters. Noam Chomsky expressed the view that knowing is dependent on "mental organs" which are "systems of rules and representations" that "develop on the basis of an innate endowment," permitting the growth of structures "along an intrinsically determined course under the triggering and partially shaping effect of experience, which fixes parameters in an intricate system of predetermined form."[1] Keil expressed this notion in a different way. He wrote that unless children "share with adults certain ways of construing the world, they will not be at all likely to acquire the same concepts and meanings."[2] Fodor calls this a neocartesian viewpoint, since it is loosely based on Descartes's doctrine of innate ideas.[3] What these people appear to be saying is that we share some universal traits which determine, to varying extents, what we perceive, and, therefore, the way we learn about and think about the world and, ultimately, how we behave.

We all share the same basic biological makeup as members of the human species, just as cats or dogs, for example, share the same basic qualities associated with being cats or dogs. We have little trouble ac-

cepting the fact that cats are different from dogs because cats share catness and not dogness. Humans in the same way share humanness. Discovering what humanness or human nature is what philosophy, psychology, and a great deal of biology are all about. Ethologist Eibl-Eibesfeldt points out that we have a "strong reluctance to accept the fact that man is far from being born as a blank slate. This reluctance is based on the erroneous assumption that anything innate to man must then be accepted as some kind of inevitable fate."[4] Actually, innate qualities do imply an inevitable fate: that of being human rather than a cat, dog, toad, or sea slug. It does not imply, particularly for humans, that we are automatons; it does imply, as Keil, Chomsky, Fodor, and Eibl-Eibesfeldt suggest, that we operate under the influence of the parameters of our biological systems.

The capabilities of our sensory systems set many of the parameters of our biological system. Much of what we know is based upon what we perceive, and what we perceive is determined by the capabilities of our visual, auditory, tactile, and other sensory systems. Our sensory systems are not the same as those of the cat, for example, which can see far better in the dark than we can. The cat, therefore, knows more in the dark than we do. That is, of course, a slightly skewed assessment, but it points out that our visual perception in the dark is qualitatively different from that of the cat and the cat is, in fact, better informed about its surroundings in the dark than we are. What the cat does with that information is another matter.

What human beings do with their perceptual information is often called *cognition*. Cognition is a product of the nervous system. Sensory receptors send messages regarding visual, tactile, auditory, olfactory, and other information in the form of a neural signal to special processing areas such as the lateral geniculate nucleus of the thalamus for visual input. After the thalamus processes visual information, it sends multiple parallel signals to the visual processing area of cortex. In this way, light wavelengths captured by photoreceptors in the retina are converted into pieces of electrical and chemical information by nerve cells and transmitted through the brain's processing centers so that we can say, "I see the *Mona Lisa!*" Other central nervous system processing areas, such as the hypothalamus and amygdala, receive inputs from many sensory-specific areas, process them, and send the processed information on to other areas of the nervous system (see Figure 3.1).

Primate brains share remarkable similarities; mammal brains share only slightly less remarkable similarities. Other animals are not automatons either; they, too, exhibit variable levels of plasticity in their behaviors. Human beings exhibit the most plasticity, of course, but the point is that we are animals, just as are baboons, cats, and toads. We, as

**Figure 3.1**
**From Perception to Cognition: A Simplified View of Major Processing Areas in the Visual System**

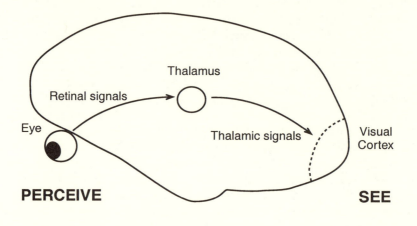

The Human Brain from the Side

do they, have basic biological systems which shape our behaviors. Human behavior, characterized by inordinate plasticity, is nevertheless grounded in a biological system of innate qualities.

Zoologist Alison Jolly emphasizes that the term "innate" is a relative term and the question regarding a particular trait or behavior should be, "How much latitude for variation is given this trait or behavior?"[5] Just because a trait or behavior has an innate quality, it is not forever fixed. The innateness provides parameters within which a behavior becomes manifest. Perhaps the parameters could be thought of as the sides of a box. Within the box is the innate quality or qualities associated with a particular behavior. The size of the box determines the variability of the behavior. A very small box constrains the behavior to heavy reliance upon the innate quality; therefore, the behavior is relatively fixed in its manifestation. A larger box provides the room for more instances of environmental, developmental, and other interactions with the innate quality; therefore, the behavior is less fixed and more plastic. A very large box allows a behavior to be so plastic that we think there is no innate quality inside the box (see Figure 3.2).

Psychologist F. C. Keil suggests ways to determine if an area of knowledge is highly constrained (small box) or less constrained (large box). A

**Figure 3.2**
**Biologically Highly Constrained versus Less Constrained Behaviors**

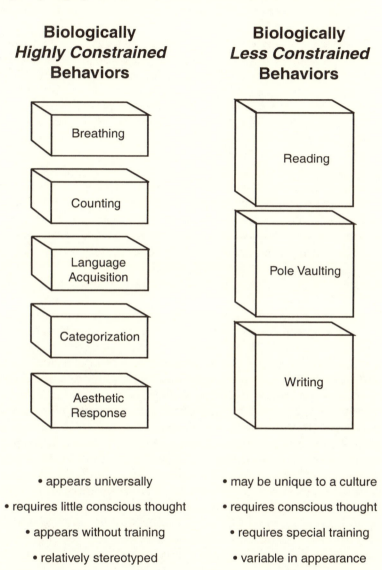

| Biologically *Highly Constrained* Behaviors | Biologically *Less Constrained* Behaviors |
|---|---|
| Breathing | Reading |
| Counting | Pole Vaulting |
| Language Acquisition | Writing |
| Categorization | |
| Aesthetic Response | |

| | |
|---|---|
| • appears universally | • may be unique to a culture |
| • requires little conscious thought | • requires conscious thought |
| • appears without training | • requires special training |
| • relatively stereotyped | • variable in appearance |

couple of pertinent ways he suggested are, first, the easier and the more universally an area of knowledge is acquired, the more constrained it is (Keil includes aesthetic response in his list of examples), and, second, conscious introspection is likely not to be a quality of highly constrained knowledge. In addition, Keil suggests four areas of knowl-

edge which research indicates are highly constrained. First, ontological knowledge (which Keil defines as the "individual's conception of basic categories of existence") is highly constrained, in that the number of classes of possible hypotheses concerning a solution to a problem is limited. That is, we have only so many guesses; some guesses (the ones most useless to us) are automatically eliminated. Therefore, we simply do not generate some hypotheses. Second, number concepts are highly constrained in that a small set of principles guide the acquisition of knowledge about counting (e.g., each object is assigned one number, the assignment is arbitrary, and each object is counted only once). Third, natural deduction also appears to be constrained, since work by D. N. Osherson suggests that children use the same mental derivations or logic to evaluate arguments as do adults.[6] Fourth, language acquisition is a well studied and reviewed area of highly constrained knowledge. One aspect of the constraints on language acquisition, categorical perception, will be discussed later. Note that Keil writes from the point of view of a cognitive psychologist, and, as such, he uses the word "constraint" to mean a limitation on the "class of logically possible knowledge structures that can normally be used in a cognitive domain."[7] His notion is applied to human beings and is fairly limited in its context. I prefer to use the term to encompass not only Keil's definition but, in addition, physical mechanisms such as sensory apparatus, reflexes, and releaser–response packages.

Zoologist Alison Jolly leans toward this broader definition and uses behavioral terms to describe how to determine if a behavior is highly constrained. According to Jolly, if a trait appears in individuals whose experience has differed widely, and if it appears without apparent relevant experience, the trait is relatively innate. If, however, a trait does not appear except under limited circumstances, it is relatively learned. For example, the ability to pole vault is limited to those athletes who have expended large amounts of time learning and perfecting the skill. Less constrained behaviors are typified by a great deal of variability among individuals in motor patterns and in perceptual or sensory cues. Relatively innate traits or highly constrained behaviors are often, according to Jolly, widespread throughout the species and relatively stereotyped in motor pattern and responsiveness to simple cues.[8] (These might be particular combinations of line, shape, color, or sound.)

Consequently, psychologists and zoologists demonstrate a belief that human behavior is shaped by biological parameters. These parameters constrain what we perceive and thereby shape our cognition or what we know. Behaviors can be more or less constrained by biological parameters. Those that are less constrained tend to require conscious thought, tend not to appear except under tutelage or other special circumstances, and are quite variable in their manifestation (e.g., the abil-

ity to write paragraphs, tap dance, or recite from Shakespeare). On the other hand, more constrained behaviors tend to be accomplished without much conscious thought, are easily accomplished by every normal member of the species regardless of culture or personal experience, and are not as variable in manifestation (e.g., walking, talking, or enjoying art) (see Figure 3.2).

### Biological Constraints in Various Domains

A great deal of research actually highlights these innate qualities and parameters constraining human behavior.[9] In some cases the research only hints at possibilities, but in others the innate quality or the amount of constraint is better defined. Sometimes a releaser is identified or hinted at, but not all constraints are releaser–response packages. I have divided the research into domains to make organization easier, but the lines of division are not clear and obvious overlaps will be evident.

*Perception* Visual perception, for example, is constrained by the characteristics of our visual system. The human system is good relative to the systems of many other species and excellent in terms of color vision and binocular vision. However, it does have parameters which allow for some peculiar effects which affect what we can know about our world as human beings. As Spelke puts it, our visual capacities "set boundaries on what we are capable of learning, limiting the states of the world that we are able to perceive or understand," and, she continues, "a study of the visual system includes consideration of innate mechanisms that order visual experience in ways that permit learning and how these mechanisms are modified, in turn, by what is learned."[10] An example of a boundary set by the capacities of our visual systems is the fact that equiluminant but opposing colors placed adjacently will appear to float. Ad Reinhart's *Abstract Painting* provides an excellent example of this phenomenon, since it makes use of the inability of our visual system to handle the job of focusing equally lighted opposite colors, such as red and green, placed side by side.[11] The shapes in Reinhart's painting are composed of equally lighted opposite colors placed side by side without the benefit of outlines. These shapes appear to jump or float no matter how hard we try to focus them or stabilize them.

Another peculiarity of our visual system causes colors to blend when put together into a small pattern which is then viewed from a distance.[12] Seurat used a technique, which he called pointillism, that provides dramatic evidence of this phenomenon. Up close, his pointillist paintings appear as blobs of primary colors, but when viewed from a distance the colors blend and the blobs are seen as trees, seashore, children running, and couples walking hand in hand.

In the same way, the abilities to visually link parts of a scene together (e.g., we do not see a house as split in half by a telephone wire crossing in front of it, we see a house with the wire crossing it in front), to discriminate figure from ground, and to perceive the correct spatial relationships of objects is likely dependent on visual capacities rather than on some higher-order cognitive processing.[13]

Richard Latto proposes that our visual system adds further constraints by making some things more salient because these are encoded within the system for adaptive purposes, which is very much akin to what is proposed here. Latto calls such items as faces, hands, and the axes of objects (exemplified by stick figures) "aesthetic primitives," because the human visual system is "selectively tuned" to these forms. Latto speculates that these aesthetic primitives are intrinsically interesting because the human visual system is adapted to pay particular attention to them. Though Latto initially leaves emotion out of his argument by noting that, while some aesthetic primitives may be universal in the species, they have "no semantic or affective overtones," in his conclusion he writes that aesthetic primitives "stir the emotions."[14] Certain of these items not only stir the emotions, but shape specific emotions in predictable ways.

Another type of constraint illustrates another way visual perception is influenced by our biology. The research of Greenough, Black, and Wallace demonstrates that newborn primates start life with many overlapping axonal branches in the visual cortex. Normal development requires that the branches be "pruned" equally for each eye. Abnormal development, as is seen in amblyopia or lazy eye, results in unequal pruning. That is, if one eye is deprived of seeing experience, the axons supporting that eye will not be pruned as they should be and the end result of maturation will be reduced vision for the individual. Greenough and his fellow researchers found that even small amounts of experience can protect against the loss of normal vision.[15] In this case, the normal physical development of the visual cortex depends on experience; the constraint is of a very different nature from the old notion that implies if it is innate, it is fixed from birth. Here, the constraint is the proper pruning of axonal branches in order to result in normal vision. Without seeing experience, however, proper pruning does not occur. In this instance, an innate quality expressed as axon maturation necessary for normal vision is affected by experience and, in turn, affects further visual experiences. This example illustrates a physical mechanism of a biological constraint on perception and how that mechanism is affected by experience.

A well-known example of a constraint on perception is the discovery made by P. D. Eimas and associates that infants seem to be able to categorize language sounds. The authors found that the one- to four-month-old

infants tested were able to discriminate between the phonemes presented. Eimas and his associates divided the babies into three groups, with the first group hearing stimuli from two different adult phonemic categories (*b* and *p*), the second group hearing stimuli from one category, and the third group as a control hearing no stimulus changes. The acoustic variations within the stimuli presented to the first two groups were equal. The results showed clearly that the infants in the first group differentiated between the phonemic categories. The infants in the second group exhibited little difference in response to the stimuli presented from one phonemic category, and the infants in the third group showed no differences in response to the lack of stimulus changes. Eimas and associates summarized their findings by writing, "One-month-old infants are able to sort acoustic variations of adult phonemes into categories with relatively limited exposure to speech, as well as virtually no experience in producing these same sounds and certainly little, if any, differential reinforcement for this form of behavior. [The implication of these findings is that] the means by which the categorical perception of speech, that is, perception in a linguistic mode, is accomplished may well be part of the biological makeup of the organism."[16] Eimas and colleagues found what may be a constraint analogous to the constraints on natural deduction or mathematics as discussed by Keil. That is, the biological system automatically limits or provides categories for, in this case, speech sounds. The organism then develops its behaviors within these boundaries or categories.

Studies also find support for auditory categorization not directly related to speech. Researchers Trehub, Bull, and Thorpe found that infants can detect melody changes suggesting that the ability to detect melody changes relies little, if at all, on learning. The researchers presented ninety-seven healthy, full-term infants from eight to eleven months old with sequences of six tones paired with four transformations of each melody. They presented one melody over and over, and when the infants were quiet and facing straight ahead, inserted a second melody. If the infants turned their heads toward the loudspeaker, Trehub and colleagues assumed that the infants detected a difference in the melodies.[17] In addition, Trehub, Thorpe, and Morrongiello found, using the same technique, that infants about seven months old can differentiate six-tone melodies with one tone changed.[18] Thus, the work by Trehub and associates indicates that human infants as young as seven months old can detect differences in melodies. This research, together with the research by Eimas and his fellow researchers, suggests that auditory perception is constrained in such a way that categories facilitating speech and melody recognition may be innately provided for human beings.

Other researchers are following leads to what may be auditory releasers for a variety of species. That is, some auditory stimuli may trigger

specific behavioral responses. Seyfarth, Cheney, and Marler found that three acoustically distinct types of predator alarm calls are distinguished behaviorally by vervet monkeys. Each of the distinct calls is made in response to specific predators: one for large mammalian carnivores, one for eagles, and one for snakes. Animals on the ground responded to alarm calls announcing a leopard by climbing trees, to eagle alarms by looking up, and to snake alarms by looking down. Tape-recorded alarms were played to the monkeys in the absence of the predators and the responses were filmed. Playback confirmed previous observations that the length and amplitude of the call and the caller's age, sex, or class had little effect on the response, and context was not a systematic determinant of response (e.g., monkeys looked up in response to the eagle alarm whether they were on the ground or in trees). The calls were acoustically dissimilar, however, and this was the feature the authors considered to be sufficient and necessary to elicit the appropriate responses by the vervets.[19]

In summary, these examples of constraints on both visual and auditory perception suggest that our biological mechanisms not only determine, to some extent, what we see and hear, but how we see and hear. We are limited by our visual and auditory systems in what light and color and sounds are detected. In addition, our built-in categorization codes determine, to some extent, what we do with the light, color, and sound that is detected. Moreover, some specific sights and sounds may have meanings of such importance to survival (e.g., alarm calls) that adaptively appropriate behaviors have evolved in response to them.

*Cross-Modal Correspondences*  A type of cross-modal correspondence occurs when qualities are ascribed across media (e.g., a sound is described as being big as a mountain). An intriguing example is the experiment by Wagner and associates, in which sixty-one eleven-month-old infants were first exposed to an ascending tone and then were shown two arrows, one pointing up and the other down. The babies tended to show a visual preference by looking at the upward pointing arrow longer than they looked at the downward pointing arrow.[20] Flavell writes in his review of perception research that this experiment had not yet been replicated but that it is fascinating for its implications for metaphor; that is, the ability to make cross-modal correspondences may be an innate quality, which may be the basis of metaphor.[21] In other words, the seemingly innate ability to make cross-modal correspondences may be the basis for the poet's writing that one thing is like another and for our understanding of what is written. A metaphor such as "life is a river" is, thus, easily comprehended because we share the ability to make cross-modal correspondences.

Aslin and Smith review other experiments which support the idea that cross-modal correspondences represent an innate quality.[22] For example,

Smith and associates found that children as young as two years old consistently grouped big and loud objects together and small and quiet objects together in perceptual tasks, but when asked to discriminate between the words "big," "loud," and so on, the children did not confuse the words.[23] The Aslin and Smith review is suggestive of a very interesting biological constraint which must surely affect cognition.

*Social*   The three studies discussed in this section ascribe biological constraints to human social interaction. In each case, releaser–response packages may be the constraint, in that a particular stimulus seems to trigger a particular response. Murray, investigating the assumption that infant cries trigger a caretaking attitude in adult humans, studied infant crying as an initiator of physiological arousal in adult male and female college students and nurses. The stimuli consisted of four types of infant cries, four animal sounds (Siamese cat, raven, chicken, and orangutan; unfortunately, Murray provided no definitive description of these sounds in her report), and two mechanical sounds (a synthesized cry and white noise). A sound spectrograph analysis was used, and the sounds were matched as to their "abrasive" qualities. (One can only assume, since she did not specify as to what she meant by abrasive, that these sounds were somehow equal in quality as far as being noisy or disturbing.) A finger strain gage and plethysmograph were used to take the cardiovascular measurements of pulse rate and amplitude and blood volume as indicators of autonomic nervous system arousal. Pulse rate acceleration and/or a decrease in pulse amplitude and blood volume were assumed to imply a stressful response on the part of the subjects. Murray found that the infant cries evoked a more stressful response than did the other sounds, thus indicating that the infant cries were more likely to elicit behavior designed to quiet the cries. Among Murray's conclusions was the idea that her results could fit the releaser model.[24] Though Murray's study has some problems, such as inadequate stimulus control and inadequate autonomic nervous system measures, it is provocative and points to the need for more research in this area.

The results of a study by Sternglanz, Gray, and Murakami are consistent with the theory proposed by Konrad Lorenz that caretaking behavior is triggered by infantile facial features.[25] Sternglanz and associates used 692 psychology students of diverse backgrounds and races as subjects. Slides used as stimuli were made from black-and-white line drawings of hairless human heads, with the eyes, eyebrows, nose, and mouth varied as to their vertical placement within the outline of the face. The various faces thus made were the independent variables. Subjects were asked to rate the slides on a seven-point scale ranging from "extremely unattractive" to "extremely attractive." A one-way analysis of variance was applied to each varied facial feature. Two-

way analyses of variance were conducted to test for the effects of the demographics (such as experience with children, sex, and age) from the questionnaire on the subject's preferences on the facial-feature test. The results showed that the infantile facial features were preferred by the students. Subjects' responses "showed an orderly relationship between responsivity and feature variation." Sternglanz and associates concluded that their study pointed to an innate preference for infantile facial features, and they speculated that this preference may be valuable for the care necessary to the survival of human infants.[26] This study offers another example of a possible constraint on social behavior.

As the last example of a biological constraint on social behavior, Provine concluded that the yawn is a releaser of yawns. Though Provine points out that the purpose of yawning behavior is unknown, it does have social aspects, given that it indicates boredom in some cultures and sleepiness in general. Provine instructed thirty-seven male and female psychology students to merely think about yawning and to push a button attached to a chart maker during their yawns in a thirty- to forty-five-minute session. Provine found yawns under these experimental conditions to be consistent in duration and consistent in frequency. Moreover, the within-subject consistency for duration and frequency was maintained over several sessions. In this experiment, thinking about yawns served as an adequate stimulus for yawning. Provine, however, also used visually observed yawns as stimuli in another test of sixty-six male and female psychology students. The students were asked to observe a videotape of either a person yawning or a person smiling and to push a button (attached to a chart maker) during any yawns of their own. Provine found that 55 percent of his subjects yawned while observing yawns, while only 21 percent yawned while observing smiles. Yawns seemingly are releasers for yawns in observers of yawns.[27]

In each of these studies, the researchers point to some relatively precise cue (infant crying, infantile facial features, and yawns) as initiators of predictable response in another person, thus leading the researchers to consider the possibility that these cues may be triggers or releasers of biologically built-in behaviors in the human organism. If so, these represent specific instances of biological constraints which restrain specific behaviors in a relatively severe manner.

*Emotion*   In 1948, Niko Tinbergen, one of the pioneers of ethology, advised that anyone attempting to research what I am calling releaser–response packages must consider the motivation of the creature under study and the context of the situation or the environmental factors which may come into play in assessing the impact of triggering stimuli. He advised that, since neuroscience was not technically capable of sorting out neural mechanisms as yet, ethology would have to content

itself with determining what natural or triggering stimuli or releasers evoke what behaviors or responses.[28]

Many years later, Campos, Campos, and Barrett outlined emergent themes in the psychological investigation of emotion, and there are some interesting parallels with Tinbergen's advice.[29] These parallels suggest that what researchers in emotion were beginning to consider may be indicative of releaser–response packages. According to Campos, Campos, and Barrett, investigators in emotion research find that they need to consider the significance of an event, how emotion serves as a monitor of that significance, and how people deal with the significant event. Implications of this new way of looking at emotion include the new importance of four factors. One is the influence of the motivational state of the individual in generating a particular emotion. For example, if an opera fan is very hungry, he may feel more frustrated than saddened by *I Pagliacci*. Second is the fact that emotional signals from another person can stimulate a similar emotional state in the perceiver. For example, actors on the stage send many varying emotional signals which may well influence playgoers' emotional responses to the play. Third is hedonic stimulation, such as soothing or painful stimuli which generate affective reactions. For example, a soothing stimulus, such as nonnutritive sucking by infants, reduces most of the heart rate increases induced by painful inoculations.[30] Fourth is what Campos, Campos, and Barrett call "ecological factors," which are essentially environmental constraints conferred upon the individual by other people, the locale, physical or biological development, the situation, and so on.

All four of these factors are similar to or the same as factors which Tinbergen advised would have to be considered in testing for the effects of a releaser.[31] Tinbergen especially advised that the organism's internal motivation must be appropriate to the situation (i.e., a hungry person may not be capable of fully appreciating an opera or a female rat not in estrus will probably not be receptive to sexual advances from a male rat). Tinbergen also stressed the importance of environmental context in attempting to discern the proximate cause of a particular behavior. For example, if the environment includes several contrasting salient stimuli, the presence of all of them will reduce the effect of any one of them.

Campos, Campos, and Barrett also wrote that the new view of emotion research has the emphasis put on the behavior rather than the feeling. Tinbergen would applaud this statement, since behavior is open to a much more objective analysis than is feeling. Behaviors of the autonomic nervous system (e.g., blushing, retching, pupil dilation, and crying) all send socially meaningful signals and can be objectively quantified, thus research attention is turned toward these quantifi-

able behaviors. In their discussion, Campos, Campos, and Barrett seem to echo what Tinbergen wrote in 1948. It therefore appears that psychologists may have begun to view emotion as a behavior affected by the same factors which affect the releaser–response package. Consequently, it seems that it would be worthwhile to investigate this possibility that some emotional response may be triggered by releasing stimuli in a reflexive way.

### Further Considerations on Emotion as Constrained Behavior

This chapter has discussed behavior in terms of being more or less constrained by biological mechanisms, but many researchers look at behavior as learned, unlearned, or some combination of the two. Learned behavior is put at one end of a scale and unlearned behavior is put at the other end. Many combinations of experience (learning) and biological mechanisms or constraints fit between the two extremes. Most scientists have reached the conclusion that no learned behavior is on the far edge of the scale (i.e., without biological parameters), because learning depends upon those biological parameters. In fact, both extreme ends of the scale would be blank, because all human behavior is a combination of experience, setting or situation, and biological parameters. The question becomes, then, not whether a behavior is learned or unlearned, constrained or not constrained, but how much the behavior depends on experience or learning or, conversely, how much it depends on biological constraints.

Many arguments about behavior center around where a particular behavior fits on this scale of learned–unlearned behavior. Keil, for example, argues that we can ascertain approximately where to place a behavior on the scale by certain clues, such as the degree of conscious activity required to perform the behavior and its ease of acquisition.[32] Jolly, as a zoologist, argues that we can place a behavior on the scale by considering how widespread the behavior is within the species and how stereotyped it is in its manifestation.[33] Thus, highly constrained or relatively unlearned behaviors require less conscious thought to perform, are acquired with ease, are widespread throughout the species, and tend to be stereotyped in appearance (among other characteristics, but I have chosen these four to simplify the explanation). Walking is a good example of a highly constrained behavior. No one would argue that human locomotion is not on the relatively unlearned end of the learned–unlearned scale, but other behaviors are currently debatable. The examples of research discussed here, which demonstrate biological constraints, place these behaviors toward the unlearned end of the scale. For example, some aspects of perception result from the limitations or parameters of the sensory system involved. In

addition, some social interactions and emotional expressions may also be on the unlearned end of the scale.

Some research indicates that at least some emotional behavior fits close to the extreme end of the unlearned side of the scale. Three areas of research—emotional response, emotional expression, and the stimuli evocative of emotional response—support this conclusion.

*Emotional Response*   The following study suggests that subjective evaluation of different emotions are consistent regardless of culture. Wallbott and Scherer had over two thousand college students in twenty-seven countries on five continents fill out questionnaires describing their feelings for seven different emotions. The results indicate that a high degree of agreement as to description exists for each emotion studied.[34] On a more objective level, physiological arousal has long been regarded as indicative of emotional response.[35] Though physiological measures had been considered by most researchers as indicators of general emotional arousal, some researchers have found ways to sort emotions by differences in physiological measures. Ekman, Levenson, and Friesen used as their subject an actor who made facial expressions appropriate to happiness, surprise, fear, anger, disgust, and sadness while physiological changes were being recorded. Ekman and colleagues found heart rate to be significantly faster for anger, fear, and sadness than for happiness, surprise, and disgust, and finger temperature was found to be significantly different for anger than for all other emotions tested.[36] In addition, Schwartz, Weinberger, and Singer asked acting students to imagine particular "emotional" scenes; the anger generated by the acting students induced significantly greater blood pressure and heart-rate changes than did the fear.[37] Thus, research in emotional response indicates that both subjective and objective measures show differences in the emotions studied, and that these differences may be consistent across cultures. This indicates that emotions such as anger, fear, sadness, disgust, surprise, and happiness are, possibly, qualitatively different and that these differences are quantifiable. In addition, these differences, because they appear to be widespread in the species and stereotyped in appearance, are probably highly constrained.

*Emotional Expression*   In the area of research in emotional expression, Paul Ekman's crosscultural work on facial expressions associated with emotional response strongly suggests universal qualities in both response and facial expression associated with the response. Ekman draws the conclusion from his work that happiness, surprise, fear, anger, disgust, and sadness are universal emotions with the same facial expressions.[38] Though this research does not address the psychological requirements attributed by Keil to highly constrained behaviors, it does address the more easily measured attributes noted by Jolly.[39] Ekman's work indicates that emotional response for at least six emotions and

their associated facial expressions are both widespread within the species and stereotyped in manifestation. A great deal more support than just these studies exists for the notion that both emotional response and emotional expression are highly constrained behaviors, and many more pertinent research studies will be discussed throughout this book.

*Stimuli Evoking Emotional Response*  The third area of emotional behavior which is likely to be highly constrained is characterized by the stimulus conditions which elicit specific emotional responses. Some of the research discussed in this chapter helps define at least some parameters of the stimulus condition, but the emotion evoked is not well defined. For example, the Sternglanz, Gray, and Murakami study clearly defines the stimulus (the varied facial features are presented graphically in the article), but the "caretaking attitude" is not clearly defined in emotional terms (though we can guess that, indeed, an emotional response is involved). The study by Seyfarth, Cheney, and Marler with vervet monkeys defines the stimulus conditions and certainly strongly suggests an emotional response (fear) on the part of the monkeys, but only gross, overt body movements are described. In addition, Ploog tested infant squirrel monkeys raised without vocal experience (i.e., they were never given the opportunity to hear their species-specific calls). The monkeys responded to the alarm call for predator birds by quickly fleeing to their mother surrogate.[40] Certainly, this study indicates an extreme ease of acquisition of this emotionally involved behavior, and would place it toward the unlearned end of the scale according to Keil's qualifications. In addition, these studies indicate a causal relationship between the specific stimulus and the specific response.

Thus, to sum up this brief look at research in emotional response, expression, and stimulus situation, we find that there appears to be at least six quantifiable emotions (fear, anger, happiness, sadness, surprise, and disgust) which may be universally similar in response and expression for the human species. Moreover, certain stimulus situations appear to predictably evoke some of these emotions.

It is argued in Chapter 2 that aesthetic response is emotional behavior. If emotional response can be highly constrained behavior, then it may also be that aesthetic response can be highly constrained behavior (note that Keil also reached this conclusion). What little research that has been conducted on the stimuli eliciting emotional response indicates a causal relationship between the specific stimulus and a specific emotional response, especially in the area of alarm calls and the evocation of fear. If, as argued in Chapter 2, specific configurations of line, shape, color, and sound elicit specific emotional responses to art, then we may be seeing an occurrence not unlike the response to alarm calls. Like alarm calls, these specific configurations may have specific emotional meanings universally understood by members of the species. The next chapter explains the biological mechanism which

can make this causal relationship possible: the releaser–response package, an instance of reflexive behavior which is highly constrained and positioned at the far end of the unlearned side of the learned–unlearned behavior scale.

## NOTES

1. Noam Chomsky, "Rules and Representations," *The Behavioral and Brain Sciences* 3 (1980): 1.

2. F. C. Keil, "Constraints on Knowledge and Cognitive Development," *Psychological Review* 88 (1981): 203.

3. J. A. Fodor, *The Modularity of Mind: An Essay on Faculty Psychology* (Cambridge: MIT Press, 1983).

4. Irenäus Eibl-Eibesfeldt, "Human Ethology: Concepts and Implications for the Sciences of Man," *The Behavioral and Brain Sciences* 2 (1979): 22.

5. Alison Jolly, *The Evolution of Primate Behavior* (New York and London: Macmillan, 1972), 137.

6. D. N. Osherson, *Logical Abilities in Children* (New York: Wiley, 1976); D. N. Osherson, "Natural Connectives: A Chomskyan Approach," *Journal of Mathematical Psychology* 16 (1977): 1–29.

7. Keil, "Constraints on Knowledge," 200.

8. Jolly, *Evolution*, 140.

9. Irenäus Eibl-Eibesfeldt, *Human Ethology* (New York: Aldine De Gruyter, 1989) offers a good review of biological constraints on human behavior and includes a very informative chapter on aesthetics.

10. E. S. Spelke, "Origins of Visual Knowledge," in *Visual Cognition and Action: An Invitation to Cognitive Science*, vol. 2, ed. D. N. Osherson, S. M. Kosslyn, and J. M. Hollerback (Cambridge: MIT Press, 1990), 100–101.

11. M. S. Livingstone, "Art, Illusion and the Visual System," *Scientific American* 258 (1988): 78–85. This article is reprinted in a special issue of *Scientific American* called "Science and the Arts" (1995), which also contains other articles of interest. An edited book, *The Artful Eye*, has, among other useful chapters, an article by Margaret Livingstone and David Hubel which adds to Livingstone's 1988 article. See M. S. Livingstone and D. Hubel, "Through the Eyes of Monkeys and Men," in *The Artful Eye*, ed. R. Gregory, J. Harris, P. Heard, and D. Rose (New York: Oxford University Press, 1995), 52–65. See also David Rose, "A Portrait of the Brain," in idem., 28–51, an excellent and brief overview of the primate visual system.

12. Livingstone, "Art, Illusion and the Visual System," 104.

13. Ibid.

14. Richard Latto, "The Brain of the Beholder," in *The Artful Eye*, ed. R. Gregory, J. Harris, P. Heard, and D. Rose (New York: Oxford University Press, 1995), 68, 90. Latto offers several opportunities for art to arouse emotions by making use of the visual system. For example, he notes that our visual systems are tuned to our environment, which has impact on the kind of landscapes we prefer (p. 87). Also, since monitoring hand movements is essential for object manipulation and recognizing facial expressions and identifying individuals are crucial to social interactions, hands and faces are particularly salient and, therefore, make interesting art.

15. W. Greenough, J. Black, and C. S. Wallace, "Experience and Brain Development," *Child Development* 58 (1987): 539–559.

16. P. D. Eimas, E. R. Siqueland, P. Jusczyk, and J. Vigorito, "Speech Perception in Infants," *Science* 171 (1971): 306.

17. S. E. Trehub, D. Bull, and L. Thorpe, "Infants' Perception of Melodies: The Role of Melodic Contour," *Child Development* 55 (1984): 821–830.

18. S. E. Trehub, L. A. Thorpe, and B. A. Morrongiello, "Infants' Perception of Melodies: Changes in a Single Tone," *Infant Behavior and Development* 8 (1985): 213–223.

19. R. M. Seyfarth, D. L. Cheney, and P. Marler, "Vervet Monkey Alarm Calls: Semantic Communication in a Free-Ranging Primate," *Animal Behavior* 28 (1980): 1070–1094.

20. S. Wagner, E. Winner, D. Cicchetti, and H. Gardner, "'Metaphorical' Mapping in Human Infants," *Child Development* 52 (1981): 728–731.

21. J. H. Flavell, *Cognitive Development*, 2d ed. (Englewood Cliffs, N.J.: Prentice-Hall, 1985).

22. R. N. Aslin and L. B. Smith, "Perceptual Development," *Annual Review of Psychology* 39 (1988): 435–473.

23. L. B. Smith, M. Sera, and C. McCord, "Relations of Magnitude in Children's Object Comparison and Language" (paper presented at the twenty-seventh annual meeting of the Psychonomic Society, New Orleans, 1986).

24. A. D. Murray, "Aversiveness Is in the Mind of the Beholder: Perception of Infant Crying by Adults," in *Infant Crying: Theoretical and Research Perspectives*, ed. B. M. Lester and C. F. Z. Boukydis (New York: Plenum, 1985), 217–239.

25. Konrad Lorenz, "Part and Parcel in Animal and Human Societies: A Methodological Discussion," in *Studies in Animal and Human Behavior*, vol. 2, trans. R. Martin (1950; reprint, Cambridge: Harvard University Press, 1971), 115–195.

26. S. H. Sternglanz, J. L. Gray, and M. Murakami, "Adult Preferences for Infantile Facial Features: An Ethological Approach," *Animal Behavior* 25 (1977): 112.

27. R. R. Provine, "Yawning as a Stereotyped Action Pattern and Releasing Stimulus," *Ethology* 72 (1986): 109–122.

28. Niko Tinbergen, "Social Releasers and Experimental Method for their Study," *Wilson Bulletin* 60 (1948): 6–51.

29. J. J. Campos, R. G. Campos, and K. C. Barrett, "Emergent Themes in the Study of Emotional Development and Emotion Regulation," *Developmental Psychology* 25 (1989): 394–402.

30. R. G. Campos, "Comfort Measure for Infant Pain," *Zero to Three* 9 (1988): 6–13.

31. Tinbergen, "Social Releasers."

32. Keil, "Constraints on Knowledge."

33. Jolly, *Evolution*.

34. H. G. Wallbott and K. R. Scherer, "How Universal and Specific Is Emotional Experience? Evidence from 27 Countries on Five Continents," *Social Science Information* 25 (1986): 763–795.

35. W. B. Cannon, *Bodily Changes in Pain, Hunger, Fear and Rage: An Account of Recent Researches into the Function of Emotional Excitement*, 2d ed. (New York and London: D. Appleton, 1929), gives the clearest rationale for the decades of

work which followed utilizing autonomic nervous system measures as indicators of emotional response.

36. Paul Ekman, R. W. Levenson, and W. V. Friesen, "Autonomic Nervous System Activity Distinguishes among Emotions," *Science* 221 (1983): 1208–1210. Note that the actor's expressions were based on the crosscultural similarities in facial expressions found for these emotions and described in the following studies: Paul Ekman, "Biological and Cultural Contributions to Body and Facial Movements in the Expression of Emotions," in *Explaining Emotions*, ed. A. Rorty (Berkeley and Los Angeles: University of California Press, 1980), 73–101; Paul Ekman, *Face of Man: Universal Expression in a New Guinea Village* (New York: Garland, 1980); and Paul Ekman, "Expression and the Nature of Emotion," in *Approaches to Emotion*, ed. K. Scherer and P. Ekman (Hillsdale, N.J.: Lawrence Erlbaum Associates, 1984), 319–343.

37. G. E. Schwartz, D. A. Wienberger, and J. A. Singer, "Cardiovascular Differentiation of Happiness, Sadness, Anger, and Fear following Imagery and Exercise," *Psychosomatic Medicine* 43 (1981): 343–364.

38. Ekman, "Biological and Cultural Contributions"; *Face of Man*; and "Expression."

39. Keil, "Constraints on Knowledge"; Jolly, *Evolution*.

40. D. Ploog, "Biological Foundations of the Vocal Expressions of Emotions," in *Emotion: Theory, Research, and Experience*, vol. 3, *Biological Foundations of Emotion*, ed. R. Plutchik and H. Kellerman (New York: Academic Press, 1986), 173–197.

## SELECTED BIBLIOGRAPHY

Eibl-Eibesfeldt, Irenäus. *Human Ethology*. New York: Aldine De Gruyter, 1989.

Jolly, Alison. *The Evolution of Primate Behavior*. New York and London: Macmillan, 1972.

Keil, F. C. "Constraints on Knowledge and Cognitive Development." *Psychological Review* 88 (1981): 197–227.

Latto, Richard. "The Brain of the Beholder." In *The Artful Eye*, ed. R. Gregory, J. Harris, P. Heard, and D. Rose. New York: Oxford University Press, 1995.

Livingstone, M. S. "Art, Illusion and the Visual System." *Scientific American* 258 (1988): 78–85.

*Chapter 4*

---

# A Particular Kind
# of Biological Constraint

## The Releaser–Response Package

In the preceding chapter, I argued that human behavior is shaped by biological constraints; I argue in this chapter that a particular kind of biological constraint, the releaser–response package, is part of human behavior. I propose that releaser–response packages provide for the origin of art. Releaser–response packages which evoke emotional response have been used by us to make art, thus providing a means of manipulating emotions with certainty and specificity. This argument for the use of the releaser–response package in art will proceed from the general to the particular. This chapter will discuss releaser–response packages in general, and the next chapter will discuss a particular releaser–response package—the defense response. Then, I will show how the defense response is used in art. Other releaser–response packages are also used in art, but this argument and evidence will concentrate on this one kind of behavior.

This chapter will discuss the releaser–response package from a historical perspective, illustrating the change in viewing the releaser–response package from a "hardwired" mechanism to a plastic one, albeit a reflexive one. It will then illustrate the releaser–response package with a couple of behaviors which have been analyzed from stimulus through neural mechanism to response. In addition, it will focus on the releaser–response package as a part of human behavior, discussing how research has demonstrated the reflexive nature of some human behaviors and the complexity of this kind of reflexive behavior. It will be seen in this and the next chapter that certain stimuli have specific emotional meaning, in that they trigger a specific emotional

response, a property of the stimuli which has made their function as stimulators of unconditioned reflexes useful to researchers. However, the implications of this property, heretofore, have not been fully considered. Specifically, the implication that certain stimuli can shape emotional response without the intercession of conscious decision making has apparently not been considered. This is an important aspect of animal behavior, human beings included, which has effects in all areas of life and, especially pertinent to the discussion here, has an effect on our response to art.

## FROM ETHOLOGICAL RELEASER–IRM–FAP
## TO RELEASER–RESPONSE PACKAGE

As originally conceived by the founders of ethology, Konrad Lorenz and Niko Tinbergen, the basic unit of behavior is a fixed action pattern (FAP), which is run by a nervous system mechanism called an innate releasing mechanism (IRM), which is elicited by an environmental stimulus called a releaser or sign stimulus. This whole sequence functions as a unit and was known as a releaser–IRM–FAP. The releaser was described as an environmental stimulus such as a stickleback fish's red belly or an English robin's red breast. The IRM was described as the nervous system mechanism triggered or turned on by the environmental stimulus and which operated the FAP. The FAP was more than a reflexive knee jerk; it was a pattern of behavior such as that seen in goldfish turning and swimming away from your tap on the side of the bowl, or even the courtship display of a male peacock. The FAP was not considered to be a series of reflexes with each subsequent move contingent upon feedback from the preceding move. The FAP was distinguished by its ability, once triggered, to run without further sensory stimulation.[1]

A closer look at the neural mechanism or IRM reveals it to be a very complex reflex arc. Lorenz described the neural mechanism or IRM as a Pavlovian unconditioned reflex which permits the organism to make an appropriate response without previous experience to specific biologically relevant stimulus situations (e.g., the recognition of prey or predator or sexual partner).[2] This neural mechanism has three parts contained within the nervous system: (1) a peripheral nervous system sensory apparatus which senses the stimulus, encodes the appropriate signals, and sends them to the central nervous system; (2) a central nervous system control which receives the sensory messages, integrates them with other information such as hormone balance and inhibitory messages, and formulates signals to send to muscles; and (3) the motoneurons which receive the information from the central nervous system and make the muscles move. Figure 4.1 gives a schematized view of the essentials necessary for a reflex arc.

Figure 4.1
The Reflex Arc

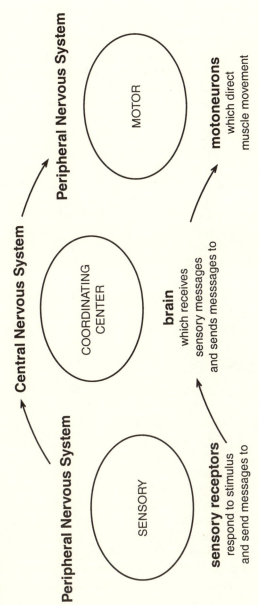

Since Lorenz and Tinbergen speculated that the basic unit of behavior was a fixed action pattern, a few changes have occurred in the theory. First, their idea regarding the nature of this reflexive behavior was construed by followers to mean that the behavior should be fixed or hardwired. That concept has changed to acceptance of the releaser–IRM–FAP as a flexible unit of behavior. Second, the terms themselves have been cause for continuing the hardwired nature of the releaser–IRM–FAP in the minds of many researchers, thus creating a need for fresh terms. Though some modern researchers use the old terms, they are tainted with the hardwired connotations ascribed some years ago. I therefore suggest the use of releaser–response package to connote the modern conception of Lorenz and Tinbergen's idea. The modern conception features plasticity rather than rigidity and looks at the idea as a unit. Third, the releaser–IRM–FAP was rarely considered as a unit. This made it difficult to study, since one part depends on the other. That is, the releaser triggers the IRM and the IRM runs the FAP. They go together, but rarely were studied together. Moreover, neuroscience did not have the capability to trace IRMs; therefore, the link between releaser and FAP could only be presumed. Now, however, neuroscience has been able to trace the neural mechanism involved in some releaser–response packages, thus illustrating the reflexive nature of the package as it was originally conceived. The next sections discuss the historical move from rigidity to plasticity in the conception of the releaser–IRM–FAP and some research on the neural mechanisms.

### From Rigidity to Plasticity

Observations of animals behaving and doing the kinds of things that Lorenz and Tinbergen asserted were reflexive fixed action patterns belied the "fixed" nature of these behaviors. Animals do not always do as they are predicted to do. Courtship practices may vary unexpectedly; dogs may not complete the bone burying pattern, leaving the bone inexplicably uncovered. Moreover, observers noted that presumed fixed action patterns, such as bone burying, did not look the same each time. Movements varied in kind and number. Researchers came to the conclusion that the initial idea of the releaser–IRM–FAP which Lorenz and Tinbergen used to explain animal behavior was too rigid to explain the observed behavioral plasticity. Rather than use the releaser–IRM–FAP as a model for research and discovery, many researchers turned away from the concept completely. Those researchers who did stay with the concept have found that it works as a model. Moreover, they have added precision and insight with their research. They have found that this behavioral unit is not immutable, but can be subject to such factors as experience, maturation of the organism,

and hormonal balance. This position has found support from the field of neuroscience, which has traced basic reflex arcs and demonstrated how this unit of behavior can have considerable flexibility.

Hailman was among the first to begin breaking down the hardwired view of such biologically built-in behaviors. He demonstrated that laughing gull chick pecking accuracy improves with experience. Newly hatched chick pecking movements are unrefined; that is, they often miss the target. The most effective stimulus to elicit pecking movements from a newly hatched chick is an oblong shape, about 9mm wide and any length, oriented so that the long axis is vertical, moving in an horizontal direction, red on a white background, and at the chick's eye level. This description neatly fits the look and manner of the parents' bills, in which food is to be found. The chick needs only an hour's experience to learn to discriminate food from bill. Accuracy at pecking at food increases to a maximum peak at about the chick's third or fourth day of life. The usefulness of the triggering stimulus for chick feeding diminishes as the chick matures. Thus, it appears that this releaser, described simply as the red spot on the parent's bill, serves to initiate pecking by the newly hatched chicks in the general area where food will be found but is no longer necessary for chick feeding behavior after the chicks acquire experience finding the food. Thus, Hailman demonstrated that a releaser–IRM–FAP can be subject to experience.[3] This demonstration led other researchers to look for other ways releaser–IRM–FAPs could be modified, modulated, or gaited.

One way releaser–response packages can be gaited is that a particular package might be manifested during only a certain portion of the organism's life, as exemplified by laughing gull chick pecking behavior. Another example is the human sucking reflex, which is present only in infants. A way releaser–response packages can be modified or even inhibited is hormonal balance, which can block the appearance of the package in the organism's behavioral patterns. Mating behaviors serve as good examples, since in many species mating occurs only when hormonal balance is appropriate.[4] Moreover, Harris-Warrick's research demonstrates that neuromodulators such as dopamine or serotonin can regulate and restructure the basic neural circuit.[5] The modern view of the old releaser–IRM–FAP is that it is, indeed, a fact of behavior, but it is not the fixed unchangeable unit that it once was thought to be. In contrast, it is subject to modulation and is, therefore, somewhat plastic.

### Definition of the Releaser–Response Package

After reviewing research on the releaser–IRM–FAP, it is apparent that a more flexible model of the behavior sequence has evolved.[6] This modern conception is summarized in Figures 4.2 and 4.3. Figure 4.2

**Figure 4.2**
**Model of the Releaser–Response Package**

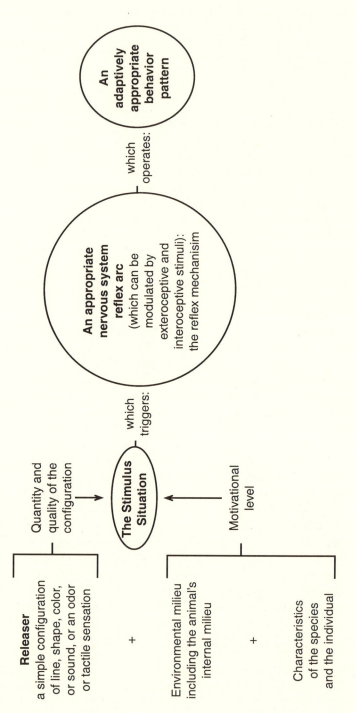

**Figure 4.3**
**Effects of Intensity Levels on Releaser–Response Package**

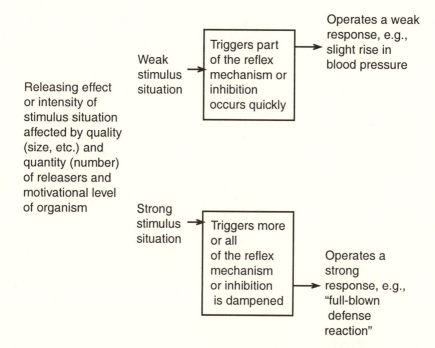

describes the basic parts of the releaser–response package. Figure 4.3 describes the effects of the intensity level of the stimulus situation on the response possibilities. The level of intensity of the stimulus situation determines the type and level of intensity of the response.

*Stimulus Situation*    Plasticity is built into the releaser–response package in several ways. First, the basic reflex arc can be inhibited or modulated by both exteroceptive and interoceptive stimuli. For example, if the stimulus situation changes, the sensory systems sense this and send neural messages which may modulate the reflex mechanism, revising commands to the motoneurons operating the behavior.

Second, specific reflex mechanisms may not be active at all times of the organism's life. For example, unless a female rat is in estrus, the reflex which operates lordosis behavior (i.e., the raising of the rump in preparation for copulation) may not activate. This reflex depends on hormonal levels. Another example, the blink or menace reflex in humans, appears only after a period of maturation. The menace reflex, which operates in response to an object such as a fist approaching the face, begins to appear in infants at about eight weeks of age. Still another example is the human sucking reflex, which is immediately operable at birth but later ceases to operate.

Third, the response or behavior activated is dependent on the intensity of the stimulus situation. The stimulus situation consists of releasers or triggering stimuli and the environmental milieu, which includes the animal's external and internal milieus, and species and individual characteristics. Such things as hormonal set (e.g., estrus), level of arousal, and number of environmentally conflicting stimuli can affect the environmental milieu. One might refer to the intensity of the environmental milieu and species and individual differences for activation of a response as the animal's motivational level. A rat highly motivated to perform lordosis would be a female in estrus, with all environmental stimuli eliminated except the appropriate touch of the male rat, which would activate the reflex mechanism setting off raising of the rump. A rat poorly motivated to perform lordosis might be a female just ending her estrus period, with a cat nearby. Her hormonal level would not be prime and the cat would provide a conflicting cue (the threat of being eaten) that would confound the effect of the male rat's touch.

In addition to the environmental milieu or motivational level of the animal, the quantity and quality of the releaser or releasers affect activation of the neural mechanism. Several complementary stimuli may be present to trigger the reflex mechanism. The stimuli themselves may also vary in quality. Very large or very strong stimuli are more effective than ordinary or weak stimuli. This phenomenon is best exemplified by *super-normal* stimuli. A super-normal stimulus exaggerates the normal stimulus properties of a releaser. For example, a bird called the oyster catcher will more readily retrieve its eggs that have fallen from the nest (the retrieval movements are described as a fixed action pattern) if the eggs are several times larger than normal.[7] In addition, for the oyster catcher and other animals, loud sounds may provoke more intense responses than do soft sounds. Bright colors may be more stimulating than soft colors. The quality of a releaser has to do with size and strength. Consequently, a releaser or triggering stimulus which is a simple configuration of line, shape, color, sound, odor, or touch may be combined with other releasers and/or may be varied in quality (e.g., loud sound, bright color, large shape, strong odor, hard touch or soft sound, soft color, small shape, slight odor, soft touch). The quantity and the quality of the releaser or releasers possibly affect behavior by activating varying portions of the reflex mechanism.

In addition, the species of animal may be important in the stimulus situation. For example, a rabbit is more likely to "freeze" in response to threat than is a cat. Individual differences likely also play a part. It is well known that individuals within a species are not clones, and it is also understood that some of these differences are due to gender. For example, male rats would not be expected to respond with lordosis

behavior. Hence, the stimulus situation is complex and many faceted. Hardly any research has been done which matches the exact stimulus situation to the exact response.

*The Reflex Mechanism*    The stimulus situation triggers or sets off the reflex mechanism. Research has traced reflex arcs which delineate some reflex mechanisms of releaser–response packages. So far, research indicates that a single reflex arc is activated by a specific stimulus situation. This single reflex arc is, however, modulated by complex inputs and can be incredibly complex. It can be referred to as a reflex mechanism. A reflex mechanism consists of the basic reflex arc with all of its inputs and feedback loops. A very simplified sketch of this mechanism appears in Figure 4.4. Note that the basic reflex arc is intact; it is just given additional complexity. Compare Figure 4.4 with the basic reflex arc diagrammed in Figure 4.1.

*Behavior*    Behaviors activated by the reflex mechanism of the releaser–response package depend on the stimulus situation. An intense stimulus situation tends to evoke an intense response. For example, a cat pouncing at a rat (a very intense stimulus situation for the rat) will make the rat run in the opposite direction. On the other hand, a hawk flying at some distance above a duck on the ground, a less intense stimulus situation for the duck, may stimulate the duck to look up with vigilance, a response less intense than running away.[8] An object hurtling directly at a fiddler crab will cause the crab to sidestep out of the way. At the point of collision (object with crab) the crab will flatten itself out on the ground. The crab's response becomes more intense as the stimulus becomes more intense.[9]

The nature of the response may depend on the particular species and on individual differences of the particular animal. Rabbits are prone to freezing under intense threat. More aggressive species and/or individuals within a species may turn to fight rather than flee or freeze under intense threat.

Though the mammalian defense reaction will be covered more thoroughly in the next chapter, it serves as an example of the nonlinear plastic qualities that are found in complex reflexive behavior. Figure 4.5 describes some threat stimuli, the reflex mechanism, and resultant behaviors possible, with their varied intensity levels. The next chapter will provide more elaboration and detail, but this provides a guide for the discussions to follow in this chapter.

## Releaser–Response Package as a Unit

The old releaser–IRM–FAP had rarely been considered as a unit; most research concentrated on one of the three parts. Likewise, the modern

Figure 4.4
Speculated Reflex Mechanism of the Releaser–Response Package

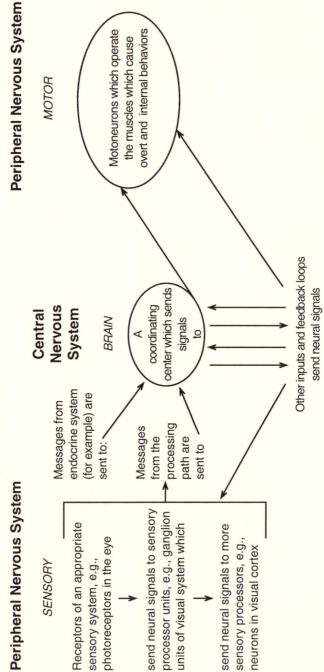

**Figure 4.5**
**A Few Expected Releasers, or Threat Stimuli, the Reflex Mechanism, and a Few Behaviors of the Mammalian Defense Reaction**

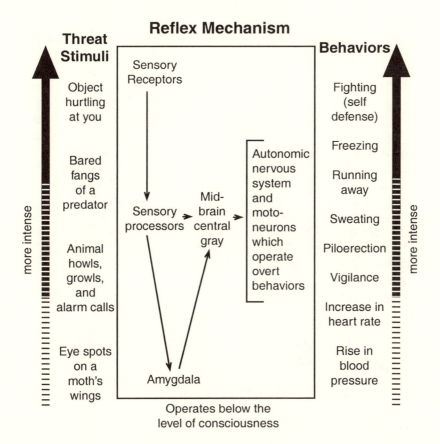

conception of this behavioral unit, which I am calling the releaser–response package, has rarely been considered as a unit. Unless the package is considered as a whole, however, it is not possible to understand this behavior, since activation of the reflex mechanism depends on the stimulus situation (the releaser or releasers and the environmental milieu), and activation of the resultant behavior depends on the actions of the reflex mechanism and inhibitory factors. Some researchers, such as Ewert, have undertaken research based on the entire unit and have, thereby, demonstrated the viability of the concept. Ewert's research will be discussed later in this section. In addition, the defense reaction as a whole releaser–response package is considered in the next chapter.

The reflex mechanism of the releaser–response package has received attention from neuroethologists, and they have found it to be very complicated. Generally, the sensory system of the organism triggers a command neuron or system which generates the behavior pattern. Rhythmic movements, such as the swimming of *tritonia*, a sea slug, and other forms of locomotion, are among the most thoroughly researched releaser–response packages. Sea slugs will respond to tactile stimulation with a patterned swimming response which does not need sensory input to proceed once it is triggered. Rhythmic movements, as exemplified by the sea slug's patterned swimming response to touch, are generally controlled by a nervous system central pattern generator which can work without further sensory or modulatory inputs, but the movements are usually "sculpted" by such inputs.[10]

Other types of releaser–response packages in other species have been researched, and in 1978 Bentley and Konishi reviewed a short list. They characterized some other behaviors under the "control" of a central pattern generator as episodic, postural, or nonrepetitive. These represent more complex behaviors than the rhythmic swimming of sea slugs and demonstrate how a complex behavior can be controlled by a reflexive mechanism. Examples of episodic movements are crayfish tail flips and teleost fish fast starts. The neuronal components of tail-flip behavior have been rather thoroughly researched, as has the fast start, which allows the fish to make a very fast escape from danger. Postural movements control body position and stability. Nonrepetitive movements include activities such as grooming, nest building, and prey capture. Bentley and Konishi pointed out that at the time of their review in 1978 work was just beginning that would track the reflex mechanisms for these latter kinds of behaviors. They cited as an example the work of Elsner, who found that grasshopper courtship song is under the control of a central pattern generator. Much more has since been accomplished; for example, Ewert has been able to detail the mechanisms of toad prey capture.[11]

Not as much research has been accomplished on the releaser and the resultant behavioral parts of the releaser–response package. Examples of releasers include the red spot on the male stickleback fish's belly, which, given the correct mating motivation, elicits aggressive behavior in another male stickleback;[12] the eye-spot pattern on the wings of certain moths, which reliably frightens away predator birds;[13] and the shape of a hawk flying overhead, which frightens prey birds on the ground.[14] The resultant behavior can be a patterned rhythmic movement, as is exemplified by swimming sea slugs; a startle movement, as seen in the fast start of a goldfish; the positioning movements for prey capture, as seen in the toad's orienting toward its prey; or just

one portion of a complex behavior, or a "reaction chain," called grooming, caretaking, nest building, courtship, defense, and so on.

In the past few years, studies have accumulated to allow whole releaser–response packages to be seen. That is, the whole story is told from stimulus through response. Two such packages are explained briefly in the following section. The first concerns mating behavior in the rat and illustrates just one fraction of the complex of behaviors which make up mating behavior. Represented is one releaser–response package. Note that the rat's internal motivation must be appropriate. The second package concerns another complex nonrepetitive behavior, toad prey-catching, but the principle researcher, Ewert, has broken the behavior into a series or reaction chain of releaser–response packages. At least four separate releaser–response packages are involved in toad prey-catching. Plasticity is built into the prey-catching behavior, since the situation determines if the toad needs all four releaser–response packages to catch its prey.

*Rat Lordosis*   If a female rat is in the appropriate hormonal state (e.g., natural estrus or primed artificially with estrogen and progesterone), stimulation of the female rat's flanks, tail base, and perineum will produce lordosis behavior. The releaser for this behavior is a simple touch to the flank area, tail base, and/or perineum by the male rat. The neural mechanism consists of the following reflex arc. Sensory afferents (nerves carrying the message that the rat has been touched) from the perineal region travel in the pudendal nerve to the spinal cord, where they send ascending processes (neuron axons) to the central gray area of the midbrain. Estrogen increases the sensitivity of the peripheral mechanoreceptors (the sensory nerves) and increases the receptive field of the pudendal nerve. Estrogen also increases the secretory activity of cells in the ventromedial hypothalamus and electrical excitability of cells in the medial and basal hypothalamus. Thus mediated by estrogen, cells in the ventromedial nucleus of the hypothalamus and cells in the preoptic area apparently modulate lordosis behavior. Descending nerve fibers from the central gray area of the midbrain then project to the reticular formation of the lower brainstem. Also, the hypothalamic outputs that are transformed and relayed in the central gray travel via the lateral vestibulospinal and reticulospinal tracts to the spinal cord. The final common pathway for the motoneurons controlling the deep back muscles which elevate the rump (the final part of the releaser–response package, the behavior) is in the medial and ventral borders of the ventral horn of the spinal cord.[15]

The releaser–response package for rat lordosis is, then, summarized as follows. The releaser is stimulation of the appropriate mechanoreceptors around the female rat's tail area by movements of the male rat. The

neural mechanism consists of neural signals sent to the midbrain, where the signal is transformed and relayed to motoneurons which control muscles in the female's back. The behavior is elevation of the rump.

*Toad Prey-Catching*   Ewert provides a rather complete description of a series of releaser–response packages which make up a complex behavior. These stimulus–response mechanisms enable the toad *bufo* to catch prey. Ewert found four separate releaser–response packages which are components of toad prey-catching; the toad may need all four to catch dinner or only one, depending on the situation. The first component begins with the prey seen in the toad's lateral visual field and ends with the toad orienting its body in the direction of the prey. The second component begins with the prey seen in the toad's frontal visual field but at a distance and ends with the toad approaching the prey. The third component begins with the prey seen close up in the toad's frontal visual field and ends with the toad maneuvering so that the prey is within its "binocular fixation area." The fourth component begins with the prey detected within the toad's binocular fixation area, which is its snapping distance, and ends with the snap or catch of the prey. Each component represents a releaser–response package; these operate in series or as needed to make up this complex releaser–response package.

The releaser in each of these releaser–response packages is a visual stimulus consisting of what appears to be only three parameters: (1) an elongated shape, (2) moving in the direction of its length, (3) within the required visual area. Ganglion cells in the toad's visual system, acting as feature detectors, send information regarding angular size, angular velocity, and contrast of the stimulus to the optic tectum of the midbrain. "Prey-detector cells," which trigger the appropriate motor response in the tectum, send projections to the motor regions of the hindbrain. Cells in the hindbrain send motor commands to the appropriate muscles, resulting in orienting, approaching, or snapping behavior.[16]

In summary, the releaser–response package is a unit made up of stimulus, neural mechanism, and resultant behavior. A reflex arc serves as its neural mechanism modulated by hormonal and environmental inputs. The releaser–response package is not hardwired in the sense that was attributed to the original ethological conception (i.e., forever fixed in manifestation); rather, it is an innate behavior which is modulated by experience and the internal and external milieu. This type of built-into-the-organism behavioral unit is of obvious adaptive importance. The kinds of releaser–response packages studied so far attest to the fact that they aid the survival of the organism by helping it to find food and safety and mates. Is it not possible that humans have built-in releaser–response packages which help insure their survival, just as the well-studied toads and sea slugs do?

## THE RELEASER–RESPONSE PACKAGE AS
## PART OF HUMAN BEHAVIOR

### Historical Perspective

In 1863, the founder of Russian physiology and discoverer of the role of inhibition in the nervous system, Ivan Sechenov, proposed that all behavior is reflexive. His book describing his thesis, *Reflexes of the Brain*, was not published in English until 1965, but his influence was, nonetheless, far-reaching, since Pavlov was his disciple. Even though both Sechenov and Pavlov hoped to demonstrate how psychological phenomena can be explained by physiological processes, Pavlov concentrated on the conditioned reflex, whereas Sechenov emphasized the unconditioned reflex. However, Pavlov's experiments could not have occurred without the unconditioned reflex. Teaching a dog to salivate to the clang of a bell (conditioned reflex) would not have been possible if dogs did not naturally salivate at the sight of food (unconditioned reflex). However, dogs salivating in response to the sound of bells is a topic less prosaic and more likely to be discussed and to be the subject of a journal article than dogs salivating at the sight of food. Hence, little attention has been paid the unconditioned reflex by psychologists.

People do not care to think that we, like dogs, salivate at the sight of food. We take care to see that our saliva remains in our mouths, unlike dogs who are not so bound by civilized conventions. We prefer to think that we have no built-in behaviors. Of course, we do, or we would never eat, walk, or make love, let alone survive birth.

### From Releaser–Response Package to Emotion

A particular built-in or reflexive behavior that is part of the human behavioral repertoire is the defense reaction. Many years ago, Sherrington, the pioneer neurobiologist, described the defense reaction as a reflex, and it should not be surprising that running away from danger (a defense reaction) is part of the human behavioral repertoire. We react to threatening situations by running away, just as other animals do. Also, we all know that at such times we are flooded by emotion, we are overcome with fear, our hair "stands on end," our faces flush, and our hearts race. The pioneering physiologist, Cannon, directed his attention to such emotional effects as these, that occur concomitant with the defense reaction. Cannon's research demonstrated that visceral response or autonomic nervous system activity, such as increased heart rate, sweating palms, and rapid respiration, is part of the emotional response associated with the defense reaction. Neuroscience has followed up these findings with research which traces

autonomic nervous system reflex arcs associated with the emotional component of defense. This research will be discussed in the next chapter.[17] Later, I will discuss how the defense reaction is used in art. Here, however, I want to draw the connection between releaser response packages—especially the defense reaction—and emotion.

Campos provides a review of the links between defense, autonomic nervous system response (especially heart rate), and emotion. Campos's interest is in human infant research, so his emphasis is, of course, on infant and developmental studies. He writes that there is "a reasonably well developed clinical literature relating fetal cardiac responses to stress, especially the stress of labor and delivery."[18] He also notes that "as the overall excitation level of the infant increases, so does the heart rate level."[19] Conversely, he continues, quoting from a paper published by Brackbill, "soothing" stimuli have effected a "significant linear decrease" in heart rate.[20] These remarks establish a link between heart rate activity, an autonomic nervous system response, and emotion in humans.

Campos then discusses several studies which link defense to heart rate increases and to fear or stress. One of these is the fear-of-strangers work Campos did with Robert Emde and T. Gaensbauer.[21] Five- to nine-month-old infants' behavioral responses were observed and heart rates monitored while strangers approached them to within three-tenths of a meter, when mothers were present and when mothers were not present. The results of the study led to the conclusion that a developmental shift occurs in heart rate response. Five-month-old infants showed heart rate decelerations in response to strangers, but nine-month-old infants showed accelerations, especially at the three-tenths of a meter distance and in the absence of the mother. "Negative" facial expressions occurred with the heart rate increases.

Campos compares an animal study and an adult human study to his findings with human infants, and, in both cases, heart rate increases occur under stressful conditions. Reite, Kaufman, Pauley, and Stynes found marked heart rate increases in infant monkeys when they were separated from their mothers. Behaviorally, these infant monkeys were described as being "agitated." When presented with phobic stimuli (spiders), adult human beings demonstrated heart rate increases and said they were afraid. Campos concludes that heart rate acceleration is the cardiac response to a "fear-provoking or defensive situation."[22]

Other studies demonstrate the assumed connection between reflexive autonomic activity and emotion, especially the fear which is associated with a defense response. Hare used increased heart rate as a measure of phobic fear of spiders in adult female human subjects.[23] Fredrikson and Ohman paired unconditioned autonomic nervous system responses to shock to "fear-relevant" (spider slides) and "fear-irrelevant"

(flower slides) stimuli, in order to study the differences in habituation of the conditioned responses.[24] What these studies confirm is that using unconditioned autonomic nervous system responses to shock in humans can only mean that humans respond to shock with autonomic nervous system reflexive responses.

Consequently, human beings have reflexes—built-in mechanisms which cause behavior—even though we prefer to think that all that we do is by will alone. We easily concede this point when discussing the knee jerk or digestion or locomotion, but balk at the thought of our emotions being manipulated by reflex activity. However, as Cannon put it, "The most significant feature of these bodily reactions [autonomic nervous system responses] . . . in the presence of emotion-provoking objects is that they are of the nature of reflexes—they are not willed movements, indeed they are often distressingly beyond the control of the will."[25]

### Reflexive Meaning

Cannon added that reflexes had long been recognized as preservers of organisms' welfare, and he proposed that the utility of the visceral component of the defense reaction is to prepare the individual for violent action, either fight or flight.[26] Assuming that this is indeed the case, the stimuli which evoke this response have strong and very specific meaning to the individual. This is not conscious meaning, where, for example, we ascribe meaning to an object, thereby making it a symbol. A stop sign is a symbol meaning stop, but we consciously ascribe or attach that meaning to the otherwise meaningless object that is a stop sign. The stimuli which trigger the autonomic nervous system components of emotional response and the defense reaction have meaning unascribed by our conscious thought. This meaning is part of the reflexive nature of the behavior and is the adaptive result of the behavior triggered. That is, whatever provokes the visceral system to reflex action in preparation for fight or flight must "mean" danger or threat. As an example, Blest demonstrated that two circles placed close together on a horizontal axis (eye spots) trigger flight in passerine birds.[27] Speaking anthropomorphically, it is possible to say that two circles placed close together on a horizontal axis mean "danger!" or "fly away!" to some birds. Actually, since eye spots are so pervasive in the animal kingdom as so-called "protective displays," it is more than likely that other animals besides passerine birds read them to mean danger. Eye spots are suggestive of carnivore eyes. It is instructive, perhaps, to think of eye spots in terms of William Blake's well-known line "Tiger, tiger burning bright / In the forests of the night." "Burning bright" refers not to a tiger on fire but to the tiger's gleaming, yellow eyes glowing in the dark of the jungle. Perhaps it is the eye-spot imagery evoked by

that line that might make one somewhat uneasy when reading it. Whether that line makes one uneasy, the releaser–response package, at least as seen in the arousal of emotional feelings, has meaning. The triggering stimuli or releasers mean "danger!" or "food!" or "security!" This is not to say that human beings and animals contemplate the meaning of the triggering stimuli as humans would contemplate the meaning of this paragraph. This is reflexive meaning, just as a tap on just the right spot on the patella means jerk your knee. You do not think, "Now I must jerk my knee." Your knee jerks on its own. As Cannon put it, it is "distressingly beyond the control of the will."

*Specific Meaningful Stimuli*   In Chapter 3, I reviewed studies by Provine; Sternglanz, Gray, and Murakani; and Murray, which tend to support the notion that human behavior may be constrained by releaser–response packages. Provine's study seems to indicate that seeing yawns "means" to yawn. Sternglanz, Gray, and Murakani's study seems to indicate that seeing infantile facial features "means" to assume a caretaking attitude. Murray's study found that a caretaking attitude is also evoked by infant cries. Many other studies suggest the presence of releaser–response packages, and many more rely on the unconditioned reflex for their design (e.g., psychological studies which rely on heart rate changes to measure fear or stress). These studies presume the reflexive nature of heart rate increases associated with threat. Chapter 6 discusses some interesting studies which may inadvertently measure a defense reaction to eye spots in humans (as measured by heart rate increases).

## SUMMARY

This chapter has argued that the releaser–response package should not be thought of as fixed and stereotyped in the same way that the old releaser–IRM–FAP came to be known. Rather, the releaser–response package must be considered as potentially multidimensional and very complex. Its three basic components (stimulus situation including releasers or triggering stimuli, reflex mechanism, and behavior activated) need not be linearly related. Many releasers may be needed to trigger neural mechanisms which activate an array of behaviors all associated with each other. The defense reaction is a good example and will be discussed in some detail in the next chapter. The entire array of behaviors need not be elicited. In general, the lower the intensity of the stimulus situation, the fewer behaviors are elicited of the total possible in the array, and these behaviors may be of less intensity than when they occur with other behaviors in the array. For example, a weak stimulus situation may elicit only autonomic nervous system responses and not overt behaviors such as running away or scream-

ing. These autonomic nervous system responses may be so slight that they are not noticed or barely noticed by the subject. (These slight responses are what are used by art to manipulate emotions.) On the other hand, a strong stimulus situation which evokes actual flight will also evoke more intense autonomic nervous system responses. The heart will pound; hair will stand on end. The intensity of the stimulus situation depends on the quality (loudness, size, etc.) and quantity of the stimuli and the internal and external environment of the subject. Toads with full stomachs may not orient toward the highest-quality releasing stimulus for prey-catching; a female rat frightened by a cat may not raise its rump when touched by an amorous male.

Several studies suggest that humans do react to releasers: yawns may trigger more yawns, infantile facial features may trigger a caretaking attitude or, possibly, put into other words, positive emotional affect. The next chapter discusses the defense reaction, first describing it using animal studies and then human studies. It will become apparent that not only are people susceptible to defense reactions, but the stimuli evoking these responses can shape our emotions, and, because of their emotion-shaping qualities, these stimuli are used in art.

## NOTES

1. See Konrad Lorenz, "Part and Parcel in Animal and Human Societies: A Methodological Discussion," in *Studies in Animal and Human Behaviour*, vol. 2, trans. R. Martin (Cambridge: Harvard University Press, 1971), 115–195; Niko Tinbergen, "Social Releasers and Experimental Method for their Study," *Wilson Bulletin* 60 (1948): 6–51; Niko Tinbergen, *The Study of Instinct* (Oxford, England: Clarendon, 1951); and Niko Tinbergen, *The Herring Gull's World* (New York: Basic Books, 1961) for early discussions of the releaser–IRM–FAP.

2. Lorenz, "Part and Parcel."

3. J. P. Hailman, *The Ontogeny of an Instinct* (Leiden, The Netherlands: E. J. Brill, 1967).

4. These and other examples can be found in D. Ingle and D. Crews, "Vertebrate Neuroethology: Definitions and Paradigms," *Annual Review of Neuroscience* 8 (1985): 457–494.

5. R. M. Harris-Warrick, "Chemical Modulation of Central Pattern Generators," in *Neural Control of Rhythmic Movements in Vertebrates*, ed. A. H. Cohen, S. Roggsignol, and S. Grillner (New York: Wiley, 1988), 285–332.

6. See Irenäus Eibl-Eibesfeldt, *Ethology: The Biology of Behavior*, trans. E. Klinghammer (New York: Holt, Rinehart & Winston, 1975); G. M. Burghardt, ed., *Foundations of Comparative Ethology* (New York: Van Nostrand Reinhold, 1985), for how researchers have been using the releaser–IRM–FAP concept in their work.

7. See Tinbergen, "Social Releasers"; Tinbergen, *Study of Instinct*; and R. A. Hinde, *Animal Behavior* (New York: McGraw-Hill, 1966), for examples and discussions of super-normal stimuli.

8. R. Melzack, "On the Survival of Mallard Ducks after 'Habituation' to the Hawk-Shaped Figure," *Behaviour* 17 (1961): 9–16.

9. W. Schiff, "The Percepting of Impending Collision: A Study of Visually Directed Avoidant Behavior," *Psychological Monographs* 79, Whole No. 604 (1965).

10. A. O. D. Willows and G. Hoyle, "Neuronal Network Triggering a Fixed Action Pattern," *Science* 166 (1969): 1549–1551; A. O. D. Willows, "Giant Brain Cells in Mollusks," *Scientific American* 224 (1971): 68–75; P. A. Getting, "*Tritonia* Swimming: Triggering of a Fixed Action Pattern," *Brain Research* 96 (1975): 128–133; and, for the "sculpting" of the sensory input, see Harris-Warrick, "Chemical Modulation."

11. See D. Bentley and M. Konishi, "Neural Control of Behavior," *Annual Review of Neuroscience* 1 (1978): 35–60; for the examples of central generators, N. Elsner, "Neuroethology of Sound Production in *Gomphocerine* Grasshoppers (*Orthoptera: Acrididae*). I. Neuromuscular Activity Underlying Stridulation," *Journal of Comparative Physiology* 97 (1975): 291–322; J. P. Ewert, "Neuroethology of Releasing Mechanisms: Prey Catching in Toads," *Behavior and Brain Science* 10 (1987): 337–403.

12. Tinbergen, "Social Releasers"; G. P. Baerends, "Do the Dummy Experiments with Sticklebacks Support the IRM Concept?" *Behavior* 93 (1985): 258–277. The answer to Baerends's question was yes.

13. A. D. Blest, "The Function of Eyespot Patterns in the *Lepidoptera*," *Behaviour* 11 (1957): 209–256; A. D. Blest, "The Evolution of Protective Displays in the *Saturnioidea* and *Sphingidae* (*Lepidoptera*)," *Behaviour* 11 (1957): 257–309.

14. See Tinbergen, *Herring Gull's World*, for a discussion.

15. The description of the neural mechanism responsible for rat lordosis comes primarily from these review articles: B. K. Komisaruk, "The Nature of the Neural Substrate of Female Sexual Behaviour in Mammals and its Hormonal Specificity: Review and Speculations," in *Biological Determinants of Sexual Behavior*, ed. J. Hutchison (New York: Wiley, 1978), 349–393; D. Ingle and D. Crews, "Vertebrate Neuroethology: Definitions and Paradigms," *Annual Review of Neuroscience* 8 (1985): 457–494. The discussion of estrogen modulation of lordosis behavior is found in R. J. Barfield, B. S. Rubin, J. H. Glaser, and P. G. Davis, "Sites of Action of Ovarian Hormones in the Regulation of Oestrus Behavior in Rats," in *Hormones and Behavior in Higher Vertebrates*, ed. J. Balthazart, E. Prove, and R. Gilles (Berlin: Springer-Verlag, 1983), 2–17; R. L. Meisel and D. W. Pfaff, "RNA and Protein Synthesis Inhibitors: Effects on Sexual Behaviors in Female Rats," *Brain Research Bulletin* 12 (1984): 187–193. Also see J. K. Morrell and D. W. Pfaff, "Characterizations of Estrogen-Concentrating Hypothalamic Neurons by their Axonal Projections," *Science* 217 (1982): 1273–1276. The final common pathway for motoneurons to muscles which elevate the rat's rump is described in S. Schwartz-Giblin, L. Rosello, and D. W. Pfaff, "A Histochemical Study of Lateral Longissimus Muscle in the Rat," *Experimental Neurology* 79 (1983): 497–518.

16. Ewert, "Neuroethology."

17. See W. B. Cannon, *Bodily Changes in Pain, Hunger, Fear and Rage: An Account of Recent Researches into the Function of Emotional Excitement*, 2d ed.

(New York and London: D. Appleton, 1929), for the comments by Sherrington and an early but clearly conceived and carefully examined discussion of the physiological changes attending emotional excitement.

18. J. J. Campos, "Heart Rate: A Sensitive Tool for the Study of Emotional Development in the Infant," in *Developmental Psychobiology: The Significance of Infancy*, ed. L. P. Lipsitt (Hillsdale, N.J.: Lawrence Erlbaum Associates, 1976), 1–31. On page 2 Campos discusses the study by E. H. Hon, "Observation on 'Pathogenic' Fetal Bradycardia," *American Journal of Obstetrics and Gynecology* 77 (1959): 1084.

19. Campos, "Heart Rate," 3. Campos refers in this context to the following studies: W. H. Bridger, B. M. Birns, and M. A. Blank, "A Comparison of Behavioral Ratings and Heart Rate Measurements in Human Neonates," *Psychosomatic Medicine* 27 (1965): 123–134; J. J. Campos and Y. Brackbill, "Infant State: Relationship to Heart Rate, Behavioral Response and Response Decrement," *Developmental Psychobiology* 6 (1973): 9–19.

20. Campos, "Heart Rate," 3. Also see Y. Brackbill, "Cumulative Effects of Continuous Stimulation on Arousal Level in Infants," *Child Development* 42 (1971): 17–26.

21. Campos, "Heart Rate," 16–19.

22. Ibid., 23. For the monkey study, see M. Reite, I. C. Kaufman, J. D. Pauley, and A. J. Stynes, "Depression in Infant Monkeys: Physiological Correlates," *Psychosomatic Medicine* 36 (1974): 363–367. For the human study, see G. P. Prigatano and H. J. Johnson, "ANS Changes Associated with Spider Phobic Reaction," *Journal of Abnormal Psychology* 83 (1974): 169–177.

23. R. D. Hare, "Orienting and Defensive Responses to Visual Stimuli," *Psychophysiology* 10 (1973): 453–464.

24. M. Fredrikson and A. Ohman, "Cardiovascular and Electrodermal Responses Conditioned to Fear-Relevant Stimuli," *Psychophysiology* 16 (1979): 1–7.

25. Cannon, *Bodily Changes*, 194.

26. Ibid. This notion remains so today. See N. McNaughton, *Biology and Emotion* (Cambridge: Cambridge University Press, 1989).

27. Blest, "Function of Eyespot Patterns."

## SELECTED BIBLIOGRAPHY

Eibl-Eibesfeldt, Irenäus. *Ethology: The Biology of Behavior*, trans. E. Klinghammer. New York: Holt, Rinehart & Winston, 1975.
Tinbergen, Niko. "Social Releasers and Experimental Method for Their Study." *Wilson Bulletin* 60 (1948): 6–51.

## Chapter 5

# The Defense Reaction

### A Releaser–Response Package Which Can Evoke Emotion in Art

The defense reaction is an animal's response to threat. A highly complex releaser–response package, the defense reaction is thought to consist of a complex reflex mechanism and several behaviors evoked by many different kinds of threat stimuli. This chapter discusses research which defines some of the behaviors, reflex mechanisms, and threat stimuli involved in the defense reaction. The next chapter discusses the defense reaction and fear, culminating with the assertion that the defense reaction can be responsible for some of the emotion evoked by art.

## DEFENSIVE BEHAVIOR

Defensive behavior is an animal's response to threat; however, many different behaviors describe defense: a rabbit may startle or freeze, a dog may fight or flee or submit or cower, a cat may hiss and bristle its fur or run up a tree, a man may run away or strike out at the aggressor. All these behaviors, and many more, have been called defensive behaviors, but, generally, defensive behaviors have been categorized under three main headings: (1) fight, (2) flight, or (3) freeze. Additionally, each of these behaviors may be expressed differently by different species and by different individuals within their species, even though the behaviors retain enough commonality to enable their categorization as fight, flight, or freeze. To add to the complexity, researchers sometimes describe the same behavior with different terms, so that it is difficult to follow behaviors in the literature. Given this situation, this discussion

of defensive behaviors has the goal of clarifying the types of possible behaviors and how these behaviors can vary in intensity.

### Defensive Behaviors Can Be Both Overt and Internal

The defense reaction can be described behaviorally in terms of both overt and internal responses. Overt behaviors associated with the defense reaction are fight, flight, and freeze. Actually, each of these categories is a continuum which includes various gradations of the type. That is, fight, for example, should be considered not just as outright combat, but as a continuum which includes aggressive movements, growls, angry facial expressions, and so on. Combat would be at the most intense end of the continuum; and much less intense behaviors, such as baring the teeth, would be at the other extreme end (see Figure 5.1 for a graphic analysis of the theoretical continua associated with defense). The intensity of the fight response is determined by the intensity of the stimulus situation (i.e., the number and kind of threat stimuli and the internal and external environmental context). For example, an extremely intense fight response might result from an attack on a dog's offspring (an extremely intense stimulus situation), but a solitary dog away from its home territory will probably not put up much of a fight when attacked by another dog which is on its own territory.

The flight and fight continua are characterized by overt behaviors, such as hissing, arching of the back, flattened ears, lunging attacks or fleeing, and internal behaviors caused by autonomic nervous system and respiratory changes. For example, cardiovascular responses associated with fight or flight are a rise in blood pressure, tachycardia or increased heart rate, vasodilation in skeletal muscle, and vasoconstriction in the kidney. Neuroscientist S. M. Hilton calls these cardiovascular changes the "visceral alerting response."[1] Associated with the visceral alerting response are other autonomic nervous system responses, such as pupillary dilation and hyperventilation. The freeze continuum, on the other hand, is characterized by overt immobilization of varying degrees and is internally accompanied by shallow breathing and, maybe, decreased heart rate. At the most intense end of the freeze continuum would be complete immobilization, and at the least intense end would be, perhaps, simple alerting or arousal (see Figure 5.1). Belkin notes that such colloquialisms as "immobilized by fear" and "so frightened my heart stopped" have real physiological meaning, and though some species have a tendency to "freeze" more often than others, Belkin points out that this behavior has been observed in creatures as diversified as lizards, nestling birds, and man.[2]

Internal behaviors vary along these defense continua, as do the overt behaviors. Heart rate changes might range from a slight increase to pound-

**Figure 5.1**
**Behavioral Continua Associated with the Defense Reaction**

## FIGHT

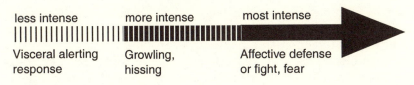

less intense        more intense        most intense

Visceral alerting    Growling,          Affective defense
response             hissing            or fight, fear

## FLIGHT

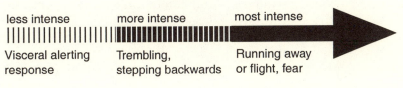

less intense        more intense        most intense

Visceral alerting    Trembling,         Running away
response             stepping backwards  or flight, fear

## FREEZE

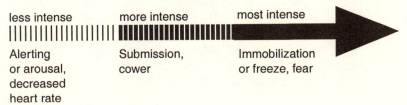

less intense        more intense        most intense

Alerting             Submission,        Immobilization
or arousal,          cower              or freeze, fear
decreased
heart rate

ing on the fight and flight continua. Heart rate increases might be unperceived by the person or the increase could be so great that one realizes that one's heart is racing. The intensity of the stimulus situation determines the intensity of the response. The stimulus situation may be so far toward the low-intensity end of the continuum that the defense response is not perceived by the person; it can be an internal response with only slight increases in heart rate and blood pressure. Conversely, an intense response is characterized by intense physiological changes, and we are very conscious of our racing hearts and sweaty palms.

Hilton writes that the internal cardiovascular responses associated with the defense reaction, the visceral alerting response, is "readily evoked in human subjects, particularly in situations causing anxiety." Hilton points out that the visceral alerting response patterns seen in human cardiovascular activity are "close counterparts of those seen in animal experiments," even though no overt behavior occurs in the human subjects.[3]

Consequently, defensive behaviors can be descriptively arranged along continua based on the intensity of the response. The range is from a very low intensity, consisting of imperceptible autonomic nervous system responses such as a slight rise in blood pressure, to a full-blown defense reaction, consisting of greatly increased heart rate, piloerection, sweating, elimination, exaggerated facial expressions, and running away. The intensity of the response depends on the intensity of the stimulus situation, which includes such variables as species and individual differences, internal and external motivation, and number and kind of threat stimuli or releasers (see Figures 4.2 and 4.3). The varieties of behaviors associated with defense can be generalized into three major continua: fight, flight, and freeze.[4]

### Individual and Species Variations in Defensive Behavior

In addition to the variations of behaviors associated with the defense reaction that have been outlined, there are species and individual variations. For example, on a species level the cat and rabbit differ in response when stimulated in the same general areas of the brain. In the cat, the defense reaction is easily evoked via stimulation of the hypothalamus and amygdala in the brain. Responses to this stimulation include the inhibition of neurons (in effect, the neurons are kept from passing on information) which maintain normal resting heart rate, vascular tone, and so on. Thus, the cat's heart rate and blood pressure is allowed to increase. In the rabbit, on the other hand, stimulation applied to the central nucleus of the amygdala results in activating rather than inhibiting neurons regulating cardiovascular response. The effect for the rabbit is a suppression of motor activity. Overtly, the cat is "unleashed" while the rabbit is "frozen." Internally, the cat's heart rate increases while the rabbit's heart rate decreases.[5]

Research describing differences on the individual level has primarily been done with humans. Human studies disclose the possibility of personality affecting behavioral outcome. Block studied the relationship between personality types and galvanic skin responses, a measure of autonomic nervous system activity, and discovered that galvanic skin responses differed in a lie detection situation according to the personality types of the subjects as measured by personality inventory tests.

Those subjects who showed a high galvanic skin response after lying were categorized by Block as "reactors." Those subjects who did not have a high galvanic skin response after lying were categorized as "nonreactors." Personality tests given these people found that they sorted into two groups which correlated with the results of the lie detector test. Reactors were distinguished by dreaminess, cautiousness, dependency, idealism, mannerliness, and suggestibility. Attributes of nonreactors included cleverness, coolness, evasiveness, independence, ingeniousness, opportunism, practicality, and realism.[6]

Another study also points to these two different ways people have of dealing with the environment. Bridger was interested in infants' differences or sensibilities to sensory stimuli and how or if any differences might be related to personality and/or later development. Using loud pure tones, which could elicit heart rate responses whether the babies were awake or asleep, calm or crying, Bridger found two patterns of responses. Some babies had a more variable base and a higher threshold for response, whereas others had a more consistent base and a low threshold for response.[7] These two different ways of responding as found by Bridger could relate to Block's reactors and nonreactors.

Finally, an animal study points to individual differences in response to affective stimuli. Flaherty and Rowan tested two strains of rats, which had been bred to differ in avoidance behavior, to see if they also differed in their response to stress. The researchers found that they did. "Low avoidance" rats were more emotionally reactive as measured by plasma glucose levels than were "high avoidance" rats.[8]

Consequently, it appears that, beside the usual within subject variations as exhibited by individual differences, a biological constraint operates which provides generalized differences. Reactors tend to avoid threat stimuli and show a greater response and a stabler base than do the nonreactors, who apparently prefer to confront rather than avoid threat. Perhaps it could be said that reactors show defense reactions whereas nonreactors show offense responses when confronted by threat, and they might be better described in those terms (i.e., defensive types and offensive types). Furthermore, these two groups, reactors and nonreactors, may be analogous to the extreme ends of a continuum described by Zuckerman. His continuum has augmentors or sensation-seekers at one extreme and reducers or nonsensation seekers at the other end. Zuckerman theorizes that these extremes are biologically based and that they determine how people deal with their environments.[9]

In summary, behavioral responses which are generally classified as defense reactions actually are many and varied. Overt behavior can run the gamut from ferocious attack to complete immobilization. Internal autonomic behavior can be expressed physiologically as dilated

pupils, piloerection, increased heart rate and blood pressure, and the like, or as decreased heart rate and shallow rapid breathing. These are not "all-or-nothing" responses, but complex responses dependent upon the stimulus situation, which is also extremely complex and comprised of external and internal factors. These factors include environmental setting and the heterogeneous summation of simple threat stimuli, internal hormonal secretions, and individual personality biases.[10] Moreover, the environmental setting can include response changes if the stimulus situation changes. That is, the addition or subtraction of some part of the stimulus situation might affect the defense reaction even after it has been triggered, since the reflex arc can be modulated by inhibition and other factors. In addition, individual and species differences can contribute to the kind and intensity of the behavioral response associated with defense. For example, some species, such as the rabbit, are more prone to the freeze response than are others. Also, indications are that within species variations can be caused not just by individual differences but by a broad-based biological difference which results in different response types.

## THE DEFENSE REACTION AS REFLEXIVE BEHAVIOR

In 1904, C. S. Sherrington, the pioneer neurobiologist, found that the defense reaction could be elicited in decerebrated dogs, and he assumed, therefore, that it was a reflex.[11] A reflex is defined as an involuntary behavior induced by a peripheral stimulus, and/or any response mediated by two or more neurons, including an afferent and an efferent path (see Figure 5.2).[12]

Konrad Lorenz described the ethological notion of the releaser–internal releasing mechanism–fixed action pattern as a Pavlovian un-

**Figure 5.2**
**Basic Design of the Reflex Arc**

**Central Nervous System
Coordinating Center**

**Sensory**                                    **Motor**

**Afferents/inputs**                           **Efferents/outputs**

Animal sees/hears/                             Animal's muscles
feels/smells                                   move it out of
a threatening stimulus.                        danger

conditioned reflex (see Chapter 4 for further discussion of the nature of this behavior).[13] I refer to this reflexive behavior, discussed by ethologists, as a complex releaser–response package. What does it mean to say the defense reaction is a complex releaser–response package? Does it mean that many reflexes are involved in the defense reaction? Blinking in response to a object coming toward your face is called the "menace reflex."[14] Often, one does more than blink. Sometimes whole body movements will occur, in which the head is lowered and the body twisted to the side or backward. Is the entire sequence of behavior which could occur in response to an object hurtling at your face the result of a reflex? Indeed, Abrahams, Hilton, and Zbrozyna indicate that the entire defense reaction *is* a complex, coordinated reflex.[15] However, when we think reflex we think of the knee jerk, which is a behavior clear in its cause and effect and brief and to the point with little apparent variation. The defense reaction, on the other hand, is none of those things. It has some apparent stereotypical behaviors, if we look at only fight or only flight or only freezing. Hilton, for example, maintains that the visceral alerting response is stereotypical for fight and flight.[16] However, overt behaviors may vary according to the situation and the intensity of the stimulus. This could only be considered reflexive in total if one stretches the concept of a reflex. However, if the defense reaction is considered in terms of a basic reflex arc overlaid with additional inputs and outputs and, perhaps, with other subsidiary arcs operating semiautonomously, the whole behavior becomes more comprehensible. This description defines the complex releaser–response package.

In the next section is a discussion of a relatively simple defense reaction. The C-start escape behavior of some fish is an example of a defense reaction and illustrates, in relatively simple terms, a complex releaser–response package, since it includes a variety of behaviors which result from one reflex arc. This description of the C-start behavior and the mechanism operating it will serve as a model for the discussion of the much more complex mammalian defense reaction neural mechanism which then follows.

## The Neural Mechanism of a "Simple" Defense Reaction

A relatively simple example of a defense reaction is the escape-providing C-start behavior of teleost fishes. This behavior is mediated by the Mauthner cell, a huge neuron which is generally considered to be the coordinating center of the reflex arc for the C-start. However, the Mauthner cell mechanism does not allow for much plasticity, as is seen in the more complex mammalian fight, flight, or freeze responses. The relative simplicity of the Mauthner cell neural mechanism does, though, offer some ease in understanding the basic reflex arc and how

it may be modulated. It provides a basic outline and demonstrates how additional inputs and outputs could be incorporated to add flexibility to behavior. It demonstrates how a behavior that appears to be rather complex—quick turning away from threat and consequent swimming—can be explained by one reflex arc. The following is a simplified summary, taken from the review by Young of the Mauthner cell mechanism which affects the startle and flight response in goldfish.[17]

Figure 5.3 illustrates the cell body, dendrites, and axon of a large neuron and synapses with smaller neurons. Synapses are the sites of information transmission between neurons. Figure 5.3 also illustrates the method of information transmission. Keep Figure 5.3 in mind during the summary of the Mauthner cell mechanism.

The Mauthner cell, found in the fish's medulla oblongata, has the largest axon in the spinal cord. The axon extends the length of the cord, putting out numerous connections to the spinal motor neurons which control the trunk muscles. Two large dendrite systems, the lateral and the ventral, receive connections from sensory receptors. Most of the research has centered on the lateral dendrite inputs. These are from the acoustico-vestibular and lateral line sensory systems. Direct electrical connections synapse on the lateral dendrite. Sensory interneurons likely provide indirect chemical connections directly to the cell body, bypassing the lateral dendrite. The ventral dendrite receives input from anterior areas of the fish's brain, particularly the optic tectum.

Axon collaterals projecting to the brain excite motor neurons which operate the muscles of the eyes, jaw, and operculum, thus affecting minor components of fish startle: closing the jaw and drawing in of the eyes. These ascending collaterals also create the inhibition which appears consequent to the Mauthner cell impulse, thus preventing the cell from firing twice in response to a given stimulus. In addition, this inhibition maintains Mauthner cell silence long enough for the escape response to go to completion, by shutting off further excitatory input from sensory receptors.

The Mauthner cell is excited by many stimuli. A sudden auditory stimulus, for example, will result in a single impulse in the cell. This is followed by a large muscle potential in the contralateral trunk musculature. (Like the optic nerve, the axons cross to the opposite side of the fish's body from each of the two Mauthner cell bodies.) The average delay from onset of stimulus to the Mauthner cell impulse is about six milliseconds, and the delay from impulse to onset of the muscle potential is about two milliseconds. Six to ten milliseconds later the fish performs the movement called the C-start, during which its body flexes so that it looks like the letter C. This last delay is because of the time needed for muscles to develop significant tension. The Mauthner cell provides only the initial flexion and, since it is now inhibited, pro-

**Figure 5.3**
**Neurons and Neural Transmission of Messages**

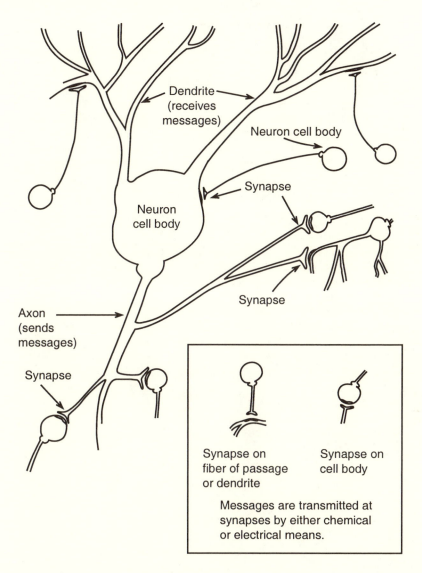

vides no further impulses for subsequent swimming. Other, smaller interneurons must also be part of the circuit in order to account for subsequent swimming; however, these presumed neurons have not been researched. Figure 5.4 provides a schematic representation of the Mauthner cell mechanism and its position in the body of the goldfish.

**Figure 5.4**
**Mauthner Cell Mechanism**

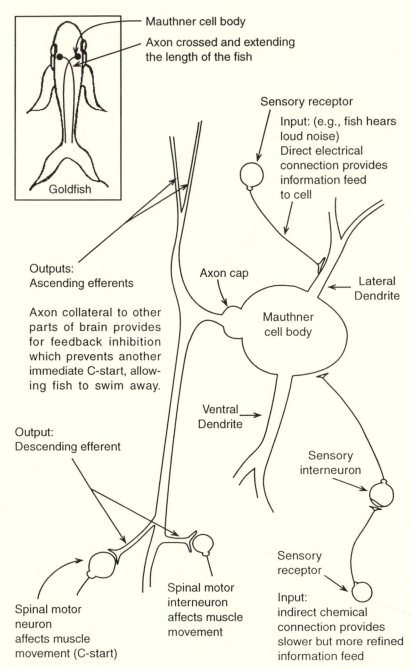

Mauthner cell body

Axon crossed and extending the length of the fish

Goldfish

Sensory receptor

Input: (e.g., fish hears loud noise) Direct electrical connection provides information feed to cell

Outputs:
Ascending efferents

Axon collateral to other parts of brain provides for feedback inhibition which prevents another immediate C-start, allowing fish to swim away.

Axon cap

Lateral Dendrite

Mauthner cell body

Output:
Descending efferent

Ventral Dendrite

Sensory interneuron

Spinal motor neuron affects muscle movement (C-start)

Spinal motor interneuron affects muscle movement

Sensory receptor

Input: indirect chemical connection provides slower but more refined information feed

The sensory afferents to the coordinating center (Mauthner cell) in this relatively simple example of a reflex for defense provide both direct and indirect inputs. This allows for a variety of types of information feeds. One type of feed probably could be described as fast and crude and the other could be described as slow and refined. The second, refined type may provide more precise information, but it is relatively slow in getting that information to the coordinating center. As will be seen, these different kinds of afferents, which allow for varieties of information to be transported, can be used as models for similar routes taken by inputs in mammalian circuits. A striking example, discussed in the next chapter, is the research by Joseph E. LeDoux, which demonstrates that a "fast and dirty" route runs from the ear to the thalamus to the amygdala in the central nervous system, and a slow but precise route runs from the ear to the thalamus to the auditory cortex to the amygdala.[18] The Mauthner cell itself could be considered analogous to the mammal's midbrain periaqueductal gray, where the mammalian defense reaction appears to be coordinated. Similarly, descending axon collaterals of the Mauthner cell are analogous to the descending efferents which direct the spinal motoneurons that cause such behaviors as running away in mammals. Ascending (to the brain) axon collaterals of the Mauthner cell, which operate the closing of the fish's eyes, are analogous to the efferents which cause facial expressions in mammals. In addition, the ascending collaterals provide a model for the various feed forward and feedback loops found in the mammalian defense reaction. Inhibition is also provided for in the ascending collateral in both the Mauthner cell and in the mammalian circuit so that the reflex arc responds only once. Thus, the basic reflex arc is amended to provide for immense plasticity and complexity in behavior.

### More Complex Defense Reaction Mechanisms

Keeping the Mauthner cell mechanism in mind as a model, let us examine some known neural connections of more complex mammalian defense reactions. Note that these connections are not always separated according to type of reaction, that is, fight or flight. Freeze is generally not considered, so this review is very general and incomplete. Also note that research has separated out a parallel circuit for the cardiovascular components of the defense reaction. Research on the cardiovascular components will be stressed in this discussion because it is primarily these components which result in universal emotional response to art. The following discussion is meant to show that neural substrates have been found for the complex behaviors of mammalian defense, that they are reflexive in nature, and that humans share these behaviors with other animals. The implication is, then, that defensive behaviors

are also reflexive in humans. An additional implication, and one that is important for response to art, is that these behaviors are performed without much or any conscious realization. This implication will be discussed further in the next chapter, but now it is important to describe how the defense reaction is operated by the nervous system.

*A Model for Mammalian Defense*    In 1979, Adams proposed the midbrain central or periaqueductal gray as the site for the coordination of offense, defense, and submission in the muroid rodent. Adams defined offense as the bite and kick attack, sideways posture, and piloerection seen in a male rat on its home territory confronting a conspecific. Defense for the male rat confronting a conspecific is described as lunge and bite attacks directed at the face or protruding parts of the body, and other behaviors that may include squealing, upright posture, fleeing, freezing, and warning noises (Note that these descriptions do not allow us to compare behaviors already discussed with these except in very general ways). Adams defines submission as the sort of behavior which is to be expected in a male mouse intruding into another's territory. Specific behavior patterns are fleeing, freezing, lying on the back, squealing, and ultrasound vocalization.

Adams theorized that each of these behaviors are coordinated or directed from the same midbrain area. He also proposed afferents and efferents, excitation and inhibition pathways for offense, defense, and submission. Briefly, his model consists of various sensory modes (visual, auditory, olfactory, and tactile) sending indirect inputs to the midbrain centers for offense, defense, and submission. Efferents from the midbrain ascend to the limbic system and, in the case of offense and submission, to forebrain structures which send reciprocals back to modulate further midbrain output. Descending projections operate the appropriate musculature producing the specific behavior. It is a model of a very complex reflex arc and, as we shall see, a reasonably accurate one.[19] Figure 5.5 is a diagram of Adams's model. To illustrate the physical placement of the reflex arc for defense, Figure 5.6 shows the general areas of the brain discussed in this section.

Since Adams's model for the neural mechanism of defense appeared, researchers have found that it is generally accurate across species, and the general thrust of the research supports Adams's model of the reflexive nature of the defense reaction. In particular, the research appears to illustrate how varieties of behaviors, all defensive in nature, can be elicited from one basic mechanism (as illustrated in Figure 5.5). Variety results, it seems, from modulatory inputs to the main reflex mechanism and by many feedback and feedforward loops.

Nine years after Adams's model was published, Siegel and Potts published their review on the neural substrates of aggression and flight in cats.[20] They divide aggression into "predatory attack" and "affec-

**Figure 5.5**
**Adams's Model of the Neural Mechanism for the Defense Reaction**

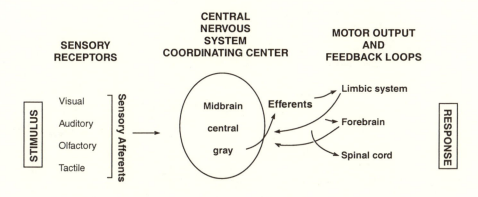

tive attack." The former probably should not be considered a defense reaction in which the fight behavior is actually self-defense on the part of the reacting animal. In the case of "predatory attack" the animal is acting as a predator; consequently, the behavior is not defensive. The latter is analogous to Adams's "offense" in rodents and, probably, "fight" in the discussion in the preceding section of this chapter. All the behaviors described by Siegel and Potts are at least mediated by the midbrain central gray, and each behavior can be elicited from a distinct area within the central periaqueductal gray. The following is a brief summary of Siegel and Potts's discussion of affective attack or defense and flight.

*Neural Substrate for Affective Defense or Fight* Affective defense in the cat includes piloerection, retraction of ears, arching of back, pupillary dilatation, vocalization, and unsheathing of claws. This response can reliably be evoked by electrical stimulation of the medial preoptico-hypothalamus and brainstem central gray.[21] Siegel and Potts indicate that, since the affective defense response can be elicited by electrical or chemical stimulation of appropriate areas in the brain, little attention has been paid to natural stimuli which elicit it. However, the threshold of elicitation is lowered by sensory stimuli such as a stick waved within the animal's visual field or a painful stimulus. Motor output for both the overt and autonomic aspects of affective defense is integrated in the medial tuberal region of the hypothalamus, according to Siegel and Potts, but, as will be seen in the reviews by Hilton and Redfern and by Bandler, this may not be the case.[22]

*Neural Substrate of Flight* Siegel and Potts describe flight elicited by brain stimulation as characterized by pupillary dilatation followed by vigorous attempts to escape. Areas from which flight is elicited by

**Figure 5.6**
**Some Areas of the Human Brain Associated with the Defense Reaction**

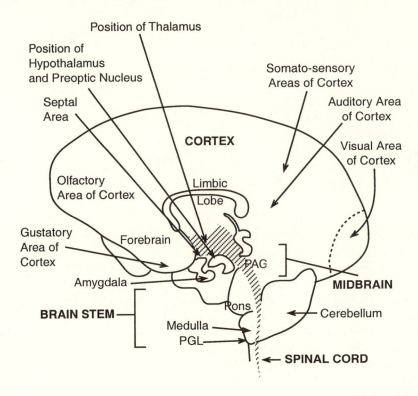

brain stimulation are the medial preoptic area, dorsomedial hypothalamus, and, to a lesser degree, the perifornical region and the midbrain periaqueductal gray.[23] Flight, like affective defense, can be elicited by brain stimulation in the absence of environmental stimuli, but the response can be intensified by provocation such as visual contact, waving a stick, poking, and attempts at capture. Flight can also be elicited by pain produced by electrical shock. Nearly all of the studies reviewed by Siegel and Potts cite significant autonomic arousal for flight, including piloerection, pupillary dilatation, salivation, elimination, and increased heart rate, blood pressure, and respiration rate. It is not known, they write, if these responses, so similar to those of affective defense, are mediated by the same neural pathway. In addition, Siegel and Potts cite studies which indicate that two antagonistic modulators of flight exist in the limbic system when the hypothalamus is stimulated. The septal region and its target, the dorsal preoptic area, as well as the basolateral amygdala, facilitate flight. On the other hand, the ventral preoptic region and the

corticomedial amygdala and its target, the bed nucleus, inhibit or suppress flight.[24] These pathways support Adams's model for reciprocals from the limbic system modulating the midbrain output.[25]

Siegel and Potts note that fight and flight can be evoked by stimulation of the midbrain central gray, which Adams proposed was the coordinating center of the mammalian defense reaction. In addition, Siegel and Potts describe how the response can be modulated by sensory stimulation and the introduction of certain chemicals. They note that the autonomic components of fight and flight are nearly identical, but research has not established if the same neural pathway is involved. They also discuss facilitators and suppressors of flight in the limbic system (see Adams's model in Figure 5.5). Note that the basic pathway discussed involves only precortical brain areas (see Figure 5.6), thus emphasizing the automatic and unconscious quality of this complex releaser–response package.

*Site for Defense Coordination*    The coordinating site for the defense reaction appears to be the midbrain central or periaqueductal gray, as Adams suggested. Yardley and Hilton mapped areas of the rat brain from which behavioral and cardiovascular components of the defense reaction could be elicited by electrical stimulation. The map shows a continuous region from the preoptic area through the ventral hypothalamus into the midbrain central gray and adjacent tegmentum.[26] The hypothalamus, thought for many years to be the site of defense control, has been found to be intimately involved but not the coordinating site. Since electrical stimulation activates fibers of passage besides control neurons, Hilton and Redfern used microinjections of excitatory amino acids, which stimulate lone neurons, in the area thought to be the defense control center in the rat hypothalamus and were unable to elicit the cardiovascular responses characteristic of the defense reaction. However, they did find that injection of the dorsal periaqueductal gray produced the full pattern of visceral and somatic responses characteristic of the defense reaction in the rat.[27] Bandler also found that microinjections of L-glutamate into the hypothalamus of the conscious cat did not elicit the defense reaction, but injections into the periaqueductal gray readily did produce the defense reaction.[28] Bandler and his colleagues have reproduced this experiment with rats.[29] In addition, Bandler mapped the central gray using electrical and chemical stimulation for various components of the defense reaction. Components such as facial expression, vocalization, stance, pupil dilation, piloerection, and arching of the back are on his map for the cat and the rat.[30] Moreover, Jurgens and Richter found that chemical stimulation of periaqueductal gray sites in the squirrel monkey produced results consistent with Bandler's studies of cats and rats.[31] Studies using electrical stimulation of sites in the region of the periaqueductal gray and adjacent tegmentum also

evoke complex responses in human beings. These responses include piloerection, increased heart rate, and increased respiration rate. Subjects described the experience as one of fear, and most did not want to have the experience again.[32] Hilton and Redfern conclude that, though there seem to be no neurons in the tuberal hypothalamus which initiate the defense response, there seem to be inputs to the midbrain, originating from the hypothalamic area, which have a tonic effect on lowering the threshold for response to threat stimuli.[33]

Thus, work in the laboratories discussed indicates that the midbrain periaqueductal gray is the site for coordination of the defense reaction. Since the defense reaction, even in all of its varieties of behaviors, appears to be centrally coordinated in one structure, the notion that the defense reaction consists neurologically of a single reflex arc is strongly supported. In addition, human beings react to periaqueductal gray stimulation with the same behaviors as do other animals, thus indicating that we, too, react in this reflexive way and that the reflex is coordinated by the same brain area as it is in the other mammals studied. Furthermore, human beings can describe their sensation in response to stimulation of the periaqueductal gray, and they call it fear. The importance of this will be discussed in the next chapter.

*Neural Substrates of the Visceral Responses Associated with Defense*    Hilton and Redfern describe the defense reaction as a response to threat consisting of a "retaliatory threatening display culminating in attack or flight . . . accompanied by visceral and hormonal changes."[34] The internal changes, which Cannon proposed were adaptions to prepare the animal for an emergency, include hyperventilation and cardiovascular changes, consisting of increased cardiac output directed mainly to skeletal muscle, heart, and brain, leaving the splanchnic organs, kidneys, and skin with less blood flow.[35] These are fully developed in the alerting stage of the overall response, thus prompting Timms and Hilton to call them, collectively, the visceral alerting response, and to agree with Cannon that these responses prepare the animal for an emergency.[36] In fact, Hilton concluded that the visceral alerting response is anticipatory and can dissipate after the overt defensive behavior begins. The ensuing overt behavior may vary, depending on the species and the nature of the stimulus situation, but the pattern of visceral and hormonal changes which precedes and accompanies the defense reaction is basically the same for all mammalian species studied so far, including man.[37] Note that the instantaneous quality of visceral response is associated here with a "full" defense reaction. A weaker or nonexistent overt response may be accompanied by weaker visceral responses which may show considerable latency in developing, and this weak response can be evoked, I propose, by some works of art.

The relative independence of the visceral alerting response from the defense reaction as a whole suggests a semi-autonomous neural connection, and Hilton and Redfern propose the nucleus paragigantocellularis lateralis (PGL) in the ventrolateral medulla (see Figure 5.6) as the site essential to the cardiovascular components of the visceral alerting response in cat and rat.[38] The PGL receives input from the midbrain dorsal periaqueductal gray, which is the site for central coordination of the defense reaction as a whole.[39]

Since I contend that threat stimuli used in art evoke emotional responses associated with the defense reaction, this section on the visceral responses associated with defense is very important. For threat stimuli used in art to evoke emotional responses, several criteria must be met. First, the response must not be so intense that the observer of art actually jumps up and runs away. Indeed, the visceral alerting response as described occurs in anticipation of overt behaviors and can actually dissipate after overt behavior begins or does not begin, allowing for the visceral alerting response to occur as a response to art.[40] Second, research shows that human beings experience the visceral alerting response.[41] Consequently, observers of art could experience the visceral alerting response in response to threat stimuli used in art. Third, there is an association between these cardiovascular changes, which Hilton calls the visceral alerting response, and emotion. That is, heart rate increases, blood pressure increases, and so on, which are the visceral alerting response, are commonly associated with the emotion fear. Thus, conditions are met which allow a link between threat stimuli used in art (which will be discussed in detail in Chapter 7) and some emotions evoked by art. The connection between the defense reaction and emotion will be discussed further in the next chapter.

*Amygdaloid Influence on the Neural Substrate for Defense*   Researchers conclude that the amygdala, septum, and preoptic areas of the limbic system may have a modulatory role in the elicitation of the defense reaction.[42] In particular, Turner, Mishkin, and Knapp found that all sensory systems send cortical projections via their cortical association areas to the amygdaloid complex, but not to the more central limbic areas or the hypothalamus. They therefore concluded that whatever influence sensory systems have on emotional processes must be mediated by the amygdaloid relays.[43] Moreover, the amygdala probably has both inhibitory and excitatory feedback loops to the brainstem areas which mediate defense.[44] In addition, amygdala inputs running through the hypothalamus may be important for the coordinated cardiovascular responses associated with defense.[45] Thus, the amygdaloid relays establish afferent pathways for defense that link the sensory input to the emotional responses associated with defense. (See Figure

**Figure 5.7**
**Revised Model of the Neural Mechanism for the Mammalian Defense Response**

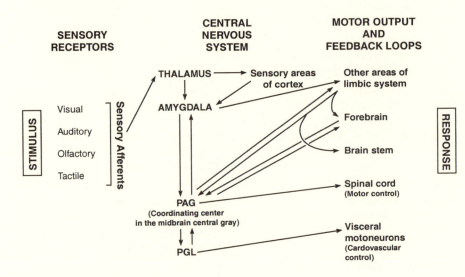

5.7 for a model of mammalian defense which is revised and updated from Adams's model as seen in Figure 5.5.)

To summarize this section on the reflex mechanism of mammalian defense, in 1978 Adams proposed a neural model for defense (Figure 5.5) including sensory afferents to a central command center, which he suggested is the midbrain central gray. Ascending efferents from the central gray are sent to the limbic system and forebrain which, in turn, send reciprocal processes back to the midbrain to modulate the initial midbrain output. Descending efferents from the central gray go to the spinal cord in order to operate the muscles affecting the specific defensive behaviors, such as running away.

Since Adams's model for the neural mechanism of mammalian defense was proposed, much research tends to generally support his conclusions. In 1988, Siegel and Potts reviewed research on the neural substrates of offense and flight (leaving freeze aside). Their work on limbic system reciprocals follows Adams's model, except that Adams theorized that the reciprocals begin in the central gray and Siegel and Potts had the hypothalamus as the source. More recently, research by LeDoux and associates implicates the source of limbic system reciprocals as the thalamus.[46]

Also in 1988, Bandler reviewed fight/flight as an entity, and his work indicates that the midbrain periaqueductal gray is the primary com-

mand or coordinating center for both flight and fight. Bandler mapped the periaqueductal gray, finding facial expressions, vocalizations, stance, pupil dilation, piloerection, and arching of the back on the map. Furthermore, stimulation of this site in human beings evokes similar responses, and the subjects described the experience as one of fear. Thus, the coordinating center for the defense reflex appears to be the same in humans as it is in other mammals studied.

In 1987, Hilton and Redfern reviewed research on the cardiovascular and respiratory components of the defense reaction. Their review shows that these responses are basically the same for all mammalian species so far studied, including man. Hilton and Redfern's review and research agrees with Bandler's finding that the coordinating site for defense, as a whole, appears to be the midbrain periaqueductal gray. However, Hilton and Redfern suspect the paragigantocellularis lateralis in the ventrolateral medulla is a subcenter coordinating the cardiovascular components of the defense reaction.

Consequently, Adams's model appears generally to be workable. So far, research has demonstrated that such a complex behavior as the defense reaction appears, indeed, to have one main coordinating site, the periaqueductal gray in the midbrain, though several subcenters no doubt will be found. One of these appears to be the PGL, where the cardiovascular components are coordinated. Multitudes of afferents and efferents have only been slightly researched, so much work remains to be done on the neural connections of defense. What has been accomplished, however, indicates that defense does result from an extremely complex reflex arc, and the coordinating site for the reflex appears to be the same for a variety of species, including the human species (see Figure 5.7).

The consequence of this research for human response is that, given the appropriate stimulus situation, human beings can be expected to respond to threat stimuli in ways similar to those expected of cats, rats, and dogs (the most frequently studied mammals). That is, the expected human response will be on one of the continua for fight, flight, or freeze. Since the response is reflexive in nature, it is, as Cannon so aptly put it, "distressingly beyond the will."[47]

## THREAT STIMULI

As has been discussed, an individual, when confronted by threat, may fight, flee, or freeze. Precisely why an animal flees rather than fights or freezes rather than flees needs further study. Some parameters are known, however, and these include whether or not an animal is on its home territory or in mating season, or the threat is a predator or a dominant conspecific of the same sex. That is, the animal's internal and environ-

mental situation help to "set the stage" for the type of behavior which is to follow. It is also likely that very specific stimuli trigger defensive attitudes under the appropriate conditions, and the intensity of the stimulus situation determines the intensity of the response. The stimulus situation consists of all of these factors together: internal and external motivation and number and kind of specific triggering stimuli.[48]

Assume for a moment a specific instance of intense threat: a tiger leaping at you from ambush. The scene begins with you walking along a jungle path. Suddenly, you see the tiger leaping toward you. You see bared teeth and gleaming yellow eyes. Terrified, you try to run. In an analysis of this imagined defense response, we note that the human involved would consciously recognize the danger. Is the decision to run made consciously? Notice that other tiger prey make similar decisions. Do gazelles make conscious decisions to run? Perhaps they do, but considering the accumulated evidence regarding the reflexive nature of the defense reaction, indications are that the decision to flee is not a decision weighed with pros and cons. It is, rather, a decision based on inherited traits. Specific threat stimuli trigger the flight response when internal and external motivation set the stage for flight. No time is allowed to consider the decision when the tiger is leaping at your throat.

The specific stimuli involved in this intense threat scenario are no doubt many, but the following three are likely candidates. First, there is the looming object; that is, an object moving toward one's head, which is, in this instance, a tiger.[49] Second, this particular looming object—the tiger—is further adorned with possible threat stimuli, one of which is bared teeth. Primatologists consider the open-mouthed, bared-teeth expression a threat stimulus for primates.[50] Third, another of the tiger's adornments is its gleaming eyes. Eye-spot patterns have been found to be elicitors of flight for birds and some of the autonomic nervous system responses associated with the defense reaction in human beings.[51] Therefore, some basis does exist to support the notion that at least three specific stimuli or releasers may trigger the defense reaction in this imaginary scene.

Taken individually, each of these stimuli might provoke a defense reaction on its own, depending on the situation. Using another simple stimulus as an example, the male stickleback fish's red belly is enough to elicit aggressive behavior in other male sticklebacks if it is mating season.[52] In an informal observation, I discovered that my small child cried in obvious fear in response to the formation of the grain on her wooden closet door. The pattern formed by the whirls of the grain looked like two eyes. It was necessary to keep the door opened so that the eye-spot pattern was out of sight against the wall. In this instance the child appeared to respond with a fairly complete defense reaction to abstracted eye spots.

On the other hand, an eye-spot pattern drawn on paper and placed in front of a person who is calm and not experiencing other threats is not likely to make that person cry with fear. The intensity of the stimulus situation is so reduced that these eye spots may only evoke a little uneasiness or momentary anxiety or, in fact, no conscious reaction whatsoever. My child reacted to the eye spots on her door when she was alone in her room either just waking up or at bedtime, so the internal and external motivation to react strongly to the eye spots was probably set by the solitude and confusion of the situation.

Tinbergen found that, in addition to internal and external motivational set, the intensity of response occurs not from repetitious presentations of the same stimulus but from simultaneous presentation of different stimuli (such as looming object, bared teeth, and eye spots). It is possible, however, for a single (or we assume a single) stimulus to evoke a very intense response if the stimulus situation is otherwise optimum. Different specific threat stimuli acting in concert are likely, though, to provide an intense response (full-blown defense reaction). For example, if the looming object in the tiger example had no bared teeth or eyes, and, in fact, turned out to be a basketball, you would avert your head but not run in terror. In addition, a stimulus situation may be so weak (an example would be the eye spots drawn on paper) that only a mood or a readiness to produce a full response may be evoked.[53] Note, again, that the intensity of the response, including whether an overt reaction even occurs, is determined by the stimulus situation; that is, the combination of internal and external motivation and the number and kind of specific simple stimuli.

Now consider another scenario. Instead of a tiger leaping at you in the jungle, you are a man in a bar with another man leaping at you. Your defense reaction in this instance probably would not be flight but fight. What makes this situation different from the tiger scenario? The man lunging at you would be, just as the tiger was, a looming object with bared teeth and gleaming eyes. However, the man is not a predator but a conspecific. Of course, you know it is a man lunging at you, but to use the animal analogy again, how does a red deer know its opponent is another red deer intent on doing harm? The answer most likely is that specific stimuli which mean fight elicit aggression if the internal and external motivational set is right.

Another kind of possible overt behavior called a defense reaction might be described by the following scenario. Imagine, this time, that you are a woman walking down a dark, lonely street by yourself. Suddenly, a figure leaps out of the shadows and grabs you. You faint. Hilton suggests that the freeze behavioral alternative of the defense reaction may underlie emotional fainting in human beings.[54] Again, the stimulus situation is probably the key for the response selection. It is known that some

species have a greater tendency to freeze under threat than do others and so, for these species, that quality would play a large part in the stimulus situation. Probably for those species that are less likely to freeze, the intensity level of the stimulus situation would need to be very high. In the preceding example, gender difference may affect the stimulus situation, thus making the difference between flight, fight, or freeze.

In summary, specific stimuli release relatively specific defensive behavior. These stimuli are very simple configurations of line, shape, color, sound, touch, smell, or movement. Sometimes, combinations of these parameters are the releasing stimuli (e.g., the moving rectangular shape which means prey to a toad). Sometimes, the releaser is only one of these parameters: Red means fight to English robins and stickleback fish in mating season.[55] The situation under which the stimuli are presented is a factor in whether a response is elicited or what kind of response is elicited. Both internal and external factors are part of the situation. When the situation is suitable, as during stickleback fish mating season, aggression will be released by the red belly of a conspecific. When the toad is not hungry, moving rectangles may not provoke much prey-catching, but when the toad is hungry, a moving rectangle means dinner. A visceral alerting response might be evoked in a lone man in the dark by the sight of gleaming, yellow eyes. More releasing stimuli, such as bared teeth and something hurtling toward him, would likely evoke flight. The intensity of the response is a function of the summation of releasing stimuli and the situation, though it is possible for an intense response to be released by a single simple releaser if the situation is adequate. The situation and specific releasers also shape the kind of response. Whether an animal or person runs, fights, or freezes is likely dependent on the stimulus situation.

This chapter has presented arguments and evidence in support of the notion that the defense reaction is a complex releaser–response package, reflexive in nature. Thus, the responding animal does not make a decision about whether to act or not to act. Additional evidence is provided to suggest that human beings experience defense reactions and that human defense reactions are mediated by the same reflex mechanism as are the defense reactions of other mammals studied. Consequently, it can be assumed that a certain lack of conscious decision making takes place in human defense reactions. Furthermore, the varieties of behaviors associated with defense range in intensity from the imperceptible to the very obvious. Imperceptible and perceptible autonomic nervous system changes accompany emotional response, and emotional response is one of the behaviors associated with defense. The next chapter discusses this association and why it is important to the notion that some emotion evoked by art is evoked via the defense reaction.

## NOTES

1. S. M. Hilton, "The Defence-Arousal System and its Relevance for Circulatory and Respiratory Control," *Journal of Experimental Biology* 100 (1982): 159–174.

2. D. A. Belkin, "Abstract: Bradycardia in Response to Threat," *American Zoologist* 8 (1968): 775.

3. Hilton, "Defence-Arousal System," 164. See D. A. Blair, W. E. Glover, A. D. M. Greenfield, and I. C. Roddie, "Excitation of Cholinergic Vasodilator Nerves to Human Skeletal Muscles during Emotional Stress," *Journal of the Physiological Society* (London) 148 (1959): 633–647, for early research demonstrating that the visceral alerting response is readily evoked in human subjects in a situation perceived as anxiety producing. Many other studies demonstrate the same thing. An example is R. D. Hare and G. Blevings, "Defensive Responses to Phobic Stimuli," *Biological Psychology* 3 (1975): 1–13. In this study, subjects who admitted to a fear of spiders responded to photographs of spiders with a visceral alerting response, and those subjects who indicated that they had no fear of spiders had no such response.

4. Some researchers have discussed offense with the defense reaction. See A. Siegel and C. B. Potts, "Neural Substrates of Aggression and Flight in the Cat," *Progress in Neurobiology* 31 (1988): 261–283. Most likely, these researchers have overlapped these behaviors due to the many similarities between self-defense (fight) and offense in terms of the overt behavior observed in the intense extreme of the continua of these two behaviors. That is, an aggressive animal exhibits much of the same biting and hitting behaviors as an animal fighting back against an aggressor or predator does. However, some evidence suggests that offense (aggression) and self-defense (fight) are separated emotionally, if one can assume that anger accompanies aggression and fear accompanies fight (Predation, on the other hand, seems to be characterized by neither fear nor anger). The following studies found anger to be characterized by greater increases in blood pressure and heart rate than fear: T. C. Weerts and R. Roberts, "The Physiological Effects of Imagining Anger-Provoking and Fear-Provoking Scenes," *Psychophysiology* 13 (1975): 174; G. E. Schwartz, D. A. Wienberger, and J. A. Singer, "Cardiovascular Differentiation of Happiness, Sadness, Anger, and Fear following Imagery and Exercise," *Psychosomatic Medicine* 43 (1981): 343–364; and Paul Ekman, R. W. Levenson, and W. V. Friesen, "Autonomic Nervous System Activity Distinguishes among Emotions," *Science* 221 (1983): 1208–1210. Much more needs to be studied to solve the problem of the differences between anger and fear and offense and defense, but the concern here is with identifying the behavioral responses associated with the defense response and the emotion fear.

5. S. M. Hilton, "Hypothalamic Regulation of the Cardiovascular System," *British Medical Bulletin* 22 (1966): 243–248; J. H. Coote, S. M. Hilton, and J. F. Perez-Gonzalez, "Inhibition of Baroreceptor Reflex on Simulation in the Brainstem Defense Centre," *Journal of Physiology* 288 (1979): 549–560; K. M. Spyer, S. W. Mifflin, and D. J. Withington-Wray, "A Diencephalic Control of the Baroreceptor Reflex at the Level of the Nucleus of the Tractus Solitarius," in *Organization of the Autonomic Nervous System, Neurology & Neurobiology*, vol.

31, ed. J. Ciriello, F. R. Calaresu, L. P. Renaud, and C. Polosa (New York: Alan R. Liss, 1987); G. E. Cox, D. Jordan, P. Moruzzi, J. S. Schwaber, K. M. Spyer, and S. A. Turner, "Amygdaloid Influences on Brainstem Neurons in the Rabbit," *Journal of Physiology* (London) 381 (1986): 135–148; and B. S. Kapp, M. Gallagher, M. Underwood, C. McNall, and P. Whitehorn, "Cardiovascular Responses Elicited by Electrical Stimulation of the Amygdala Central Nucleus in the Rabbit," *Brain Research* 234 (1982): 251–262.

6. J. Block, "A Study of Affective Responsiveness in a Lie-Detection Situation," *Journal of Abnormal and Social Psychology* 55 (1957): 11–15. Block's study was based on the following earlier work: H. E. Jones, "The Galvanic Skin Response as Related to Overt Emotional Expression," *American Journal of Psychology* 47 (1935): 241–251; H. E. Jones, "The Study of Patterns of Emotional Expression," in *Feelings and Emotions: The Mooseheart Symposium*, ed. M. L. Reymert (New York: McGraw Hill, 1950), 161–165.

7. W. H. Bridger, "Sensory Habituation and Discrimination in the Human Neonate," *American Journal of Psychiatry* 117 (1961): 991–996.

8. C. F. Flaherty and G. A. Rowan, "Rats (*Rattus norvegicus*) Selectively Bred to Differ in Avoidance Behavior also Differ in Response to Novelty Stress, in Glycemic Conditioning, and in Reward Contrast," *Behavioral and Neural Biology* 51 (1989): 145–164.

9. M. Zuckerman, "Biological Foundations of the Sensation-Seeking Temperament," in *The Biological Bases of Personality and Behavior*, vol. 1, ed. J. Strelau, F. H. Farley, and A. Gale (Washington, D.C.: Hemisphere, 1985), 97–113.

10. The term "heterogeneous summation" was coined by Niko Tinbergen and refers to the notion that simultaneous presentation of several releasers of like kind (e.g., eye spots, looming object, loud sound) tend to produce an intense response. See Niko Tinbergen, "Social Releasers and Experimental Method for Their Study," *Wilson Bulletin* 60 (1948): 6–51.

11. See V. C. Abrahams, S. M. Hilton, and A. W. Zbrozyna, "Active Muscle Vasodilatation Produced by Stimulation of the Brain Stem: Its Significance in the Defense Reaction," *Journal of the Physiological Society* (London) 154 (1960): 491–513; Hilton, "Defence-Arousal System."

12. S. I. Landau, ed., *International Dictionary of Medicine and Biology*, vol. 3 (New York: Wiley, 1986).

13. Konrad Lorenz, "Part and Parcel in Animal and Human Societies: A Methodological Discussion," in *Studies in Animal and Human Behaviour*, vol. 2, trans. R. Martin (1950; reprint, Cambridge: Harvard University Press, 1971), 115–195.

14. S. I. Landau, *International Dictionary of Medicine and Biology*.

15. Abrahams, Hilton, and Zbrozyna, "Active Muscle Vasodilatation."

16. Hilton, "Defence-Arousal System."

17. D. Young, *Nerve Cells and Animal Behaviour* (Cambridge: Cambridge University Press, 1989).

18. Joseph E. LeDoux, "Fear Pathways in the Brain: Implications for a Theory of the Emotional Brain," in *Fear and Defence*, ed. P. F. Brain, S. Parmigiani, R. J. Blanchard, and D. Mainardi (New York: Harwood Academic, 1990), 163–177; Joseph E. LeDoux, "Emotion as Memory: Anatomical Systems Underlying Indelible Neural Traces," in *The Handbook of Emotion and Memory: Research and Theory*, ed. S. Christianson (Hillsdale, N.J.: Lawrence Erlbaum Associates, 1992),

269–288; and Joseph E. LeDoux, "Emotion, Memory and the Brain," *Scientific American* 270, no. 6 (1994): 50–59.

19. D. B. Adams, "Brain Mechanisms for Offense, Defense, and Submission," *The Behavioral and Brain Sciences* 2 (1979): 201–241.

20. Siegel and Potts, "Neural Substrates."

21. M. Wasman and J. P. Flynn, "Directed Attack Elicited from Hypothalamus," *Archives of Neurology* 6 (1962): 220–227; S. A. G. Fuchs, H. M. Edinger, and A. Siegel, "The Organization of the Hypothalamic Pathways Mediating Affective Defense Behavior in the Cat," *Brain Research* 330 (1985): 77–92; S. A. G. Fuchs, H. M. Edinger, and A. Siegel, "The Role of the Anterior Hypothalamus in Affective Defense Behavior Elicited from the Ventromedial Hypothalamus of the Cat," *Brain Research* 330 (1985): 93–107; R. J. Bandler, "Identification of Hypothalamic and Midbrain Neurones Mediating Aggressive and Defensive Behavior by Intracerebral Microinjections of Excitatory Amino Acids," in *Modulation of Sensorimotor Activity during Alterations in Behavioral States*, ed. R. J. Bandler (New York: Alan R. Liss, 1984), 369–392; and M. B. Shaikh, J. A. Barrett, and A. Siegel, "The Pathways Mediating Affective Defense and Quiet Biting Attack Behavior from the Midbrain Central Gray of the Cat: An Autoradiographic Study," *Brain Research* 437 (1987): 9–25.

22. S. M. Hilton and W. S. Redfern, "Does the Hypothalamus Contain Neurones Integrating the Defense Reaction?" in *Organization of the Autonomic Nervous System: Central and Peripheral Mechanisms*, ed. J. Ciriello, F. R. Calaresu, L. P. Renaud, and C. Polosa (New York: Alan R. Liss, 1987), 315–325, and R. J. Bandler, "Brain Mechanisms of Aggression as Revealed by Electrical and Chemical Stimulation: Suggestion of a Central Role for the Midbrain Periaqueductal Grey Region," *Progress in Psychobiology and Physiological Psychology* 13 (1988): 67–154.

23. Siegel and Potts, "Neural Substrates." This study cites numerous studies in which flight is elicited by brain stimulation.

24. Ibid. See, among the numerous studies cited by Siegel and Potts, J. L. Brown, R. W. Hunsperger, and H. E. Rosvoid, "Defense, Attack, and Flight Elicited by Electrical Stimulation of the Hypothalamus of the Cat," *Experimental Brain Research* 8 (1969): 113–129; C. L. J. Stokman and M. Glusman, "Amygdaloid Modulation of Hypothalamic Flight in Cats," *Journal of Comparative Physiological Psychology* 71 (1969): 365–375.

25. Adams, "Brain Mechanisms."

26. C. P. Yardley and S. M. Hilton, "The Hypothalamic and Brainstem Areas from which the Cardiovascular and Behaviourial Components of the Defence Reaction are Elicited in the Rat," *Journal of the Autonomic Nervous System* 15 (1986): 227–244.

27. Hilton and Redfern, "Does the Hypothalamus?"

28. R. J. Bandler, "Induction of Rage following Microinjections of Glutamate into Midbrain but not Hypothalamus of Cats," *Neuroscience Letters* 30 (1982): 183–188.

29. R. J. Bandler, T. McCullough, and B. Dreher, "Afferents to Midbrain Periaqueductal Gray Regions Involved in the 'Defence Reaction' in the Cat as Revealed by Horseradish Peroxidase: I. The Telencephalon," *Brain Research* 330 (1985): 109–119.

30. Bandler, "Brain Mechanisms of Aggression."

31. U. Jurgens and K. Richter, "Glutamate-Induced Vocalization in the Squirrel Monkey," *Brain Research* 373 (1986): 349–358.

32. B. S. Nashold, W. P. Wilson, and D. G. Slaughter, "Sensations Evoked by Stimulation in the Midbrain of Man," *Journal of Neurosurgery* 30 (1969): 14–24; D. E. Richardson and H. Akil, "Pain Reduction by Electrical Brain Stimulation in Man. Part 1: Acute Administration in Periaqueductal and Periventricular Sites," *Journal of Neurosurgery* 47 (1977): 178–183; and K. Amano, T. Tanikawa, H. Iseki, H. Kawabatake, M. Notani, H. Kawamura, and K. Kitamura, "Single Neuron Analysis of the Human Midbrain Tegmentum," *Applied Neurophysiology* 41 (1978): 66–78.

33. Hilton and Redfern, "Does the Hypothalamus?"

34. Ibid., 315.

35. W. B. Cannon, *Bodily Changes in Pain, Hunger, Fear and Rage: An Account of Recent Researches into the Function of Emotional Excitement*, 2d ed. (New York and London: D. Appleton, 1929).

36. R. J. Timms, "A Study of the Amygdaloid Defence Reaction Showing the Value of Althesin Anaesthesia in Studies of the Functions of the Fore-Brain in Cats," *Pflugers Archiv* 389, no. 1 (1981): 49–56; and S. M. Hilton, "Defence-Arousal System."

37. Hilton, "Defence-Arousal System."

38. Hilton and Redfern, "Does the Hypothalamus?" More recent work supports Hilton and Redfern's assertions. See R. J. Lin, Q. L. Gong, and P. Li, "Convergent Inputs to Neurones in the Nucleus Paragigantocellularis Lateralis in the Cat," *Neuroreport* 2 (1991): 281–284; W. Wang, Y. Zheng, and M. Xu, "Effect of Microinjection of Lidocaine and L-Glutamate into the Nucleus Paragigantocellularis Lateralis on the Respiration and Arterial Blood Pressure in the Rat," *Journal of West China University of Medical Sciences* 25 (1994): 266–270 (According to the English abstract of this article, which is available only in Chinese, the researchers found that the PGL plays a role in the control of respiration and in the maintenance of normal arterial blood pressure); and E. J. Van Bockstaele and G. Aston-Jones, "Integration in the Ventral Medulla and Coordination of Sympathetic, Pain and Arousal Functions," *Clinical and Experimental Hypertension* 17 (1995): 153–165 (According to this review article, the PGL also plays a part in the control of alertness and attention, which is relevant to art since art attracts attention).

39. A. J. Beitz, "The Organization of Afferent Projections to the Midbrain Periaqueductal Gray of the Rat," *Neuroscience* 7 (1982): 133–159; J. E. Marchand and N. Hagins, "Afferents to the Periaqueductal Gray in the Rat: A Horseradish Peroxidase Study," *Neuroscience* 9 (1983): 95–106.

40. See LeDoux, "Emotion, Memory and the Brain," for the neural mechanism which makes possible alerting with the possibility for no overt reaction.

41. See, for example, Hilton, "Defence-Arousal System."

42. See, for example, J. P. Flynn, "Neural Basis of Threat and Attack," in *Biological Foundations of Psychiatry*, ed. R. G. Grenell and S. Gabay (New York: Raven, 1976), 273–295; A. Siegel and H. Edinger, "Neural Control of Aggression and Rage Behavior," in *Handbook of the Hypothalamus*, vol. 3, *Part B: Be-*

*havioral Studies of the Hypothalamus,* ed. P. J. Morgane and J. Panksepp (New York: Dekker, 1981), 203–240.

43. B. H. Turner, M. Mishkin, and M. Knapp, "Organization of the Amygdalopetal Projections from Modality Specific Cortical Association Areas in the Monkey," *Journal of Comparative Neurology* 191 (1980): 515–543.

44. See P. Langhorst, M. Lambertz, G. Schulz, and G. Stock, "Role Played by Amygdala Complex and Common Brainstem System in Integration of Somatomotor and Autonomic Components of Behavior," in *Organization of the Autonomic Nervous System: Central and Peripheral Mechanisms,* ed. J. Cirello, F. R. Calaresu, L. P. Renaud, and C. Polosa (New York: Alan R. Liss, 1987).

45. Hilton and Redfern, "Does the Hypothalamus?"

46. See Note 18.

47. Cannon, *Bodily Changes,* 194.

48. This assumption is based on the general findings of ethologists as described in Tinbergen, "Social Releasers." See Chapter 4 for further discussion.

49. The menace reflex, which is closing one's eyes as an object approaches the face, is one behavior associated with impending collision with an object. See Landau, *International Dictionary.* See also T. G. R. Bower, J. M. Broughton, and M. K. Moore, "Infant Responses to Approaching Objects: An Indicator of Response to Distal Variables," *Perception and Psychophysics* 9 (1970): 193–196, for a description of a so-called "full" defense reaction in response to a looming object.

50. A. Jolly, *The Evolution of Primate Behavior* (New York and London: Macmillian, 1972).

51. A. D. Blest, "The Function of Eyespot Patterns in the *Lepidoptera,*" *Behaviour* 11 (1957): 209–256; A. D. Blest, "The Evolution of Protective Displays in the *Saturnioidea* and *Sphingidae (Lepidoptera),*" *Behaviour* 11 (1957): 257–309; Richard G. Coss, "Mood Provoking Visual Stimuli: Their Origins and Applications" (master's thesis, University of California Industrial Design Graduate Program, 1965); Nancy E. Aiken, "Human Cardiovascular Response to the Eye Spot Threat Stimulus," *Journal of Evolution and Cognition* (forthcoming).

52. Tinbergen, "Social Releasers"; G. P. Baerends, "Do the Dummy Experiments with Sticklebacks Support the IRM-Concept?" *Behavior* 93 (1985): 258–277.

53. Tinbergen, "Social Releasers."

54. Hilton, "The Defence-Arousal System."

55. D. Lack, *The Life of the Robin,* rev. ed. (London: Witherby, 1946); Tinbergen, "Social Releasers."

## SELECTED BIBLIOGRAPHY

LeDoux, Joseph E. "Emotion, Memory and the Brain." *Scientific American* 270, no. 6 (1994): 50–59.

Young, D. *Nerve Cells and Animal Behavior.* Cambridge: Cambridge University Press, 1989.

# Chapter 6

# The Defense Reaction, Emotion, and Art

Fear has been described as "the normal feeling and behavior that occurs in the presence of threat."[1] If some art startles, causes tingles down the spine, makes palms sweat, hastens the heart beat, or creates anxiousness, then this art is evoking responses associated with the emotion fear. Some of these responses may be conditioned reflexes based on personal or cultural associations. Some of these responses may be, however, unconditioned responses based on naturally occurring reflex actions to particular threat stimuli.

Research that establishes the nature of the defense reaction and the neural mechanism of the portion of the defense reaction called the visceral alerting response supports my contention that certain stimuli evoke emotional response to art because (1) some emotional responses to art are described in the same way that fear or anxiety is described; (2) the neural mechanism for the visceral components of the defense reaction allows semi-independent operation, thus allowing only this portion of the defense response to be evoked; (3) these same visceral components (increased heart rate, blood pressure, etc.) are the same as those responses used to measure fear or stress; (4) these visceral components are considered to be unconditioned responses to threat stimuli; and (5) some of these threat stimuli are found in art.

Preceding chapters established the first four of these reasons. Chapter 2 put articulation of aesthetic response in terms of emotional descriptions. Among the examples are statements that the artwork made observers feel uneasy or anxious. Chapter 5 discusses research that clearly indicates that the cardiovascular responses associated with de-

fense are semi-autonomous from the response as a whole and can be elicited independent of the overt defensive behaviors. Thus, an uneasy feeling evoked by art can be defensive in nature. Throughout, research has been discussed which takes for granted the unconditioned reflexive nature of such responses as increased heart rate evoked by threat and their use as measures of stress, anxiety, and fear. Some of the threat stimuli used to evoke these responses have been mentioned, and the next chapter discusses how some of these are used in art.

This chapter discusses in more detail the links between the defense reaction and fear, and offers a proposed continuum for fear. Finally, it discusses research on the neural substrate for fear. All these discussions lend support to the argument that art evokes emotion reflexively via the triggering of the defense reaction.

## THE DEFENSE RESPONSE AND FEAR

Throughout the discussion of the defense reaction or response in Chapter 5 runs the thread of attached emotional response. In fact, defensive behaviors are often described as emotional behaviors. In 1929, Cannon took the viewpoint that these emotions, as depicted by their concomitant bodily changes, are directed toward efficiency in physical struggle. That is, the defense response is a reflex action which helps preserve the individual's life, and "great excitement" is part of the behavioral pattern.[2] More recently, Brain and Marks concurred with Cannon as they looked at fear as the emotion aroused when the defense reaction occurs.[3] The emotion and the defense response are considered as a unit, as research indicates they should be considered.

Links between emotion and the defense reaction have also been established experimentally. Psychological studies using autonomic responses as measures led researchers such as Sokolov and Lacey and colleagues to propose that increased heart rate should be associated with stimulus "rejection."[4] Graham and Clifton proposed that such instances of increased heart rate were probably indicative of a defense reaction.[5] In a later article, Clifton suggested that heart rate changes may reflect emotional behavior when no overt response occurs.[6] Finally, Nashold and associates found that electrical stimulation of the midbrain periaqueductal gray (PAG; the central nervous system coordinating center for the defense response) of alert human subjects consistently brought forth facial blushing, piloerection, hyperventilation or breathing arrest, and heart rate increases along with feelings of intense fright.[7] Thus, stimulation of the known coordinating center in the midbrain central gray for the defense reaction produces fear in human subjects. In addition, Richardson and Akil found that their attempts to inhibit chronic pain by stimulation of the peraqueductal gray

proved to be effective for the pain, but the strong emotional responses which also occurred warranted its dismissal as a therapy.[8] Thus, besides the wealth of material already discussed, these studies help establish the link between the emotion fear, and the defense reaction.

### A Continuum of Fear

Chapter 5 discussed the defense reaction in terms of behavioral continua. This chapter will discuss fear (as the primary emotion elicited by threat stimuli) as a continuum, because fear is not just one response but a variety of responses which vary in intensity. This variation in intensity levels is important to the understanding of how art can evoke the defense reaction, since art generally evokes only low-intensity responses. This continuum, as seen in Figure 6.1, can be imaginatively superimposed on the flight continuum from Figure 5.1. As intensity on the flight continuum increases, the emotions associated with flight also increase in intensity, and, in this example, associated cardiovascular responses also increase in intensity. Note that this fear continuum might be superimposed over fight or freeze, except that some variations in behaviors appear to exist. For example, heart rate decreases may attend the freeze behavior; therefore, a fear continuum for freeze may be needed.

Cardiovascular responses associated with the defense reaction which can be used to define fear are increased blood pressure and heart rate, vasoconstriction in the skin and kidneys, and vasodilation in skeletal muscle. Hilton calls these changes the visceral alerting response.[9] These responses are described as strong responses accompanying the full defense reaction. An autonomic response to threat need not be a full-blown response. Autonomic responses can vary in intensity, just as overt responses vary in intensity. For example, some research indicates that heart rate may not increase when the response is interpreted as "anxiety" (i.e., heart rate may not increase if the intensity of the response is very low).[10] Consequently, the visceral alerting response is an index of fear,

**Figure 6.1**
**A Fear Continuum (Showing Examples of Some Autonomic Behavioral Responses Associated with Various Stages of Fear)**

| Uneasiness | Anxiousness | Fright | Panic |
|---|---|---|---|

| Blood pressure increases | Heart rate increases | Palmar sweating |
|---|---|---|
| Digital vasoconstriction | Respiratory increases | |
| | Piloerection | |

but when fear is low in intensity, so, too, is the visceral alerting response. Not all of the expected responses may occur, and those that do occur may do so at very low levels. Hilton, no doubt, used high-intensity stimulus situations to evoke responses which would result in high-intensity responses. Low-intensity stimulus situations, such as those found in art, would evoke low-intensity responses. Therefore, the nature of a defense reaction in response to art might consist of only a slight increase in heart rate as part of the fear continuum.

### A Neural Substrate for Fear

Daniel L. Schacter, in *Searching for Memory*, separates types of memories into three catagories: (1) implicit, which includes motor skills and procedural habits; (2) explicit, which are declarative memories, such as the lunch menu for yesterday or the multiplication tables; and (3) emotional memories, which make explicit memories more accurate and permanent.[11] The amygdala is the key structure for the processing and establishment of emotional memories. Research by Antonio Damasio and colleagues demonstrates that emotional conditioning in human beings depends on the amygdala. Damasio and associates paired the sound of a loud horn with a blue colored slide for three patients, one with selective amygdala damage, another with selective hippocampus damage, and another with both amygdala and hippocampus damage. All three patients responded with large skin-conductance responses (an autonomic nervous system response indicating viseral alerting response arousal) to the loud horn. People without brain damage exhibit emotional conditioning after several pairings of the loud horn with the blue slide by responding to the blue slide alone with a large skin-conductance response. The patient with hippocampus damage showed normal emotional conditioning to the blue slide but did not remember the conditioning episode. The patient with amygdala damage could remember the episode but did not show any effects of the conditioning. The patient with damage to both the amygdala and the hippocampus neither recalled the episode nor showed evidence of emotional conditioning. Thus, Damasio concluded that the effects of emotional conditioning depend on the amygdala, and the processing for explicit knowledge (what happened during the conditioning episode) is separate from emotional processing.[12]

Joseph LeDoux and colleagues, working primarily with rats, have been able to follow the neural paths from stimulus to response for fear. A threatening stimulus is perceived by the appropriate sensory system (LeDoux has worked primarily with the auditory system, but has also had similar results with visual system research), and the information is sent to the thalamus. The thalamus forwards sensory in-

formation to the lateral nucleus of the amygdala and the appropriate sensory area of the cortex, with the projections arriving at their desinations at about the same time.

The thalamic fast track to the lateral nucleus of the amygdala projects to the central nucleus of the amygdala, which sends the information to the defense center to coordinate the behaviors of the defense reaction. LeDoux points out that an animal needs to react quickly to danger if it is to survive; thus, the thalamic fast track sets off the visceral alerting response, preparing the individual for action (see Figure 6.2).

LeDoux also points out that the brain must store primitive cues for danger and be able to detect them for efficient adaptive responses to threat stimuli. He suggests that the thalamus may be the storage and detection center for these primitive cues. The thalamus makes matches between incoming sensory information and the stored cues and sends a rough match on to the amygdala, which then sends an alert to the defense coordinating center, the periaquaductal gray. The thalamic information consists of fragments, which are just enough to alert the animal to danger.[13]

I suggest that these fragments are configurations of line, shape, color, and sound (and touch), such as eye spots, zigzags, and loud sounds. I tested fifty Asian and American adults for their cardiovascular response to eye spots, using six slides of various configurations of two or three black circles on a white background. (See Figure 6.3 for the patterns used as stimuli in this test; the eye-spot pattern is number 1 in the figure.) The eye-spot pattern was compared to the other patterns on the basis of heart rate, blood pressure, and finger pulse volume change. Results were significant for heart rate and finger pulse volume. That is, the cardiovascular responses of the fifty subjects were different for the eye-spot pattern when compared to the other circular patterns.[14] This test lends support to the behavioral response to a presumed primitive cue, which is detected by thalamic neurons that alert the amygdala via the thalamic fast track.

Meanwhile, the sensory cortex has been processing the sensory information sent by the thalamus at the same time it was received by the amygdala (see Figure 6.2). Cortical neurons put together a clear picture of the sensory information and send it to the lateral nucleus of the amygdala. Also, the hippocampus is sending contextual information to the lateral nucleus of the amygdala. When the clear picture in context is put together in the amygdala, the animal is able to fully evaluate the stimulus situation and determine if a threat is actually present.[15] It is at this point that human beings can make the conscious association between stimulus and response and can call it fear. However, when threat stimuli are used in art, the intensity level is usually low and the effect is, therefore, fleeting, so that conscious association seldom occurs.

Figure 6.2
Neural Pathways of Fear

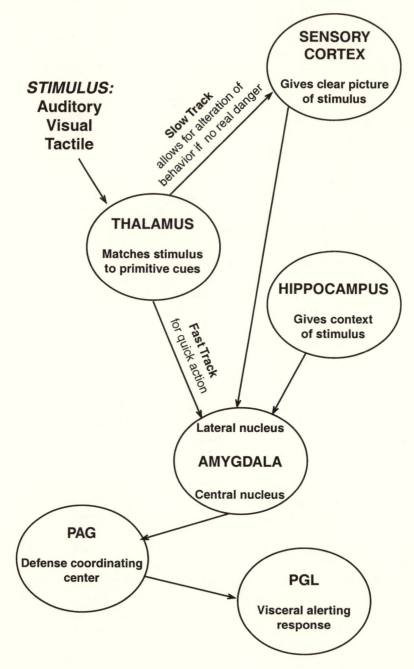

STIMULUS:
Auditory
Visual
Tactile

SENSORY CORTEX

Gives clear picture of stimulus

Slow Track
allows for alteration of behavior if no real danger

THALAMUS

Matches stimulus to primitive cues

HIPPOCAMPUS

Gives context of stimulus

Fast Track
for quick action

Lateral nucleus

AMYGDALA

Central nucleus

PAG

Defense coordinating center

PGL

Visceral alerting response

**Figure 6.3**
**Stimula Used in a Test for Human Response to the Eye-Spot Threat Stimulus**

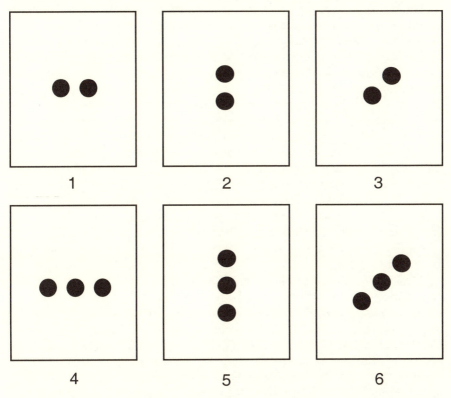

*Source*: Adapted from Richard G. Coss, *Mood Provoking Stimuli: Their Origins and Applications* (Los Angeles: UCLA Industrial Design Graduate Program, 1965).

LeDoux points out that the fast track to the amygdala allows the appropriate response to begin (activates the defense reaction) before we can recognize what is happening. This portion of the neural substrate for fear is preconscious.[16] Thus, this portion of the fear pathway can be activated and deactivated by cortical and hippocampial information without our realizing what occurred. If a work of art activates the visceral alerting response, the cortical clear picture and the hippocampial contextual information notify the amygdala that we are not in danger. Because the thalamic relay works at the preconscious level, we are left with the remains of a feeling which we are unable to name. This is one of the things that happens when we respond to art, and this is why Kant called aesthetic response a special response dif-

ferent from other emotional responses.[17] As argued in Chapter 2, this response is not a special response peculiar to art; it is part of ordinary emotional response, but because it is vague and difficult to name, it assumed an identity of its own: aesthetic response.

The thalamic fast track to the amygdala is the working mechanism of the Pavlovian unconditioned stimulus response. It is what makes possible conditioned responses. LeDoux points out that the amygdala processes unconditioned stimuli so that conditioning can take place, thus expanding the range of stimuli that can activate the defense or other reactions. Except for the hardwired responses to the primitive cues, the amygdala draws upon stored conditioned information to evaluate the significance of incoming sensory data. The removal of the amygdala means that no new emotional associations can be made.[18] Intact amygdalas mean that human beings can be conditioned to new emotional associations, and these associations can also be used in art to evoke emotional responses (e.g., huge posters of Lenin in Moscow's Red Square, the "Star-Spangled Banner," and the flag).

William James wrote, "An experience may be so exciting emotionally as almost to leave a scar on the cerebral tissues."[19] He was right. Research by James McGaugh supports James's assertion. Emotionally exciting stimulation activates the release of adrenal epinephrine, along with other stress-related hormones, which cause the circuit to "sizzle" in the amygdala and sites activated by the amygdala. These sites regulate the storage of long-term memories of emotionally exciting experiences. Moreover, the more exciting the experience, the stronger the memory.[20] Furthermore, classically conditioned emotional memories are rapidly acquired and are indelible. They can be suppressed but never erased.[21] The implications of this research for art will be discussed in Chapter 9. Chapter 7 discusses studies of some of the stimuli I suspect are primitive cues which appear to trigger reflexive response in humans and shows how these are used in art to produce emotional responses.

## NOTES

1. I. M. Marks, *Fears, Phobias, and Rituals: Panic, Anxiety, and Their Disorders* (New York and Oxford: Oxford University Press, 1987), 24.

2. W. B. Cannon, *Bodily Changes in Pain, Hunger, Fear and Rage: An Account of Recent Researches into the Function of Emotional Excitement*, 2d ed. (New York and London: D. Appleton, 1929).

3. P. F. Brain, "A Historical Look at the Concepts of Fear and Defence, and some Comments on Psychobiology," in *Fear and Defence*, ed. P. F. Brain, S. Parmigiani, R. J. Blanchard, and D. Mainardi (New York: Harwood Academic, 1990), 1–22; Marks, *Fears, Phobias, and Rituals*.

4. E. N. Sokolov, "Neuronal Models and the Orienting Reflex," *The Central Nervous System and Behavior: Transactions of the Third Conference* (New York:

Josiah Macy Foundation, 1960), 187–276; E. N. Sokolov, *Perception and the Conditioned Reflex* (New York: Macmillian, 1963); J. Lacey and B. C. Lacey, "The Relationship of Resting Autonomic Activity to Motor Impulsivity," *The Brain and Human Behavior* (Baltimore: Williams & Wilkins, 1958), 144–209; J. Lacey, J. Kagan, B. C. Lacey, and H. A. Moss, "The Visceral Level: Situational Determinants and Behavioral Correlates of Autonomic Response Patterns," in *Expression of the Emotions in Man*, ed. P. Knapp (New York: International Universities Press, 1962), 161–196.

5. F. Graham and R. K. Clifton, "Heart-Rate Change as a Component of the Orienting Response," *Psychological Bulletin* 65 (1966): 305–320.

6. R. K. Clifton, "The Relation of Infant Cardiac Responding to Behavioral State and Motor Activity," in *Minnesota Symposia on Child Psychology*, vol. 11, ed. W. A. Collins (Hillsdale, N.J.: Lawrence Erlbaum Associates, 1978), 64–97.

7. B. S. Nashold, W. P. Wilson, and D. G. Slaughter, "Sensations Evoked by Stimulation in the Midbrain of Man," *Journal of Neurosurgery* 30 (1969): 14–24.

8. D. E. Richardson and H. Akil, "Pain Reduction by Electrical Brain Stimulation in Man. Part 1: Acute Administration in Periaqueductal and Periventricular Sites," *Journal of Neurosurgery* 47 (1977): 178–183.

9. S. M. Hilton, "The Defence-Arousal System and its Relevance for Circulatory and Respiratory Control," *Journal of Experimental Biology* 100 (1982): 159–174.

10. C. H. Folkins, "Temporal Factors and Cognitive Mediators of Stress Reaction," *Journal of Personality and Social Psychology* 14 (1970): 173–184; U. Lundberg, G. Ekman, and M. Frankenhaeuser, "Anticipation of Electric Shock: A Psychophysical Study," *Acta Psychologica* 35 (1971): 309–315.

11. Daniel L. Schacter, *Searching for Memory* (New York: Basic Books, 1996).

12. See ibid., 214; A. Bechara, D. Tranel, H. Damasio, R. Adolphs, C. Rockland, and A. R. Damasio, "Double Dissociation of Conditioning and Declarative Knowledge Relative to the Amygdala and Hippocampus in Humans," *Science* 269 (1995): 1115–1118.

13. See Joseph E. LeDoux, "Emotion as Memory: Anatomical Systems Underlying Indelible Neural Traces," in *The Handbook of Emotion and Memory: Research and Theory*, ed. S. Christianson (Hillsdale, N.J.: Lawrence Erlbaum Associates, 1992); Joseph E. LeDoux, "Emotion, Memory and the Brain," *Scientific American* 270, no. 6 (1994): 50–59.

14. Nancy E. Aiken, "A Biological Basis for the Emotional Impact of Art" (Ph.D. diss., Ohio University, 1992); Nancy E. Aiken, "Human Cardiovascular Response to the Eye Spot Threat Stimulus," *Journal of Evolution and Cognition* (forthcoming).

15. LeDoux, "Emotion as Memory"; LeDoux, "Emotion, Memory and the Brain."

16. LeDoux, "Emotion as Memory"; LeDoux, "Emotion, Memory and the Brain."

17. Immanuel Kant, *Critique of Judgment*, trans. J. M. Bernard (New York: Hafner, 1951).

18. LeDoux, "Emotion as Memory," 276–277.

19. William James, *The Principles of Psychology* (New York: Henry Holt, 1890), 670.

20. James L. McGaugh, "Affect, Neuromodulatory Systems, and Memory Storage," in *The Handbook of Emotion and Memory: Research and Theory*, ed. S. Christianson (Hillsdale, N.J.: Lawrence Erlbaum Associates, 1992), 245–268.

21. LeDoux, "Emotion as Memory," 279.

## SELECTED BIBLIOGRAPHY

Aiken, Nancy E. "Human Cardiovascular Response to the Eye Spot Threat Stimulus." *Journal of Evolution and Cognition* (forthcoming).

Brain, P. F., S. Parmigiani, R. J. Blanchard, and D. Mainardi, eds. *Fear and Defence*. New York: Harwood Academic, 1990.

LeDoux, Joseph E. "Emotion as Memory: Anatomical Systems Underlying Indelible Neural Traces." In *The Handbook of Emotion and Memory: Research and Theory*, ed. S. Christianson. Hillsdale, N.J.: Lawrence Erlbaum Associates, 1992.

———. "Emotion, Memory and the Brain." *Scientific American* 270, no. 6 (1994): 50–57.

Schacter, Daniel L. *Searching for Memory*. New York: Basic Books, 1996.

*Chapter 7*

---

# Threat Stimuli Used in Art

In Chapter 6, fear was discussed as part of the defense reaction which occurs when organisms respond to threat. The description included how fear can vary from vague uneasiness to outright horror. Also described was how the stimulus situation affects the intensity and kind of response, so that a weak stimulus situation may result in a weak response, such as vague uneasiness. A somewhat stronger stimulus situation could produce piloerection, increased heart rate, and sweating palms. Both strong and weak responses, such as uneasiness, anxiety, tingles down the spine, increased heart rate, and sweaty palms, can be evoked by art. I propose that art uses many of the same releasers that are present in natural stimulus situations to evoke these responses.

In this chapter, some of the releasers that are used in art to evoke fear will be discussed in some detail. First, eye spots, alarm calls and predator howls, and pointed versus curved shapes will be considered. These have been relatively well researched, and the discussion will demonstrate their meaningful and affective nature as evidenced in research studies. Their effect is similar, whether in a natural situation or in an aesthetic situation, except that the effect may be weakened in the latter. Some other releasers used in art also will be discussed briefly. Though the emphasis here is on threat stimuli, releasers of other emotions are also used in art, and some of these will also be discussed.

## SPECIFIC THREAT STIMULI WHICH
## MAY BE USED IN ART

### Eye Spots

*Eye Spots as Triggers of the Defense Reaction*    Animal literature demonstrates that eye spots are threatening to a variety of species of insects, amphibians, birds, and mammals. Eye spots have been described as "terrifying masks" which serve to "bluff" enemies (see Figure 7.1).[1] Blest demonstrated experimentally that passerine birds respond to eye spots. He placed dead mealworms on a box and allowed the birds (yellow buntings, chaffinches, and great tits) to feed on them. When each bird alighted on the box to eat, a bulb below the mealworm was lit, revealing one of several patterns. The birds flew away from the pattern that most closely resembled the eyes of a vertebrate more often than they did from other circular patterns, parallel lines, or crosses.[2] Marks notes in his review of fears and phobias that this avoidance of eye spots is probably innate, since birds reared in isolation will exhibit this behavior.[3]

Redican suggests that a fixed and direct stare is a threat for primates.[4] The behavioral reaction can be manifested in many ways. Coss found that a group of fifteen men and fifteen women showed more pupillary dilation and brow movement (theoretically indicating negative affective arousal) to slides of two horizontally placed circles, compared to one circle or two or three diagonally or vertically placed circles.[5] Kleinke and Pohlen found that heart rate increases significantly for adult human subjects who hold eye contact compared to those who do not hold contact.[6] Sackett raised monkeys in isolation and then showed them slides of "threatening faces," which resulted in the monkeys becoming "greatly disturbed."[7] Sometimes the reaction to a fixed stare is a grimace or a "fear grin," which is associated with a submissive attitude. Andrew describes the fear grin in several primate species, including man, in response to threat.[8]

This last response, a fear grin, probably relates to research which is perplexing unless an ethological view point is adopted. Spitz and Wolf found that human infants aged two to six months consistently, across races, smiled in response to a human face, even a face which would inspire fear in an adult. Spitz and Wolf noted that if one eye on the stimulus face were covered, the infants did not smile.[9] Though Spitz and Wolf did not draw this conclusion, it seems reasonable, given the studies just discussed, to interpret these responses as fear grins triggered by eye spots. The lack of a smile in response to one eye and the smile in response to the fearsome face seem to especially support this contention. This interpretation fits the results of the experiments better than does the conclusion that infant smiles are a positive reaction

**Figure 7.1**
**Moths and Butterfly with Eye Spots on Their Wings**

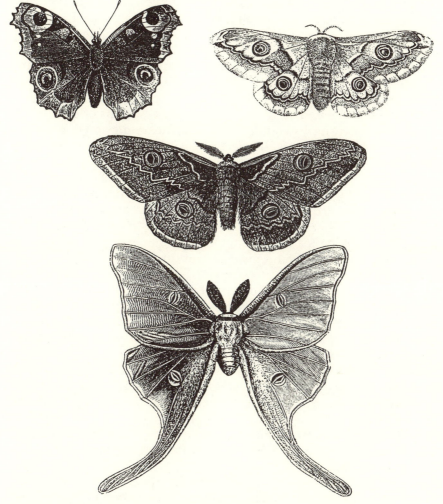

*Source*: Jim Harter, *Animals* (New York: Dover, 1979).

*Note*: When the insects' wings are folded at rest, only one set of eye spots would be visible. If disturbed, the insects unfold their wings, revealing more "eyes."

to a human face, since the fear grin is a primate response to threat. In this instance, the eyes may be a threat stimulus and the grin is the fear grin indicative of a submissive attitude. Though Spitz and Wolf did use just an oval shape with eye spots to elicit a smile in infants, it would be interesting to measure infants' response to eye spots using ethological methodology and cardiovascular measures.

I used ethological methodology and cardiovascular measures in a test of adult human beings' response to eye spots (as mentioned in Chapter 6). Fifty adult Asian and American men and women viewed slides of eye spots and other circular configurations (see Figure 6.3) while their heart rate, relative blood pressure, and finger pulse volume were measured. Since the direction of cardiovascular measures— for example, heart rate increases rather than decreases—in response to threat have been questioned (see the discussion in Chapter 5 on flight and freeze responses), I looked only for a different response to the eye spots as compared to the other configurations of circles. The results were statistically significant for both heart rate and finger pulse volume. Moreover, the results were consistent for all fifty subjects, regardless of their cultural background or gender.[10]

These studies are just a few of the many experiments which point to eye spots as triggers of fear in many species, including the human species. This particular releaser has been well researched and, though more work with humans would be helpful, it is regarded as a potent trigger for evoking fear. It is quite possible that eye spots are used in art to trigger an emotion on the fear continuum.

*Eye Spots in Art*   Coss suggests that "the evolutionary development of human sensitivity to specific visual releasers may have influenced primitive and prehistoric cultures to select specific patterns for incorporation as decorative elements." He further suggests that the reason these particular patterns, eye spots among them, were selected was the emotional power of the pattern.[11] Eye spots are probably best exemplified in art by portraits and masks, each notable for their usual emphasis on the eyes and, for masks, their magical intent. In fact, we tend to look at the eyes more than other parts of the face. Yarbus traced eye movements of people who looked at a photograph of a girl's face for one minute. The traced movements concentrate on the eyes; in fact, half of the fixations were on the eyes. We tend to say such portraits as that used by Yarbus are "compelling."[12]

Masks sometimes greatly exaggerate the eyes. In an informal presentation to students, I asked how slides of masks from the Ivory Coast, the Congo, and Alaska, which I had selected for their emphasis on the eyes, made them feel. Though I made no attempt to isolate the eyes (so other features of the masks could have had an effect), the students unanimously agreed that these masks made them feel disconcerted or uneasy.

According to Eibl-Eibesfeldt and Sutterlin, the staring face is used to ward off evil because it is "aggressive" and "evokes arousal." The authors illustrate their assertion with architectural art from European churches showing faces with prominent bulging eyes. These faces tend to adorn or protect entrances and pulpits.[13]

Many works by Pablo Picasso are notable for the emotional meaning conveyed by the eyes. One of the most striking examples is *Les Demoiselles d'Avignon* of 1907, in which Picasso put to use what he had learned about the effect of eyes in masks. He had recently discovered African art and obviously felt the effects of the masks, since the faces of his "ladies" are depicted as masks with great, staring eyes. Picasso's artist friend, Georges Braque, reportedly told Picasso that "*Les Demoiselles d'Avignon* was painted with ignited gasoline, and he at first shied away from it."[14] Picasso himself reiterates my point about the effect of the masks. He said, in discussing the African masks that he had seen for the first time at the Trocadero, "They were magic things . . . threatening spirits. . . . I understood what the Negroes used their sculpture for. . . . They were weapons . . . spirits, the unconscious . . . emotion— they're all the same thing. I understood why I was a painter. . . . *Les Demoiselles d'Avignon* must have come to me that very day."[15] Picasso spoke intuitively about what I have been attempting to explain in the previous chapters and here. The masks that he saw had immediate threatening meaning, possibly due to the eye spots and pointed shapes, which will be discussed in the next section. He realized the implications (in his words, they could be used as weapons) and, as Leighten put it, Picasso then proceeded to attack "the forms and genres of traditional art [with] unprecedented violence."[16]

Visual art is replete with examples of eye spots. Works from the earliest times to the present use them. The examples given are just a few of the ways they have been used. Usually it is not eye spots alone that contribute to the emotional effect of masks or portraits, for example. Other configurations of line, shape, color, or sound also can be used to evoke the total emotional effect. Recall that more than one releaser often contributes to the stimulus situation. It may work the same way in art; many releasers may be used in one artwork to elicit emotional response. One which Picasso used more than once is the pointed shape.

### Pointed Shapes versus Curved Shapes

Lindauer calls the feeling value of line, shape, color, or sound *physiognomy*. He makes it clear that physiognomy is a "property of the stimulus that initiates our response to art" and that it has nothing to do with learned associations. The feelings which arise in the observer "arise spontaneously and directly and are felt to be in the work itself."[17] I suggest that Lindauer is writing about the same thing that I am; he, however, calls the phenomenon physiognomy whereas I argue that part of the emotion that occurs in response to art occurs because releasers are present in the art and they evoke emotion. Lindauer continues by comparing what he calls physiognomic stimuli to nonphysiognomic stimuli

(I call the physiognomic stimuli releasers, and the nonphysiognomic stimuli non-releasers) in an attempt to demonstrate that people will match a specific feeling value to the physiognomic stimuli/releasers more often than could happen by chance, and that feeling values are matched to nonphysiognomic/nonreleasers on a random basis. He compared a pointed shape and a curved shape to saturation values of red, green, yellow, and blue. He found that highly saturated colors were matched to the pointed shape and lower saturated colors were matched to the curved shape more often than could happen by chance. Unfortunately, his experiment, though interesting, did not test his theory, since no feeling values were involved. Let us, then, take a look at this theory in terms of some relevant work.

The shapes used by Lindauer in his matching study were the shapes used by the famous Gestalt psychologist, Wolfgang Köhler, who asked subjects to match the shapes to the sounds made when saying "maluma" and "takete," two nonsense words not part of the languages of the people tested. His subjects matched maluma to the curved shape and takete to the pointed shape without hesitation, leading Köhler to conclude that the nonsense words and shapes share similar Gestalts.[18] Davis replicated the experiment using native children from the Mahali peninsula in Lake Tanganyika and English school children, with results similar to those of Köhler.[19] Figure 7.2 shows the drawings used by Köhler in his experiment, by Davis in his replication, and by Lindauer.

So far in this discussion we can see the difference in the two drawings, and research indicates that this difference somehow relates to other differences in sounds and color saturations. Implied in this work is the idea that these different shapes have different feeling values, though these experiments do not actually test for this. Now let us look at two earlier studies which demonstrate a more direct link between affect and the shapes of lines.

In 1921, Lundholm asked if the "affective character" of a line is part of the line itself or is suggested by literary meaning. Lundholm used groups of roughly synonymous adjectives and asked his eight subjects to draw lines matching the words. The results indicated to Lundholm that there is a "feeling tone connected with pure lines, which is perceived by a majority of observers."[20] The lines which were drawn by the eight subjects could be grouped roughly into curves and angles, with big curves matched to sad, quiet, lazy, dead, gentle, and serious 69 to 100 percent of the time; 84 percent of these lines had a downward direction for sad. Lines with small angles were drawn to represent furious 21 percent of the time, agitating 14 percent of the time, and hard 46 percent of the time. Lines with small angles and small curves were drawn to represent agitating and furious 70 percent and 64 percent of the time, respectively. Conversely, angles of any size were

**Figure 7.2**
**Köhler's Takete and Maluma Shapes**

takete

maluma

*Source*: Wolfgang Köhler, *Gestalt Psychology* (New York: Liveright, 1947), 225. Used by permission.

never drawn to represent sad or quiet or lazy, and curves were used to represent agitating and furious 7 percent or less of the time. This appears to be evidence of some perceived affective difference between angles and curves. Add this evidence to the cross-modal differences found by Köhler, Davis, and Lindauer, and what does it mean? It means that curved lines and angled lines are probably releasers of specific emotional responses. Look at some of the "introspective comments" made by Lundholm's subjects: "Sharp angles are unpleasant, sharp angles

hurt, small angles are cruel, curves denote grace and beauty, serenity and kindness."[21] These comments indicate that the emotion fear is connected to sharp angles, and feelings of security are connected to curves.

A follow-up study to Lundholm's study used not eight people but 500 "educated people." Poffenberger and Barrows used predrawn lines based on the lines drawn by Lundholm's subjects and the same classes of adjectives as Lundholm had used. The lines given the subjects are those shown in Figure 7.3. The 500 subjects chose lines from this group (choices could be used over again) to match to thirteen classes of feelings. These were, classed by their primary adjective, sad, quiet, lazy, merry, agitating, furious, dead, playful, weak, gentle, harsh, serious, and powerful. The results agreed with those of Lundholm completely for the adjectives sad, quiet, lazy, merry, playful, and harsh. Sad, quiet, and lazy are represented by big curves. Merry and playful are represented by small and medium curves, and harsh is represented by small and medium angles. Whereas Lundholm found the small angles represent agitating and furious, Poffenberger and Barrows found small and medium angles represent them both. Lundholm found that big curves represented gentle 75 percent of the time, whereas Poffenberger and Barrows found that big, small, and medium curves represented gentle. The key finding is the overwhelming agreement on the difference between angles and curves in terms of feeling value.[22]

More recently, Johanna Üher tested 1,100 European adults for the affective value of zigzag or angular lines and curved lines. She used twenty-four pairs of adjectives, such as hard–soft, tense–relaxed, restless–tranquil, hostile–friendly, and harsh–gentle, and asked the subjects to match zigzag lines and curved lines to them. Her results confirm the findings of Lundholm and Poffenberger and Barrows.[23]

Besides these tests matching affective adjectives to angled and curved lines, there is a test for autonomic response to these stimuli. Richard Coss conducted tests using pupil dilation as the dependent variable with curved and sharp angled lines similar to those in Figure 7.3 as the stimuli. Coss found that the amount of pupil dilation in response to these stimuli was significantly different.[24]

The studies discussed provide evidence to support the notion that there is a difference in the affective value of sharp angles and curves. Poffenberger and Barrows quote an aesthetician named Cox in their introduction, and I repeat that quote here, since it indicates the pervasiveness of an affective difference between angles or pointed shapes and curves: "Straight lines will always express rigidity and stiffness while curves will express some sort of growth or motion. The vertical line is a line of stability, of strength and vigor. . . . All these characteristics of lines may be the result of association or they may have some deeper reason, but they are there, in the lines themselves, without re-

**Figure 7.3**
**Lines Matched to Affective Adjectives in the Poffenberger and Barrows
Study of 1924**

*Source*: A. T. Poffenberger and B. E. Barrows, "The Feeling Value of Lines," *Journal of
Applied Psychology* 8 (1924): 192.

gard to what the lines may be used to represent, and are the most
valuable means to artistic expression."[25]

If the feeling value of lines is used to express emotion in art, we
should be able to distill some paintings to their linear qualities and
judge them according to the quality of the line and the emotions felt

when observing them. Rudolf Arnheim traced the lines in a Cézanne still life and a Picasso still life to make just such a comparison. Figure 7.4 shows Arnheim's linear abstractions from the two still lifes.

Arnheim describes the Cézanne with terms such as "order, symmetry, roundness, and softness." He asks us to compare "this image of prosperous peace with the catastrophic turmoil in Picasso's work [where] the contours tend to be hard, sharp, lifeless."[26]

Two more examples of art from these two painters provide another example of the differences between the affective tone of curved lines and angled lines or curved shapes and pointed shapes. In Figure 7.5, I have traced reproductions of the *Small Bathers* by Cézanne and *Les Demoiselles d'Avignon* by Picasso. The subject matter of both paintings is a group of nude women; the composition or internal form is very similar. However, the emotions evoked by the two paintings are very different because of the treatment or the shapes chosen to illustrate the women. At the time these paintings were made (the Cézanne is a few years older), the Picasso provoked a storm of controversy because of the way the nudes were painted. Their faces are depicted as masks, as mentioned, and their bodies are drawn with pointed shapes. Today, we are not excited by the newness of the treatment, since we have seen many other Picassos and other distortions of the human figure. Nevertheless, the emotional effect evoked by the Picasso can still be described as anxiousness or uneasiness. The "young ladies" are still quite threatening, and their threat appears to lie in the manner of their depiction. Their pointed shapes may trigger an emotional response on the fear continuum; their eyes, as discussed, very likely trigger an emotional response on the fear continuum.

Turning from Picasso and Cézanne to other painters and to what respected aestheticians and critics have to say about some of their works, we see that curves and serenity and angles or pointed shapes and threat are means of expression in other works. Munro, writing about Vincent Van Gogh's mature paintings, has this to say: "They glare, blaze and clash with barbaric exuberance. Such discords are not to be dismissed as bad art: children and primitive peoples, and moderns that have grown used to them, find them pleasantly vigorous and stimulating. The bizarre distortions of shape in Van Gogh's later works are in the same excited spirit. As in an El Greco, everything is made to writhe and zig-zag in nervous agitation."[27] Zigzags are what the subjects in the Lundholm and Poffenberger and Barrows studies matched to the adjective agitating. Here, Munro uses such words as agitation, vigorous, stimulating, and barbaric exuberance. Though he is writing not only of the linear qualities of Van Gogh's paintings but also the color, the "nervous agitation" in these paintings is derived primarily from the zigzagging lines.

Clark comments on the "Mala Noche," a plate from Goya's *Caprichos* series. He writes, "We are frightened by the shape of the fluttering

**Figure 7.4**
**Arnheim's Linear Abstractions of Two Still Life Paintings**

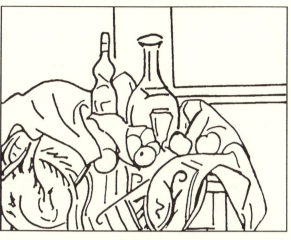

(a)

(b)

*Source*: Rudolf Arnheim, *Art and Visual Perception: A Psychology of the Creative Eye. The New Version* (Berkeley and Los Angeles: University of California Press, 1965), 375. Copyright © 1974 The Regents of the University of California. Used by permission of The Regents of the University of California and the University of California Press.

*Note*: The Cézanne (a) should be compared to the Picasso (b) on the basis of the linear quality (i.e., curves versus angles).

scarf . . . even when nothing particularly alarming is going on." Clark continues by explaining that if the plates in this series did nothing more than illustrate the "perfectly banal" text which Goya wrote to explain the series, "They would not frighten us at all. . . . Whereas they

**Figure 7.5**
**Linear Abstractions of Two Paintings**

(a)

(b)

*Note*: The Cézanne (a) and Picasso (b) should be compared for the curving versus the angular quality of the lines. Note the eye spots in the Picasso.

are a series of archetypal nightmares, in which the shadows on the nursery wall do really turn into a man hanging on a gibbet or a congress of goblins."[28] The plates in the series are generally of everyday, banal subjects. In the case of the "Mala Noche," it is a dark and windy night but two women appear to be simply standing in the wind as if they were waiting on a bus. The linear quality of the white scarf is what frightened Kenneth Clark. I have traced the outline of the white elements in "Mala Noche" from a plate in Clark's book. This outline is shown in Figure 7.6; it is easy to see the pointed quality of the shapes.

Both Munro and Clark have interesting things to write about Goya's *The Third of May* or *The Shooting*. Clark writes, "It is . . . a grim reflection on the whole nature of power. . . . He has contrasted the fierce repetition of the soldiers' attitudes and the steely line of their rifles, with the crumbling irregularity of their target." Coming on *The Third of May* in the Prado after seeing paintings by Titian, Rubens, and Velázquez, "It deals a knock-out blow."[29] Munro writes that the painting has a "power" of "stark, gripping terror." He explains how this is expressed, and among the ways are the lines: "There is no grace of line or decorative pattern: only the contrast of one group killing and one being killed. The rhythm is jerky, stiff, staccato, of broad blunt limbs in v-shaped angles."[30] Notice that both Clark and Munro describe this painting with words such as "terror," "fierce," and "v-shaped angles." The words, the feelings, and the linear quality are equated.

Furthermore, Clark compares the Goya to a Manet of similar design and subject matter (actually a study for a large version which Manet cut up, presumably because he was not happy with it). I have reduced these paintings to their linear abstractions in Figure 7.7 so that what Clark writes might be more clearly understood. Clark contrasts the two paintings by writing the passage already quoted about the Goya and the following about the Manet: It is "flat and inexpressive."[31] Clark continues by pointing out that the Manet does nothing to reveal the horror of such an execution, whereas, of course, the Goya does everything to express terror. Look at the difference in the quality of the line. The Goya has those v-shaped angles; the Manet is composed of verticals and horizontals. The implication is that the former expresses fear and the latter does not.

## Alarm Calls and Predator Howls

In 1857, Herbert Spencer suggested that the underlying principle in all vocal phenomena is the pleasure or pain which comes from exercising muscles used in vocalization and the attachment of feeling to some passing sensation. For example, loud sounds are the result of strong feelings, such as extreme pain accompanied by loud shrieks. Spencer

**Figure 7.6**
**Linear Abstraction of Goya's "Mala Noche"**

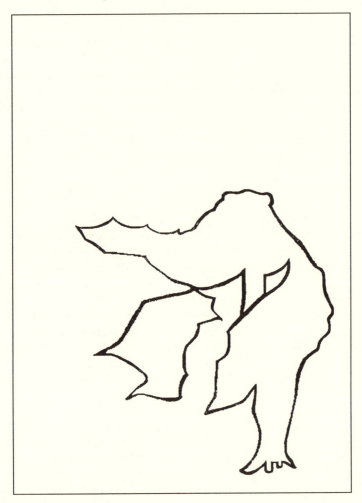

writes that the "distinctive traits of song are simply the traits of emo-
tional speech intensified and systematized." Spencer sums his theory, "If
music, taking for its raw material the various modifications of voice which
are the physiological results of excited feeling, intensifies, combines, and
complicates them; if it exaggerates the loudness, the resonance, the
pitch, the intervals, and the variability, which are the characteristics of
passionate speech; if, by carrying out these further, more consistently,
more unitedly, and more sustainedly, it produces an idealized language
of emotion; then its power over us becomes comprehensible."[32]

are a series of archetypal nightmares, in which the shadows on the nursery wall do really turn into a man hanging on a gibbet or a congress of goblins."[28] The plates in the series are generally of everyday, banal subjects. In the case of the "Mala Noche," it is a dark and windy night but two women appear to be simply standing in the wind as if they were waiting on a bus. The linear quality of the white scarf is what frightened Kenneth Clark. I have traced the outline of the white elements in "Mala Noche" from a plate in Clark's book. This outline is shown in Figure 7.6; it is easy to see the pointed quality of the shapes.

Both Munro and Clark have interesting things to write about Goya's *The Third of May* or *The Shooting*. Clark writes, "It is . . . a grim reflection on the whole nature of power. . . . He has contrasted the fierce repetition of the soldiers' attitudes and the steely line of their rifles, with the crumbling irregularity of their target." Coming on *The Third of May* in the Prado after seeing paintings by Titian, Rubens, and Velázquez, "It deals a knock-out blow."[29] Munro writes that the painting has a "power" of "stark, gripping terror." He explains how this is expressed, and among the ways are the lines: "There is no grace of line or decorative pattern: only the contrast of one group killing and one being killed. The rhythm is jerky, stiff, staccato, of broad blunt limbs in v-shaped angles."[30] Notice that both Clark and Munro describe this painting with words such as "terror," "fierce," and "v-shaped angles." The words, the feelings, and the linear quality are equated.

Furthermore, Clark compares the Goya to a Manet of similar design and subject matter (actually a study for a large version which Manet cut up, presumably because he was not happy with it). I have reduced these paintings to their linear abstractions in Figure 7.7 so that what Clark writes might be more clearly understood. Clark contrasts the two paintings by writing the passage already quoted about the Goya and the following about the Manet: It is "flat and inexpressive."[31] Clark continues by pointing out that the Manet does nothing to reveal the horror of such an execution, whereas, of course, the Goya does everything to express terror. Look at the difference in the quality of the line. The Goya has those v-shaped angles; the Manet is composed of verticals and horizontals. The implication is that the former expresses fear and the latter does not.

### Alarm Calls and Predator Howls

In 1857, Herbert Spencer suggested that the underlying principle in all vocal phenomena is the pleasure or pain which comes from exercising muscles used in vocalization and the attachment of feeling to some passing sensation. For example, loud sounds are the result of strong feelings, such as extreme pain accompanied by loud shrieks. Spencer

**Figure 7.6**
**Linear Abstraction of Goya's "Mala Noche"**

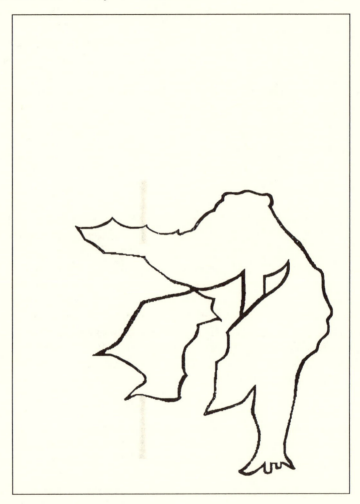

writes that the "distinctive traits of song are simply the traits of emo-
tional speech intensified and systematized." Spencer sums his theory, "If
music, taking for its raw material the various modifications of voice which
are the physiological results of excited feeling, intensifies, combines, and
complicates them; if it exaggerates the loudness, the resonance, the
pitch, the intervals, and the variability, which are the characteristics of
passionate speech; if, by carrying out these further, more consistently,
more unitedly, and more sustainedly, it produces an idealized language
of emotion; then its power over us becomes comprehensible."[32]

**Figure 7.7**
**Linear Abstractions of Two Similar Compositions**

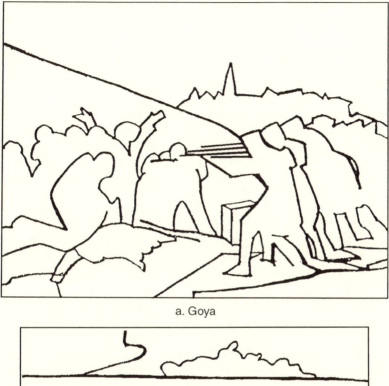

a. Goya

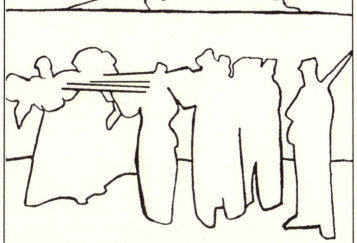

b. Manet

*Note*: The Goya (a) is more angular than the Manet (b).

Years later, in 1906, Parry extended Spencer's idea to include our ability to share in the pleasure of a work of art created by another person. Parry suggests that aesthetic experience has its roots in the excitement shared by the group (perhaps in anticipation of flight) when a member of the group screams an alarm.[33] After Darwin published *Origin of Species*, Spencer replied to Darwin's assertion that music arose from the sounds which the male makes during the excitement of courtship by writing a postscript to his 1857 essay in which he makes a more general claim: "I have aimed to show that music has its germs in the sounds which the voice emits under excitement, and eventually gains this or that character according to the kind of excitement."[34] It is possible that an obvious adaptive response such as alerting at the sound of an alarm call by a conspecific or the howl or growl of a predator could be successfully transferred to musical sound with similar emotional effect. In fact, researchers have found that alarm calls and predator howls evoke excitement and are specific in meaning.

*Research Pointing to Calls as Releasers of Defensive Behavior*   Seyfarth and associates found that a meaningful relationship exists for vervet monkeys between the class of predator and the kind of alarm call. For example, a carnivorous predator, such as a leopard, elicits a call that sends monkeys up into the trees and out of danger of being easy prey on the open ground.[35] However, the precise nature of meaning in alarm calls has been questioned. I want to discuss some of this research in order to demonstrate that the calls have meaning and the meaning is one of threat resulting in defensive behavior. Indications are that the calls are acoustic triggers of reflexive behavior which become more precise as to predator reference with experience (for vervets, at least).

Macedonia suggested an alternative interpretation to the Seyfarth research. He suggested that the urgency of the situation may be reflected in the call, and this may be the cue used by conspecifics to determine the specific defensive behavior taken. Whereas Seyfarth and associates predict that alarm calls vary in structure according to the class of predator, the urgency interpretation proposes that alarm calls vary in structure according to the level of response urgency. Macedonia concluded, in order to determine which interpretation is supported by the evidence, that one must provide evidence for referential signaling or meaningfulness of predator class.

Using two species of lemurs, the ringtailed and the ruffed, Macedonia set up an experiment in a natural setting using calls recorded from adult lemurs of the same species during encounters with actual or simulated predators. Only alert individuals at rest or engaged in quiet activities and separated from the other tested species were subjected to the recorded calls. Scoring was accomplished by hidden observers for the first five seconds after the call was played. Two call classes

were used: an "antiraptor call," which was predicted to result in defensive behavior in response to an eagle or other such bird of prey, and an "anticarnivore call," which was predicted to result in defensive behavior in response to mammalian predators. Results of this experiment showed that the ringtailed lemurs' responses support the referential-signal interpretation; that is, the call refers to the specific predator. However, the responses of the ruffed lemurs indicates an interpretation other than the two already proposed: "an aggressive/ defensive disposition" toward a disturbing stimulus; that is, a readiness to fight or flee or a vigilant alerting which is not specific to predator or urgency. In follow-up experiments, Pereira and Macedonia were able to separate referent signaling from urgency signaling and found that the ringtailed lemurs use referent signaling only.[36] The point of discussing these studies here is that there seems to be no question about the meaningfulness of the calls and of the defensive quality of the responses. The researchers are just concerned with sorting out how these calls are meaningful, and they are finding various meanings which can be as precise (for vervets and ringtailed lemurs) as words disclosing the kind of predator. In all meanings, however, these calls mean danger; some ways are just more explicit than others.

In a related study, Hauser and Wrangham tested redtail monkeys, blue monkeys, red colobus monkeys, and the great blue turaco bird, in the Ugandan field, for response differences to the calls of predators, competitors, and noncompetitors. Recorded calls were played when the subjects were in fruiting fig trees and were settled for at least five minutes after speaker placement. No playbacks were made within thirty minutes of a natural call or a sighting of a stimulus species. The stimulus conditions were randomized (predator, competitor, and noncompetitor) for each subject, and the subject's behavior was observed thirty seconds immediately before and thirty seconds immediately after the start of the playback call. The variables of scanning direction, rate, and timing of movement out of and back into the tree were compared for pre- and post-playback and during playback. The results indicated that acoustic cues in the calls were sufficient for these animals to differentiate among these classes: predator, competitor, and noncompetitor.[37] Consequently, indications are that, as antipredator calls have meaning, so do the calls of competitors and noncompetitors.

Research with naïve subjects would lend support to the notion that the responses to these calls are innate. For example, Herzog and Hopf found that infant squirrel monkeys raised in social isolation responded appropriately to their species-specific warning calls upon initial hearing.[38]

Furthermore, Seyfarth and Cheney conducted experiments using vervets and starlings (birds), emphasizing the vervet monkeys' responses to starling alarms. They found that vervets responded to the

alarm calls of the birds. This study would seem to indicate that some quality expressive of threat in alarm calls is recognized across species.[39]

This discussion only concerns studies with species other than the human species, but the studies are provocative because they show how certain combinations of sounds can mean danger, thus evoking fear. Can humans react with fear to some of these same or similar calls? Scherer reviewed various types of calls for a variety of species (unnamed, unfortunately, but including the human species), and found a relationship between pitch and affective state. The calls were matched by human observers to descriptions of emotional quality, such as angry or disgusting. High-pitched calls appear to create anger or fear (and joy in humans). Low-pitched calls appear to evoke contempt or disgust. In addition, Scherer and Oshinsky found that human judgment of affective states based on acoustic cues seems to be the same regardless of language differences. Note that Andrew, in his descriptive monograph on primate calls and facial expressions, discusses striking similarities, especially between chimpanzee and human calls and facial expressions.[40]

Sound configurations which may make a difference include pitch, pitch range and variability, tempo, harmonics, loudness, voice quality (such as harshness), and frequency contour. Scherer cites, in particular, the finding that, for many species (unnamed), high frequencies may characterize aversive states. He notes that he is perplexed, however, that human joy is also expressed by high frequencies.[41] If a more thorough analysis reveals that this is, indeed, the case, perhaps this seeming contradiction between aversion and joy can be explained by the discussion in Chapter 8 on how fear-evoking art can be pleasant. Scherer's work is supportive of the notion that vocal expression and emotion are connected and are fairly consistent across human languages and, even, across different species. Therefore, it is possible that a predator's howl or growl and an antipredator call, even a call of another species, could elicit fear in humans. Also, it seems possible that similar configurations of sound could be used in art to elicit emotions on the fear continuum.

*Alarm Calls and Predator Howls in Art*    At the start of this discussion of alarm calls and predator howls, I noted that Herbert Spencer initially suggested that vocal expressions were used in art to evoke emotion. Early in this century, several investigators studied the effect music has on the emotions. For example, in 1922, Ortmann argued that the root of musical appreciation lies in our physiology. He wrote,

It is true, that the path leading from the simple tone-sensation to the enormously complex reaction, experienced, let us say, when the Philadelphia Orchestra under Stokowski plays Wagner, is neither direct nor single. Yet,

whatever its meanderings and ramifications, it is a psychological continuum, unbroken by any of the popularly postulated gulfs of mystery. If the complex reactions to music cannot yet be explained this failure is not the result of the entrance, at some point or another, of some super-psychological forces, but the result of our inability clearly to trace, throughout its length, the unbroken chain of complex neural response.[42]

Since tracing the neural response was not possible, and measuring physiological reactions was (and is) less than precise, researchers attempted to explore the emotions evoked by music in another way. They asked subjects to report the emotion felt in response to simple melodies and, even, singular notes. For example, in 1928 Sherman asked thirty graduate students to report on the emotions they thought were conveyed by a trained singer who was asked to convey qualities of four emotions—surprise, fear–pain, sorrow, and anger–hate—by singing a fundamental e with the syllable "ah" at intervals of one second over five repetitions. This test was repeated using the fundamental a. Intensity, pitch, and duration were controlled as much as possible, and the singer was screened from view so that there could be no visual cues. A third test used a short melody, a b c b a b c d e d b c a, with the notes presented first in A major and then in A minor. The results showed a "close correspondence" between the emotions of sorrow and anger–hate, as intended by the singer, and the reports of the emotions as understood by the subjects. The other two emotions, as they were intended, and the reports of these emotions, as they were understood by the subjects, were not well correlated. In addition, sorrow was closely connected to the melody in the minor key. This study is suggestive of a relationship between some musical quality, such as the minor key, for example, and the emotion conveyed.[43]

During the same year, Heinlein used a similar methodology to study the effects of the major and minor keys on emotions conveyed by music. He asked subjects to choose a term from a list of descriptive "feeling words" which best described the chords played on a piano. The subjects were free to choose other terms. Some of the terms on the list were bright, dull, soothing, doleful, melancholy, and joyful. Generally, major chords were thought to convey joyfulness and minor chords were thought to convey melancholy. Heinlein varied pitch and intensity of the chords while keeping the keys the same, and found that both pitch and intensity were also factors in conveying emotions. He found that loud chords are rarely soothing and soft chords are frequently soothing, whether they are in major or minor keys. He found that chords in the upper pitch range, either major or minor, were described as bright, cheerful, joyful, clear, and soothing. On the other hand, chords played in the lower pitch range, either major or minor, were described as dull,

gloomy, sad, or dark.[44] This study begins to parse out the elements in music that convey emotion. Note that these elements, pitch and intensity, are similar to the elements that convey meaning in the calls discussed in the work of Seyfarth, Scherer, and others.

Several years after experiments such as those by Heinlein and Sherman had fallen from fashion, Pratt wrote, "In music the presentation of mood is direct, for the way in which the tonal material is put together by the composer constitutes the very essence of auditory mood, the gaiety or the melancholy of the music itself. . . . Music at its best is not symbolic at all. . . . It does not suggest mood and feeling. It *IS* mood and feeling."[45]

Pratt, however, could not extricate himself from the mainstream of aesthetic thinking and concluded that art cannot evoke real emotions. In fact, he asserted that the whole problem of the obvious connection between art and emotion as expressed by Santayana's question of how the emotion gets into the art (see Chapter 2 for a more detailed discussion) could be "neatly and quickly solved if it could be shown that music arouses real emotion in the listener."[46]

Part of Pratt's difficulties with accepting the notion that art does evoke real emotion lies in his definition of emotion. He seemed to think that emotion is solely defined by "visceral commotion," and these physiological changes are not appropriate to describe what he assumed to be the proper disinterest of music appreciation. Also, he assumed that these physiological changes could not be linked to the tonal structure of the music. For example, he concluded that the emotion question could be solved "if it could be demonstrated that the poignant grief of the last movement of the Tschaikowsky 'Sixth' . . . had its origin in the visceral commotion of the audience rather than in the design of the tonal structure."[47] The emotions felt listening to the Sixth Symphony result from unconditioned responses stimulated by certain configurations (releasers) which can be found in the tonal structure of music, and by conditioned responses and cultural associations. The "visceral commotion" results from such stimuli and is part of and not the origin of the emotion felt. The origin of the emotion is the music.

Pratt describes the music of Mozart, Beethoven, Tchaikovsky, and Ravel in terms of some of the emotions which have been discussed as part of the fear continuum and in terms of other emotions. He asserts that, if it could be shown that real emotion were evoked by art, the problem of how art embodies emotion could be solved (note that I do not think that the problem turns on that point, but it was demonstrated in Chapter 2 that art does evoke real emotion). He also asks, if the sadness evoked by art is real, how it is that we find pleasure in that sadness (this question will be addressed in the next chapter). The point here is that the questions asked and the argument presented are ques-

tions and arguments which have already been considered by authorities; the answers simply were not found. However, the so-called problem of expression is solved by showing how emotion evoked by art is real emotion, that it is evoked by releasers and associations found in the art itself, that it is context dependent, and that much of it is preconscious so that we are not able to easily figure out what is happening or why we are reacting the way we do to art. As Pratt writes,

A few people do undoubtedly soak in some sort of emotional bath while listening to the heart-rending measures of Tschaikowsky or to the sickening despair of Ravel; but for every one whose visceral processes are thus aroused there are ninety and nine who in proper psychical distance gladly lend an attentive ear to the sadness of Tschaikowsky and the sorrow of Ravel without themselves descending into any slough of despond. If to hear the intense grief of the fugal passages of the *Eroica* required real tears and adrenal secretions, then an anomalous if not impossible psychological state would have to prevail. The gorgeous clash of dissonant minor seconds which brings the tremendous but short fugue to an incomplete close—several measures of almost unbearable anguish—has been a source of supreme delight to countless lovers of music. How in the very temple of such delight could unveiled misery have her shrine? How can a listener be at once pleased and pained? . . . If the lover of music finds delight in the melancholy of Mozart and the sadness of Beethoven, these qualities must somehow be closely bound up with the music itself, for visceral sorrow and sighing can hardly proceed from the listener who is at the same time filled with pleasure.[48]

In fact, listeners can be at once pleased and pained by music. The next chapter will outline in detail how this is possible, but a discussion of the opening clarinet run from *Rhapsody in Blue* should illustrate this situation.

The opening clarinet run in George Gershwin's *Rhapsody in Blue* is almost certain to result in piloerection (a response on the fear continuum) in the listener if the situation is adequate. That is, if you are attentive, you can reasonably expect to feel a tingle down the spine upon hearing this sequence of notes played on the clarinet. I played a tape recording of the run for a group of people in an informal presentation, and their responses were generally consistent with a tingle down the spine. An interesting comparison might be made between the acoustic qualities of this clarinet run and the acoustic qualities of primate alarm calls and primate predator howls and growls. The clarinet run, it seems, provides a high-pitched version of a growl. Note that Scherer found that comparative studies had shown that several species responded with either fear, anger, or, for humans, joy to high-pitched sounds. Note that Heinlein found that bright, cheerful, joyful, clear, and even soothing were adjectives applied to either major or

minor chords played in the upper pitch ranges. Gershwin, it seems, discovered a very effective mix of pitch combined with acoustic variation to create one of the most attention-grabbing openings in music. It is probably so effective because it has the same releasing qualities of natural alarms or predator growls or howls. It will be explained why it is so pleasurable in the next chapter, but let us look now at a few comments made by people who were present at the first performance of *Rhapsody in Blue*. Ira Gershwin, George Gershwin's brother, wrote about the inspiration for the rhapsody. He wrote that Gershwin was caught by surprise by Paul Whiteman's announcement of a concert of new works by Deems Taylor, Victor Herbert, and George Gershwin. Gershwin had not written his contribution, so "finding in his notebooks a theme (the clarinet glissando) which he thought might make an appropriate opening for a more extended work than he had been accustomed to writing, he decided to chance it. Soon Whiteman was rehearsing *Rhapsody in Blue* and when it was presented at Aeolian Hall [on February 12, 1924] with the composer at the piano, the response was immediate. Soon it was being played all over the world."[49] Olin Downes reviewed the original performance in the next day's *New York Times*. He wrote, "It [the rhapsody] starts with an outrageous cadenza of the clarinet."[50] Unfortunately, Downes leaves us to guess what he meant by outrageous, but my guess is the effect it produces in the autonomic nervous system. Though Ira Gershwin and others who were present at that first performance did not make the connection between the pilomotor reflex and the clarinet glassando, some of their comments are suggestive of this and similar autonomic nervous system responses occurring in the presence of this work. For example, Paul Whiteman wrote about the first performance of the *Rhapsody in Blue*, "The audience was electric. You can feel those things in the back of your neck. I felt it then."[51] Erma Taylor wrote, "It was on September 26, 1898, that . . . Gershwin let out a birth wail that twenty-four and one-half years later would be echoed by the clarinet glissando of *Rhapsody in Blue* [and] when I hear the *Rhapsody in Blue* the blood in my veins stops flowing and my heart stands still."[52] Ms. Taylor was describing fear, but was finding pleasure in it.

It has been established experimentally that music can affect piloerection. Gray played eight pieces of music for fifty men and women who were either hospitalized psychotics or nonhospitalized nonpsychotics and found that they responded with "gooseflesh" to the music to a statistically significant degree. Gray found no statistical difference between the response of men and women, but he did between psychotics and nonpsychotics. The psychotic group responded to the music with more instances of gooseflesh than did the nonpsychotic group (Gray felt that this result may have been confounded, possibly,

by hallucinations). The subjects were asked to raise their hands whenever they felt the gooseflesh during the playing of the following eight pieces: "The Great Gate at Kiev" by Moussorgsky, "Cortège de Bacchus" from the *Sylvia* Ballet Suite by Delibes, "Over the Steppe" by Gretchaninoff, sung by Igor Gorin, "Cloudburst" from *The Grand Canyon Suite* by Grofé, *Schelomo* by Bloch, "Coronation" from *Le sacre du sauvage*, "Ride of the Valkyries" by Wagner, and "Lure of the Unknown Love," sung by Yma Sumac. Fifteen subjects reported no gooseflesh while listening to any of the eight selections, while one subject reported ninety-six occurrences across all eight selections. Thirty-five subjects had at least one occurrence of gooseflesh while listening to the selections. The most occurrences of reported gooseflesh were in response to the fourth selection; that is, all thirty-five who experienced the pilomotor reflex experienced it during the playing of Grofé's "Cloudburst."[53] While this study lacks many controls (e.g., we are not told what portions of these eight selections were played, whether the volume was controlled for each selection, etc.), it does, nevertheless, suggest that the pilomotor reflex is stimulated by music.

In summary, though it cannot be proved that alarm calls and predator howls are used in art, indications are that these and other audio releasers of reflexive response may be used in art. Some researchers have studied the relationship between musical structure or sound and emotions evoked. In 1922, Ortmann argued that the root of musical appreciation lies in our physiology; that is, he realized that there was a direct relationship between the sounds in music and the emotion evoked, and that the reflex which resulted, in increased heart rate, for example, could be traced. Unfortunately, in 1922 the technical capability for tracing this reflex was not available. Other early researchers, such as Sherman and Heinlein, took another more accessible approach to the problem by investigating the relationships between subjects' reports of emotions felt while listening to music and the structure of the music performed. In 1954, an aesthetician, Pratt, wrote that the problem of how art evokes emotion could be "neatly solved" if art could be shown to evoke real emotions. By real emotions, Pratt meant those that could be measured by taking physiological measurements (e.g., monitoring heart rate, blood pressure, electrodermal skin resistance, etc.). Though I do not think the problem of how art evokes emotion can be so "neatly solved," I have tried to answer Pratt and demonstrate that art does evoke real emotions. Also, in answering this question, it can be seen that certain sounds seem to evoke certain physiological events which we translate into emotion.

The example used to demonstrate that art does evoke real physiological events is the tingle down the spine or gooseflesh physiological event caused by the pilomotor reflex as part of the defense response.

This can be evoked by a sound reminiscent of an alarm call or a predator howl. The clarinet glissando at the beginning of Gershwin's *Rhapsody in Blue* is a good example. It seems to quite reliably evoke tingles down the spines of its listeners. Though no experimental research has been done to support this contention other than my informal presentation of the glissando followed by nods of agreement from the audience that they did, indeed, feel the hairs raise on the backs of their necks, Gershwin's contemporaries, writing about the effect the rhapsody had on them, hint that they reacted in a similar way. Moreover, Gray performed an experiment designed to test for gooseflesh in response to music. Thirty-five of his fifty subjects did experience this response to at least one of the selections of music he played for them. Unfortunately, I do not know if the music he played included sounds reminiscent of alarm calls or predator howls. However, the evidence presented here provides hints that musical sounds similar to alarm calls and predator howls evoke physiological responses in listeners.

### The Color Red

Another possible threat stimuli or natural releaser of emotional response on the fear continuum used in art is the color red. In 1925, a reddish pebble, weathered so that it had assumed a face-like appearance, was found in the Transvaal and is now preserved in the Bernard Price Institute for Paleontology, University of the Witwatersrand, Johannesburg (catalog number L1713). Fascinating the archaeologists was the evidence suggesting that the stone may have been carried a great distance by, presumably, ancestors of our species. This, plus evidence demonstrating an interest in red pigment by *Homo erectus*, suggests that art appreciation may precede modern human beings.[54] Robert Brain, in his study of body decoration, comments, "Red may be associated with blood and life." Furthermore, he notes that red "seems to have a special significance everywhere." It is readily procurable, it is the primary color with the longest wavelength perceptible to our retinas, and it is the color of blood.[55] Researchers Knight, Power, and Watts argue that early female *Homo sapiens* elaborated the fundamental signal associated with menstruation and impending fertility, red blood, into body painting and ritual as a collective deceptive device to force men to provision them and their children. Knight, Power, and Watts build a carefully argued case for the deceptive reproductive strategy of women as the basis of the elaboration of complex symbolic communication resulting in ritual (art), religion, and language. Power and Aiello support this assertion with evidence of the apparent progressively increasing use of red ochre in early hominid archaeological sites.[56] Red has, and has had, a powerful effect on us; it could be a primitive

cue detected by special neurons in the thalamus which alert our bodies to prepare for, if not danger, something special.

Several researchers have studied the affective value of the color red. In a fascinating early study, Lundholm asked eight adults to draw a line representative of the color red and to describe their feelings about the color red. The lines drawn were characterized by either small waves or acute angles (The quality of this line and its relationship to affective adjectives, which constituted another part of this study, is discussed in the section on pointed shapes). The comments as to the affective value of the color red included "cruel, furious, like fire, like anger, implies great intensity and energy."[57] Assume, for a moment, that red is, indeed, a threat stimulus. The response to it then, under the appropriate conditions, would be, as Cannon put it, "great excitement."[58] If we study these few comments made about the affective value of red, we see both threat (cruel, furious, like fire, like anger) and excitement (implies great intensity and energy).

Keeping this idea in mind, let us glance at some evidence from some early crosscultural studies reviewed by Pickford.[59] For example, Hevner asked subjects to match adjectives to the color red and found that the words used most often were "happy" and "exciting."[60] Note that Scherer reported that the emotions human beings associated with high pitches were fear, anger, and joy.[61] If high pitches are indeed threat stimuli, they would elicit fear, possibly anger, and, even though it seems contradictory, under some circumstances, joy (this seeming contradiction is clarified in the next chapter). Being excited could certainly be associated with fear and anger; happy is a synonym for joyful. Consequently, red seems to have an affective value similar to that of high pitches, and, thus, could evoke responses consistent with a threat stimulus. In another matching study, Osgood asked Navajo and Anglo–Americans to match colors to the words good or bad, happy or sad, and the like. Red was matched most often to fast, which seems to relate to exciting.[62]

Another group of researchers studied red from another point of view. They were interested in color preferences, but their studies provide an interesting insight into the affective value of red. As will be seen in the next chapter, it is quite possible to prefer something you fear. The preference studies demonstrate that red is particularly compelling. In 1922, Garth asked 559 full-blooded American Indian children in grades four through ten to rank order seven colored discs of the standard Milton Bradley colors for red, blue, green, purple, orange, yellow, and white. They overwhelmingly preferred red. Their overall rank order was red, blue, violet, green, orange, yellow, and white. Garth noticed, however, that the Indian children in the upper grade levels tended to rank blue ahead of red. In 1924, Garth studied the effects of educational level on the color preferences of 1,000 white children. He repeated the experi-

mental design he had used with the Indian children and found that, though the first graders tested preferred red, the second graders preferred blue. Moreover, as the grade level increased, the preference for blue over red increased. Garth theorized that perhaps the differences he observed in preferences had something to do with stimulation. He cited an experiment by Fere, who used a device called a dynamometer, and found that "red light served to stimulate his subjects more than any other color of light, so that it seemed to facilitate the contraction of the muscles. Next came orange light, green, yellow, and blue lights in a series of degrees of ability to stimulate the subject."[63] It is interesting to note here the remarks made by Lundholm's subjects about the color blue. They described blue as "gentle, placid, calm, serene, quieting, and sad."[64] I do not know what, if any, conclusions can be drawn here about the effect of education on the appeal of what may be a calm and serene affective value for blue, but it can easily be seen that the affective values attributed to the two colors by Lundholm's subjects are exact opposites: red being stimulating and blue being calming. Garth and Collado asked 1,004 Filipino children in grades one through nine to rank order colors as Garth had done in his 1922 and 1924 studies. The Filipino children preferred red, then green, blue, violet, orange, white, and yellow. Again, educational level appeared to be a factor as it was in the earlier studies by Garth (note, however, that what appears to be a factor of education could also be a factor of development other than education or of maturation).[65]

Other studies reveal the compelling nature of red. Gesche studied Mexican children and Garth, Kunihei, and Langdon studied Japanese children and found they preferred red. Burnham, Hanes, and Bartleson took another look at the color preferences of North American Indian children, 559 of them, and found they preferred red. Adams studied the color preferences of infants and adults. Using length of fixation of the eyes on the color, Adams tested twenty infants, one and three months old, for fixation time to blue, green, yellow, red, and gray. Adults were asked to rank the colors as to their "pleasantness." The results showed that the one-month-olds fixated longer on the colors than they did on the gray stimulus, thereby indicating to Adams a preference for color over gray. The three-month-olds preferred red. The adults preferred blue.[66] Looking once again at the Lundholm study, the subjects were asked to describe a beautiful line, and the adjectives used, such as smooth, and the associations made, such as "waves of the sea," are very similar to their descriptions of the color blue.[67]

What do the results of these studies mean? There certainly appears to be an interaction between development and color preference. Red appears to be stimulating, blue appears to be calming, and red and

blue appear to share the same affective relationship as zigzags or pointed lines and curved lines.

## OTHER STIMULI THAT MAY EVOKE
## EMOTIONAL RESPONSE TO ART

Not all releasers of emotional response are threat stimuli. Consider the Sternglanz and colleagues study discussed in Chapter 3, in which the emotion which appeared to be released was a positive one in response to infant facial features. Even though we may not be able to be precise about what emotion was triggered, it was probably not fear. It is likely that other releasers trigger other emotions. Among the possible examples are curved shapes and rhythms.

### Curved Shapes

Curved shapes have just been discussed as affective opposites of zigzags or pointed shapes. In 1880, Grant Allen speculated on our interest in curved lines. Allen noted that children and "savages" are very much interested in pictures of people, and the first recognizable object drawn by children is a face. Allen proposed that the circle as face may be the starting point for visual art.[68] Desmond Morris demonstrated that chimpanzees draw circles and speculated that, as Allen had suggested in 1879, that circles and other curves and marks are the result of rhythmic movements made for their own sake because it feels good to make them.[69] Rhoda Kellogg provides evidence supporting the universality of circles, curves, and the like in children's art and the art of "primitive" adults.[70]

Bleakney suggests that the circle is associated with the face of mother, who is the provider of warmth and food and comfort.[71] Bleakney's argument is inadequate, but at least he was equating the shape of the line to emotional quality. Others have researched the possibility that the shape of the line means an emotional quality. Poffenberger and Barrows, as discussed in the section on pointed lines versus curved lines, asked 500 subjects to match lines to descriptive terms. Ninety percent matched horizontal lines to quiet. Seventy-four percent matched downward sloping curves to sad or gentle. Seventy-nine percent matched upward rising lines to merry. Hevner also asked subjects to match lines and adjectives. He found that curves were matched to serene and graceful, whereas angles were rough or robust.[72] These studies recall the match of maluma to a curved shape and the match of Cézanne's still life and nudes to a calming emotional effect, as discussed in the section on pointed versus curved shapes (see also Figures 7.2, 7.3, 7.4, and 7.5).

The direction of slope of a curved line segment appears to be related to different emotional effects. For example, sadness seems to be elicited by the particular downward curve of a line, as exemplified by the "weeping" branches of a willow tree. Notice that the findings of Lundholm and Poffenberger and Barrows, as discussed in the section on pointed versus curved shapes, show a strong relationship between downward sloping lines and sadness. Stooped posture, which also follows a similar downward curve, may be evocative of sadness or despair. Picasso's *The Tragedy* of 1903 and *The Couple* of 1904 are examples of sad paintings, probably because of the drooping postures of the figures.

### Rhythms

Kate Gordon, in her 1909 book on experimental or scientific aesthetics, discusses rhythm as drawn from bodily functions such as heartbeat, walking, and breathing.[73] Rhythms may also have affective meaning. Some may be threatening, but other rhythms appear to have other qualities. In an informal setting, I asked adult students to describe their feelings about four short selections from different African rhythms. They agreed on the description attributed to each of the four different rhythms. The first was described as delicate, the second as harsh, the third as graceful, and the fourth as strident. These descriptions hint at different emotional qualities. I did not ask them how the rhythms made them feel, but it might have been enlightening to have done so.

Some research supports the concept that rhythms do have affective meaning. Gabrielsson used rhythms played on bongo drums and various extracts from marches, waltzes, sambas, and so on, and asked subjects to rate the rhythms according to their applicability to descriptive adjectives. Some distinct emotional qualities emerged from the ratings. Some pieces were agreed on as being exciting or calm, vital or dull, tense or relaxed, hard or soft.[74] Harper and Harper made no attempt to present statistical results or tell who or how many subjects were used in their tests, but they do give some hints as to what may occur when music acts on the autonomic nervous system. For example, they found that heart rate tracings on a polygraph machine were fairly consistent when taken for the same subject when the same music was played several times. They found repeated episodes of "premature beats" (I presume this means that the pulses occurred before they were anticipated) at special points in the music. Syncopated rhythms seemed particularly capable of inducing these premature beats. Speeding up the rhythm could accelerate the pulse; slowing down the rhythm could decelerate the heart rate.[75] In addition, when Harper and Harper asked subjects to squeeze an ergometer (an instrument used to measure the

strength of a handgrasp) at regular intervals with equal effort, they found that the subjects were not able to properly carry out the task when listening to music. Lullabies were invariably correlated with decreased muscular strength and marches were correlated with increased muscular strength.[76] Clynes and Nettheim, using a match-the-rhythm-to-the-emotion technique, tested 40 Australian Aborigines and 189 university students and staff from the United States and New South Wales and found the subjects matched the same emotions to the same rhythms. Though the stimuli were not well controlled and the methods seem cumbersome, Clynes and Nettheim nevertheless provide a crosscultural study which hints that certain rhythms and emotions are intricately intertwined.[77]

The rhythm of a lullaby is commonly assumed to be soothing. Mothers sing lullabies to their babies to help them relax at bedtime. Music is said to "soothe the savage beast." The word is even defined in the dictionary as any lulling song. Lullabies are characterized by soft sounds and slow easy rhythms. They are to music what curved shapes are to the visual arts.

Lullabies are found, of course, in bedtime songs for children. They also appear as passages in symphonies and other long musical works. On the Beatles' album *Abbey Road*, a lullaby is briefly screamed. The contradiction posed by mixing screaming rage with a mother's soothing touch not only captures attention but seems to make a statement about those who wish to closet themselves in the soft security of established ideas but cannot avoid the insistent pressures of change (considering the context of the rest of the album). The screamed lullaby also could be making statements about an overlap of love and hate and of peace and violence. This brief musical statement could not be so effective if threat and fear were not evoked by screams and calm, peace, and security were not evoked by the lullaby rhythm. John Lennon used this device another time with his "Imagine." This time he combined the lullaby rhythm with the expected soft, pleasant, soothing vocal. However, instead of words speaking of security and safety, we hear words of revolution speaking of atheism and anarchy. Moreover, the music sounds so soothing and is so lulling that the revolutionary message in the lyrics becomes almost subliminal, adding to the subversiveness of the message.

This list of threat and other stimuli used in art to evoke emotion is by no means comprehensive. There likely are many more natural releasers of emotional response used in art. These that I have discussed have initiated some research. Another possible releaser used in art, but which I found little about in the literature, is monumentality. Something very huge, such as the Sears Tower, the Egyptian pyramids, the Easter Island faces, and the Sistine ceiling, is awe inspiring. Examples

of action painting are notable not only for their "action" but for their size. A Mark Rothko painting is like a huge void that an observer could just step into and become engulfed in it. Popular music had a message in the 1960s, and one way it was made known was by turning up the volume. Volume is to music what size is to visual art. No doubt many more natural releasers evoke emotional responses to art, but we have a difficult time sorting them out since we respond to them without thinking. In the same way, artists use them without thinking, but with what feels right.

If, however, all this is true—that is, natural releasers of reflexive behavior are used in art to evoke some of the emotional response that is evoked by art—why should we derive pleasure from what may be a dominant emotion evoked, namely, fear? It seems obvious why we would derive pleasure from the curved lines in a painting by Renoir and the soft, soothing sounds of a lullaby, but what is nice about a tingle down the spine or an anxious feeling? The discussion in the next chapter will address this question.

## NOTES

1. H. B. Cott, *Adaptive Coloration in Animals* (London: Methuen, 1940), 387–390.

2. A. D. Blest, "The Function of Eyespot Patterns in the *Lepidoptera*," *Behaviour* 11 (1957): 209–256; see also A. D. Blest, "The Evolution of Protective Displays in the *Saturnioidea* and *Sphingidae (Lepidoptera)*," *Behaviour* 11 (1957): 257–309.

3. I. M. Marks, *Fears, Phobias, and Rituals: Panic, Anxiety, and Their Disorders* (New York and Oxford: Oxford University Press, 1987).

4. W. K. Redican, "Facial Expressions in Nonhuman Primates," in *Primate Behavior*, ed. L. Rosenblum (New York: Academic Press, 1975), 103–194.

5. Richard G. Coss, "The Perceptual Aspects of Eye-Spot Patterns and Their Relevance to Gaze Behavior," in *Behavior Studies in Psychiatry*, ed. S. J. Hutt and C. Hutt (Oxford: Pergamon Press, 1970), 121–147.

6. C. L. Kleinke and P. D. Pohlen, "Affective and Emotional Responses as a Function of Other Person's Gaze and Cooperativeness in a Two-Person Game," *Journal of Personality and Social Psychology* 17 (1971): 308–313.

7. G. P. Sackett, "Monkeys Reared in Isolation with Pictures as Visual Input: Evidence for an Innate Releasing Mechanism," *Science* 154 (1966): 1468–1473. Even though this famous article appeared in *Science*, which indicates that the study was replicated, neither the stimulus nor the response was carefully controlled, so it cannot be determined if the whole face or only portions of the face contributed to the monkeys' responses. Also, the responses were not quantified, so it cannot be determined exactly what they were. However, the monkeys, raised in isolation, did react with apparent fear to pictures of threatening conspecific faces.

8. See A. Jolly, *The Evolution of Primate Behavior* (New York and London: Macmillian, 1972); R. J. Andrew, "The Origins and Evolution of Calls and Facial Expressions of the Primates," *Behaviour* 20 (1963): 71–83.

9. R. A. Spitz and K. M. Wolf, "The Smiling Response: A Contribution to the Ontogenesis of Social Relations," *Genetic Psychology Monographs* 34 (1946): 57–125.

10. Nancy E. Aiken, "A Biological Basis for the Emotional Impact of Art" (Ph.D. diss., Ohio University, 1992); Nancy E. Aiken, "Human Cardiovascular Response to the Eye Spot Threat Stimulus," *Journal of Evolution and Cognition* (forthcoming). For a discussion of the problems with cardiovascular measure direction, see, for example, G. Turpin, "Effects of Stimulus Intensity on Autonomic Responding: The Problem of Differentiating Orienting and Defense Reflexes," *Psychophysiology* 23 (1986): 1–14. For a discussion of ethological methodology, see Niko Tinbergen, "Social Releasers and Experimental Method for Their Study," *Wilson Bulletin* 60 (1948): 6–51.

11. Richard G. Coss, "The Ethological Command in Art," *Leonardo* 1 (1968): 279.

12. A. L. Yarbus, *Eye Movements and Vision* (New York: Plenum, 1967).

13. Irenäus Eibl-Eibesfeldt and Christa Sutterlin, "Fear, Defence and Aggression in Animals and Man: Some Ethological Perspectives," in *Fear and Defence*, ed. P. F. Brain, S. Parmigiani, R. J. Blanchard, and D. Mainardi (New York: Harwood Academic, 1990), 396.

14. F. Gilot, *Matisse and Picasso: A Friendship in Art* (New York: Doubleday, 1990), 47.

15. P. Leighten, *Re-Ordering the Universe: Picasso and Anarchism, 1897–1914* (Princeton, N.J.: Princeton University Press, 1989), 87.

16. Ibid., 73.

17. M. S. Lindauer, "Physiognomy and Art: Approaches from Above, Below, and Sideways," *Visual Arts Research* 10 (1984): 52–53.

18. W. Köhler, *Gestalt Psychology* (1938; reprint, New York: Liveright, 1947), 225.

19. R. Davis, "The Fitness of Names to Drawings: A Cross-Cultural Study in Tanganyika," *British Journal of Psychology* 52 (1961): 259–268.

20. H. Lundholm, "The Affective Tone of Lines: Experimental Researches," *The Psychological Review* 28 (1921): 60.

21. Ibid., 52.

22. A. T. Poffenberger and B. E. Barrows, "The Feeling Value of Lines," *Journal of Applied Psychology* 8 (1924): 187–205.

23. Johanna Üher, "Die Ästhetik von Zick-Zack und Welle: Ethologische Aspekte der Wirkung linearer Muster" (Ph.D. diss., Universität München, 1991).

24. Richard G. Coss, *Mood Provoking Visual Stimuli: Their Origins and Applications* (Los Angeles: University of California Industrial Design Graduate Program, 1965).

25. Poffenberger and Barrows, "Feeling Value of Lines," 187. Poffenberger and Barrows did not give enough citation to find the original piece by Cox. Note the comments made by Cox on the affective quality of vertical lines; the painting by Manet, discussed later in this section, illustrates what Cox wrote.

26. Rudolf Arnheim, *Art and Visual Perception: A Psychology of the Creative Eye* (Berkeley and Los Angeles: University of California Press, 1965), 375.

27. Thomas Munro, *Great Pictures of Europe* (New York: Brentano's, 1930), 229.

28. Kenneth Clark, *Looking at Pictures* (New York: Holt, Rinehart & Winston, 1960), 124–126.

29. Ibid., 123, 126–127.

30. Munro, *Great Pictures*, 99.

31. Clark, *Looking at Pictures*, 129.

32. Herbert Spencer, "The Origin and Function of Music," in *Literary Style and Music* (London and Port Washington, N.Y.: Kennikat Press, 1970), 60, 67.

33. C. H. H. Parry, *The Evolution of the Art of Music* (New York: D. Appleton, 1906).

34. Spencer, "Origin and Function of Music," 77.

35. R. M. Seyfarth, D. L. Cheney, and P. Marler, "Vervet Monkey Alarm Calls: Semantic Communication in a Free-Ranging Primate," *Animal Behavior* 28 (1980): 1070–1094; R. M. Seyfarth and D. L. Cheney, "The Ontogeny of Vervet Monkey Alarm Calling Behavior: A Preliminary Report," *Z. Tierpsüchologie* 54 (1980): 37–56.

36. J. M. Macedonia, "What Is Communicated in the Anti-Predator Calls of Lemurs: Evidence from Playback Experiments with Ringtailed and Ruffed Lemurs," *Ethology* 86 (1990): 177–190, and M. E. Pereira and J. M. Macedonia, "Ringtailed Lemur Anti-Predator Calls Denote Predator Class, not Response Urgency," *Animal Behavior* 41 (1991): 543–544.

37. M. D. Hauser and R. W. Wrangham, "Recognition of Predator and Competitor Calls in Nonhuman Primates and Birds: A Preliminary Report," *Ethology* 86 (1990): 116–130.

38. M. Herzog and S. Hopf, "Behavioral Responses to Species-Specific Warning Calls in Infant Squirrel Monkeys Reared in Social Isolation," *American Journal of Primatology* 7 (1984): 99–106.

39. R. M. Seyfarth and D. L. Cheney, "The Assessment by Vervet Monkeys of Their Own and Another Species Alarm Calls," *Animal Behavior* 40 (1990): 754–764.

40. K. R. Scherer, "Acoustic Concomitants of Emotional Dimensions: Judging Affect from Synthesized Tone Sequences," in *Nonverbal Communication*, ed. S. Weitz (New York: Oxford University Press, 1974), 105–111; K. R. Scherer, "On the Nature and Function of Emotion: A Component Process Approach," in *Approaches to Emotion*, ed. K. R. Scherer and P. Ekman (Hillsdale, N.J.: Lawrence Erlbaum Associates, 1984), 293–318; K. R. Scherer, "Vocal Affect Signaling: A Comparative Approach," in *Advances in the Study of Behavior*, vol. 15, ed. J. S. Rosenblatt, C. Beer, M. Busnel, and P. J. B. Slater (Orlando: Academic Press, 1985), 189–244; K. R. Scherer and J. Oshinsky, "Cue Utilization in Emotion Attribution from Auditory Stimuli," *Motivation & Emotion* 1 (1977): 331–346; and R. J. Andrew, "The Origins and Evolution of Calls and Facial Expressions of the Primates," *Behaviour* 20 (1963): 1–109.

41. Scherer, "Vocal Affect Signaling."

42. O. Ortmann, "The Sensorial Basis of Music Appreciation," *Journal of Comparative Psychology* 2 (1922): 227. Ortmann was reacting to the notion which was espoused by leading aestheticians of the day that art has some mystical quality that cannot be explained by biology. For example, Bosanquet, probably the leading aesthetician of the time, did not consider Spencer's comments on the origin of music worth taking seriously and only mentioned them in a

footnote. See Bernard Bosanquet, *A History of Aesthetic* (1892; reprint, London: Swan Sonnenschein, 1904).

43. M. Sherman, "Emotional Character of the Singing Voice," *Journal of Experimental Psychology* 11 (1928): 495–497.

44. C. P. Heinlein, "The Affective Characters of the Major and Minor Modes in Music," *Journal of Comparative Psychology* 8 (1928): 101–142.

45. C. C. Pratt, "The Design of Music," *Journal of Aesthetics and Art Criticism* 12 (1954): 290.

46. Ibid., 291. See also George Santayana, *The Sense of Beauty: Being the Outlines of Aesthetic Theory* (New York: Scribner's, 1896), for the discussion about emotion and art.

47. Pratt, "Design of Music," 291.

48. Ibid., 291–292.

49. Ira Gershwin, untitled essay in *Gershwin, 1938*, ed. M. Armitage (New York: Longmans, Green, 1938), 20.

50. Olin Downes, "A Concert of Jazz," *New York Times*, 13 February 1924, 16.

51. Paul Whiteman, untitled essay in *Gershwin, 1938*, ed. M. Armitage (New York: Longmans, Green, 1938), 26.

52. Erma Taylor, untitled essay in *Gershwin, 1938*, ed. M. Armitage (New York: Longmans, Green, 1938), 181, 191.

53. R. M. Gray, "The Pilomotor Reflex in Response to Music" (master's thesis, University of Kansas, 1955).

54. K. P. Oakley, "Emergence of Higher Thought," *Philosophical Transactions of the Royal Society of London* 292 (1981): 205–211.

55. Robert Brain, *The Decorated Body* (New York: Harper & Row, 1979), 107, 114.

56. Chris Knight, Camilla Power, and Ian Watts, "The Human Symbolic Revolution: A Darwinian Account," *Cambridge Archaeological Journal* 5, no. 1 (1995): 75–114; Camilla Power and Leslie Aiello, "Female Proto-Symbolic Strategies," in *Women in Human Evolution*, ed. Lori D. Hager (London and New York: Routledge, 1997), 153–171.

57. Lundholm, "Affective Tone of Lines," 58.

58. W. B. Cannon, *Bodily Changes in Pain, Hunger, Fear and Rage: An Account of Recent Researches into the Function of Emotional Excitement*, 2d ed. (New York and London: D. Appleton, 1929).

59. R. W. Pickford, *Psychology and Visual Aesthetics* (London: Hutchinson Education, 1972).

60. K. Hevner, "Experimental Studies of the Affective Value of Colors and Lines," *Journal of Applied Psychology* 19 (1935): 385–398.

61. Scherer, "Vocal Affect Signaling."

62. C. E. Osgood, "The Cross-Cultural Generality of Visual–Verbal Synaesthetic Tendencies," *Behavioral Science* 5 (1960): 146–169.

63. T. R. Garth, "The Color Preferences of Five Hundred and Fifty-Nine Full-Blood Indians," *Journal of Experimental Psychology* 5 (1922): 392–418; T. R. Garth, "A Color Preference Scale for One Thousand White Children," *Journal of Experimental Psychology* 7 (1924): 235–236.

64. Lundholm, "Affective Tone of Lines," 58.

65. T. R. Garth and I. R. Collado, "The Color Preferences of Filipino Children," *Journal of Comparative Psychology* 7 (1927): 397–404.

66. I. Gesche, "The Color Preference of 1,152 Mexican Children," *Journal of Comparative Psychology* 7 (1927): 297–311; T. R. Garth, I. Kunihei, and R. M. Langdon, "The Color Preferences of Japanese Children," *Journal of Social Psychology* 2 (1931): 397–402; R. W. Burnham, R. M. Hanes, and C. J. Bartleson, *Color: A Guide to Basic Facts and Concepts* (New York: Wiley, 1963); and R. J. Adams, "An Evaluation of Color Preference in Early Infancy," *Infant Behavior and Development* 10 (1987): 143–150.

67. Lundholm, "Affective Tone of Lines," 59.

68. Grant Allen, "Aesthetic Evolution in Man," *Mind* 5 (1880): 445–464.

69. Grant Allen, "The Origin of the Sense of Symmetry," *Mind* 4 (1879): 301–316; and Desmond Morris, *The Biology of Art* (New York: Knopf, 1962).

70. Rhoda Kellogg, *Analyzing Children's Art* (Palo Alto, Calif.: National Press Books, 1969).

71. J. S. Bleakney, "A Possible Evolutionary Basis for Aesthetic Appreciation in Men and Apes," *Evolution* 24 (1970): 477–479.

72. Poffenberger and Barrows, "Feeling Value of Lines"; Hevner, "Experimental Studies."

73. Kate Gordon, *Esthetics* (New York: Henry Holt, 1909).

74. A. Gabrielsson, "Adjective Ratings and Dimension Analyses of Auditory Rhythm Patterns," *Scandinavian Journal of Psychology* 14 (1973): 244–260. Unfortunately, the stimuli in this experiment were not well controlled. The influence of the kind of instruments used to play the rhythms, the influence of other instruments and voices, and musical genres were not factored out.

75. G. Harper and H. Harper, "Music, Emotion, and Autonomic Function," in *Music and the Brain: Studies in the Neurology of Music*, ed. M. Critchley and R. A. Henson (London: William Heinemann, 1977), 206.

76. Ibid., 216.

77. M. Clynes and N. Nettheim, "The Living Quality of Music," in *Music, Mind, and Brain: The Neuropsychology of Music*, ed. M. Clynes (New York: Plenum, 1982), 47–82.

*Chapter 8*

---

# From Threat to Pleasure

Soothing stimuli are pleasurable, but what of threat stimuli? People and animals react to threat stimuli with fear and avoidance or aggression. How can these same stimuli be noxious in nature but pleasurable when they are used in art? There are at least two reasons why the same stimuli repels us when used in nature but attracts us when used in art: (1) the context (i.e., the noxious stimulus is in art and, under this condition, is rarely a real threat), and (2) the apparent need for stimulation, which makes small and, sometimes, large thrills pleasurable. On the other hand, pleasure is not necessarily a defining quality of art. We can appreciate the artist's cleverness or the unique qualities of the art without finding the artwork pleasurable.

## CONTEXT

For anyone who has experienced films, paintings, music, and the like and can distinguish between real-life events and two-dimensional images moving on a screen, the stimulus situation created by art is generally less intense than an analogous real-life stimulus situation, because part of the context or the stimulus situation is the recognition that "this is not really happening." That is, the actor in the play, even though he is alive and on the stage in front of us, is not really stabbing the actress, and she is not really dying. If we were to observe a similar scene on the corner of 12th and Main on a rowdy Saturday night, we would be shocked and horrified. That would be a real murder, and to witness a murder must be horrifying. To witness a murder in a play

on the stage is, instead of horrifying, exciting. Part of the difference is the context in which the two similar-appearing acts occur. The murder which occurs on the corner of 12th and Main is, in all likelihood, the real thing; the murder which occurs on the stage is a charade. We may gasp when the actor raises his knife, and we may cringe when he seemingly plunges it into the actress's heart, but these are mild responses compared to the shock of witnessing an actual murder. Consequently, art can frighten, but as people gain experience and realize that it is not real-life, the terror is reduced.

The context in which threat stimuli are used in art is safe; however, not everyone understands the safe quality in the stimulus situation of art. For example, children do not always realize that art is safe. Children will frequently cover their eyes during fear-evoking scenes in movies, for example. Nightmares may follow. The flying monkey scenes in *The Wizard of Oz* of 1939 are notoriously frightening for young children. The source of fear in the flying monkey scenes is probably a number of different threat stimuli working together. In a device used quite often in animated films, two "looming" eyes, the threat stimuli are obvious: a looming object and eye spots. When used together, the effect can be extremely intense. Children may actually jump from their seats to the floor or hide their heads in mothers' laps. Is this pleasurable for children? Probably not. Ask young children who have experienced the flying monkeys in *The Wizard of Oz* if they would like to see the movie again. Their answer is likely to be, "Yes, but tell us when the monkeys will be on so we will know when not to watch."

By the time these children have acquired some experience with movies, scary picture books, and so on, their fear of such things as the flying monkey scenes in *The Wizard of Oz* diminishes. They realize that there is no real danger posed by the flying monkeys or the looming eyes. Therefore, though they may literally jump up or startle at such scenes in films, they, like adults, quickly calm down. It is, after all, only a movie or only a picture.

Psychologist G. R. Levin's discussion of arousal lends further insight into the "fear can be pleasurable" problem within the context of the stimulus situation. That is, the study of arousal can help explain why excitement, even the excitement of fear, can be desirable. This brief look at arousal will introduce the next section on self-stimulation, which is, in essence, an extension of arousal theory. Arousal, Levin writes, can be thought of as a continuum, with excitement at the one extreme and sleepiness on the other. Ordinary wakefulness comprises the middle, and arousal levels are defined according to the organism's state or position on the arousal continuum. "Emotional reactions involve an increase in arousal level. [Extreme emotional reactions show] dramatic physiological reactions. But if we look carefully, we see simi-

lar, though smaller, changes every day. Mild emotional reactions, as when a child laughs at a joke, tells a deliberate lie, or tenses up when criticized, include changes in heart rate, breathing, and palm sweating that parallel the large changes seen in extreme arousal."[1] Figure 8.1 illustrates the arousal continuum.

Levin writes about the effect of context on emotional response, rather than the more particular aesthetic response, but he is describing the same thing that occurs in aesthetic response. He writes, "Apparently the child's understanding of the situation as safe or not determines the emotional coloring of the arousal. In older children reactions to a ghost story or a roller coaster ride probably vary in the same way."[2] However, added to the notion of a safe versus an unsafe situation is maturation. Levin discusses the ideas of William Mason, "who hypothesized that arousal-reducing actions and arousal-increasing ones follow contrasting age curves when the baby develops in a normal environment." Arousal reduction is predominant right after birth, but as a baby matures it begins to seek out arousal-increasing actions.[3] This theory is supported by the tickler–cuddler studies of Paul Weisberg, who found that the younger children in a three- to seven-year-old group that he studied tended to seek out the college students he used as "cuddlers," whereas the older children in the group would turn to the "ticklers."[4] As children mature, they tend to seek arousal or

**Figure 8.1**
**Overt and Internal Manifestations of Arousal Level**

| LOW | INTERMEDIATE | | HIGH |
|---|---|---|---|
| *Sleepy* | *Calm* | *Alert* | *Excited* |
| **Physiology:** | **Brain:** | **Brain:** | **Physiology:** |
| Heart rate decreased | alpha rhythm present | alpha rhythm absent | Heart rate increased |
| Blood pressure decreased | | | Blood pressure increased |
| Palmar sweating low, muscles relaxed, etc. | | | Palmar sweating high, tense muscles, etc. |

*Source*: Adapted from Gerald R. Levin, *Child Psychology* (Monterey, Calif.: Brooks/Cole, 1983), 232.

emotion-producing stimuli. Thus, what for the young child is a portion of *The Wizard of Oz* to be avoided can be, for the older child, a portion to be eagerly awaited. The context is not only deemed "safe," but, by virtue of maturation, becomes desirably exciting.

## SELF-STIMULATION

Though little children and some other people may find some art too horrifying or too intense to observe or hear, people generally find that the excitement or other emotions generated by art are stimulating and therefore pleasurable. Thrills evoked by art, such as a tingle down the spine, are, in context, stimulating and safe and fun. As the human organism matures, it tends to seek arousal-producing stimuli. Self-rewarding activities are pleasurable for human and nonhuman primates; that is, primates will perform some behaviors, such as examining objects and drawing on walls, seemingly for the pure pleasure of it.[5] Research indicates that animals of many species will work for self-stimulation, and that an interaction seems to exist between response to threat, fear, and pleasure.[6] Moreover, the pleasure found in danger or fear varies according to the individual. Some people will seek out danger or some similar stimulus in order to find pleasure.[7] This seemingly contradictory relationship between fear and pleasure may explain how threat stimuli, which evoke fear, can be pleasurable when used in art.

Desmond Morris observed captive chimpanzees performing activities which he called "self-rewarding" because they appeared to need no reward for their performance. According to Morris, these activities are normally seen in animals "which have all of their survival problems under control," and these behaviors are usually termed "play, curiosity, self-expression, [and] investigation." Among primates, self-rewarding activities include rhythmic gymnastic movements of the whole body and fine motor movements used to manipulate objects. "Any strange object will be investigated, opened, closed, moved, shaken, rearranged, pulled, pushed, stretched, twisted and generally thoroughly examined. These investigations are often rhythmically performed." Morris called drawing a self-rewarding activity because the chimpanzees would draw without a reward. In fact, the animals he observed sometimes preferred drawing to being fed and would "exhibit temper-tantrums" if their drawing were to be interrupted.[8] This observation is similar to the observations made by Köhler and his associates when they devised the famous manipulation of tools experiments with monkeys in the early part of this century. They found that the problem given the monkeys to solve with the tools found in the cage was more efficiently solved if no bananas were offered.[9] Solving

the problem or manipulating the tools or drawing seems to be stimulation or reward enough.

Morris noted that "manipulative investigation . . . is . . . taken to a striking extreme in captive specimens."[10] Research interest has been in abnormal or pathological self-stimulation in captive animals and in autistic and socially deprived human beings, rather than in the more normal play and investigatory activities described by Morris. Erwin and Deni, for example, describe several types of abnormal behaviors observed in captive animals, and these are different from those described by Morris. However, these behaviors, described as self-biting, stereotyped pacing, head tossing, and whole body rocking, may well be pathological extremes of the behaviors described by Morris as self-rewarding.[11]

An additional and related area of research interest is in self-stimulation by means of direct electrical or chemical stimulation of the brain. A great body of research has evolved in this area.[12] Interest centers on the effects of drugs on the brain and the portions of the brain which, when stimulated, affect pleasurable results for the subject. This is often measured in terms of whether the subject will either work for or select stimulation. Interestingly, for mice and rats at least, the periaqueductal gray, the area considered to be the coordinating site for the defense reaction, has, when stimulated, resulted in apparent pleasure. Cazala found that the experimental situation seemed to be a determining factor in whether the brain stimulation evoked escape or approach responses in the mice under study. Some mice were tested in a Y-maze discrimination task, where the animals could successively trigger and turn off continuous electrical stimulation to electrodes implanted in a portion of the brain. The implanted structures were all associated with defense and included the dorsal mesencephalic central gray and the lateral hypothalamus. These areas were self-stimulated by mice in the Y-maze, but mice in the alternate experimental situation, a lever-press box, only pressed the lever to receive stimulation to the lateral hypothalamus. Cazala speculated that besides the possibility of the stimulus situation playing some part in these differing results (this is not a surprising theory in light of the earlier discussion concerning the impact of the stimulus situation on the eventual behavioral outcome), the possibility of known anatomical connections between and among the structures implanted with electrodes could also play some part. In addition, Cazala notes that endorphins, which are released under certain stressful conditions but which are also known to play a part in self-stimulation, may set the stage for a "negative" or "aversive" brain structure (i.e., one implicated in defense) to contribute, at least indirectly, to positive reinforcement.[13] Meanwhile, Ichitani and Iwasaki

found that electrical stimulation of the ventral portion of the central gray in rats produced both approach and avoidance responses, but simulation of the dorsal central gray produced only escape responses, so the precise anatomical area may be an important factor in which response is elicited from the central gray.[14] This neurobiological research indicates that overlaps are present in the brain structures associated with response to threat. These same structures also can affect pleasure. This dichotomy, whatever its explanation, may explain, at least in part, how we can derive pleasure from threat or danger.

This neurobiological research on mice and rats provides a biological background for the sensation-seeking research done with human beings using techniques less invasive than electrodes implanted in the brain. The thrust of this research with human subjects is on individual differences in pleasure derived from danger. Whereas self-stimulation is, in general, pleasurable, individual differences in the intensity levels of stimulation determine the level of pleasure.[15] Chapter 5 discussed the research by Block and others which established that individual differences exist in physiological response to threat stimuli. Zuckerman and others have linked these response differences to stimulus intensity and to pleasure.[16] They have devised a sensation-seeking continuum, which has those who seek sensation (race car drivers and sky divers, for example, who need near-death experiences to find pleasure) at one extreme and those who avoid excitement at the opposite extreme. In-between these extremes are most of us, who receive our thrills from art and roller coasters. This research strongly indicates that individual differences exist in nervous system reaction to stimulus intensities, and that these differences are defined as differences in the pleasurability of the stimulus. For some, the safe thrills found in art can be pleasure enough to self-stimulate, but others seek more dangerous ways to find pleasure, such as jumping out of airplanes.

Consequently, in order to answer the question of how responses to threat stimuli can be pleasurable in art, we need to look to the stimulus situation and to a biological basis for interconnections between pleasure and fear. The stimulus situation which includes threat stimuli in art is safe. Once experience has been gained that helps us differentiate between the real tiger leaping at us and the tiger leaping at us on the motion picture screen, we include safe in the stimulus situation. This dramatically reduces the intensity of the stimulus situation, which results in a reduction of resultant behavioral intensity. That is, we are more likely to have sweaty palms than we are to run away. Moreover, neurobiological research in brain stimulation indicates that there may be an interaction between fear and pleasure in the brain itself. What Morris observed as simple investigatory and self-rewarding interest in novel stimuli in his chimpanzees may be behavior found on the

innocuous end of the sensation-seeking continuum. Perhaps the pathological version of this self-stimulation as seen in self-biting and the like is found near the other extreme end of the sensation-seeking continuum, along with jumping from airplanes. Individual differences appear to be the key to determining the amount of pleasure derived from simple novel stimuli to threat stimuli used in art to near death experiences. There appears to be no doubt, however, that danger can provide pleasure, but must art provide pleasure? Art does not have to provide pleasure to be art.

## NOT ALL ART IS PLEASURABLE

I used the flying monkey scenes in *The Wizard of Oz* to demonstrate that some art can be too intense for some people. Children who are especially upset by these scenes do not find this part of the film pleasurable. However, art does not need to be pleasurable. Pleasant emotions are only some of the emotions evoked by art and need not be the defining emotional quality of art. Much of art is, of course, pleasurable, and art that evokes pleasure tends to attain a wider and a happier audience than art that is unpleasant. However, the emotional quality of an artwork does not determine its value as a work of art. For example, Picasso's *Les Demoiselles d'Avignon* is not a pleasant painting, but it is a very valuable work of art.

Some works of art are so lacking in pleasurability that they are impossible or difficult to observe. For example, Andy Warhol's film *Sleep* is a film of a person sleeping. The camera supposedly remains on the subject for the entire length of a night's sleep. "Supposedly," because I have not seen this film; few have seen this film in its entirety. Warhol's point was to make a film so boring that no one would watch it, but they would talk about it, thus changing the media and making something entirely different. We can find pleasure in Warhol's cleverness but not in the film. Warhol is saying things about media and about pleasure in art, and it is an interesting statement. Similarly, John Cage produced his famous "musical" recording of four minutes and thirty-three seconds of silence. Few would sit attentive for four and one-half minutes while the tape whirls to its end, but that is not important. Taking pleasure in the composition is not necessarily important in a musical work, and Cage makes this point admirably.

Both Cage's silence and Warhol's *Sleep* are extreme examples of artworks so boring or unpleasant that few if any people have actually observed them. Other works of art are actually meant to be seen or heard but are so unpleasant that some people cannot partake. For example, I found filmmaker Ingmar Bergman's *Virgin Spring* so disgusting due to the graphic depiction of a rape and its aftermath that I felt

physically ill. I think my reaction was somewhat extreme, and I saw it a second time without that distress. However, the point is that it is possible for some people to react so strongly to unpleasant art that they shun it. (Note that I am referring to intrinsic qualities of the art itself and not to personal associations or prejudices, as discussed in Chapter 2.) Some people may find some of Picasso's paintings to be "too scary." Francis Bacon's paintings of screaming popes and Chaim Soutine's dripping side of beef may be too disgusting or unsettling to be observed very long or very often.

An example of music that could be considered unpleasant but is meant to be heard is that of John Lydon. Lydon's music, as performed by the Sex Pistols or Public Image Limited, is exemplified by an intense, unrelenting rhythm and high-pitched, often shrieking vocals. The combination can result in distress for the listener, yet people listen. The music is exciting, and it is unique. Generally, Lydon's music meets the requirements outlined in Chapter 2 for valuable art, but it is not always pleasant.

## SUMMARY

I have proposed that ethological releasers (i.e., natural stimuli that effect reflexive responses) are used in art to evoke the same reflexive responses that they evoke under natural conditions. Animal howls and alarm calls, eye spots, and pointed shapes are very likely releasers of defense reactions under natural conditions, and these natural releasers are used in art to evoke weak defense reactions or, at least, emotional components of the defense reaction. John Lydon's high-pitched shrieks are not unlike animal howls and alarm calls. His vocals can evoke anxiety and distress.

Art evokes all kinds of emotional response and natural releasers may play a part in eliciting these various emotional responses. Not all are pleasurable, but pleasantness is not a defining quality of art. Yet we can derive pleasure from tingles down the spine and sweaty palms. Such responses as this, which are associated with fear, an unpleasant emotion, can actually be pleasant in art, since we realize that art is safe and because we find pleasure in stimulation. In fact, research is demonstrating the possibility of neurological connections which provide for a certain amount of pleasure from our fear. Chapter 9 will explore the implications of the use of releasing stimuli in art.

## NOTES

1. G. R. Levin, *Child Psychology* (Monterey, Calif.: Brooks/Cole, 1983), 232.
2. Ibid., 244.

3. Ibid.; W. A. Mason, "Motivational Factors in Psychosocial Development," in *Nebraska Symposium on Motivation* 18, ed. W. J. Arnold and N. M. Page (Lincoln: University of Nebraska Press, 1970), 35–68.

4. Paul Weisberg, "Developmental Differences in Children's Preferences for High- and Low-Arousing Forms of Contact Stimulation," *Child Development* 46 (1975): 975–979.

5. For just one example, see Desmond Morris, *The Biology of Art* (New York: Knopf, 1962).

6. See, for example, P. Cazala, "Self-Stimulation Behavior Can Be Elicited from Various 'Aversive' Brain Structures," *Behavioural Brain Research* 22 (1986): 163–171.

7. See, for example, M. Zuckerman, "Biological Foundations of the Sensation-Seeking Temperament," in *The Biological Bases of Personality and Behavior* 1, ed. J. Strelau, F. H. Farley, and A. Gale (Washington, D.C.: Hemisphere, 1985), 97–113.

8. Morris, *Biology of Art*, 144–145.

9. See A. Jolly, *The Evolution of Primate Behavior* (New York and London: Macmillan, 1972).

10. Morris, *Biology of Art*, 145. Presumably, Morris was referring to captive animals with less freedom than the animals he observed for his research.

11. J. Erwin and R. Deni, "Strangers in a Strange Land: Abnormal Behaviors or Abnormal Environments?" in *Captivity and Behavior*, ed. J. Erwin, T. L. Maple, and G. Mitchell (New York: Van Nostrand Reinhold, 1979), 1–28.

12. See the special issue of *Neuroscience and Biobehavioral Reviews* 13 (1989), for reviews of the neural basis of reward and reinforcement.

13. Cazala, "Self-Stimulation Behavior."

14. Y. Ichitani and T. Iwasaki, "Approach and Escape Responses to Mesencephalic Central Gray Stimulation in Rats: Effects of Morphine and Naloxone," *Behavioural Brain Research* 22 (1986): 63–73.

15. Zuckerman, "Biological Foundations."

16. Ibid.; also, for example, F. H. Farley, "Psychobiology and Cognition: An Individual Differences Model," in *The Biological Bases of Personality and Behavior* 1, ed. J. Strelau, F. H. Farley, and A. Gale (Washington, D.C.: Hemisphere, 1985), 61–74; J. A. Feij, J. F. Orlebeke, A. Gazendam, and R. W. van Zuilen, "Sensation Seeking: Measurement and Psychophysiological Correlates," in idem., 195–210.

# Chapter 9

# Answers to Big Questions

In the preceding chapters a theory has been discussed which explains one of the ways that emotion is evoked by art. Specifically, the theory is that part of the emotional impact of art comes from reflexive responses to particular configurations of line, shape, color, and sound which are used in art. These configurations evoke emotion because they are natural releasers of reflexive responses. Some of these responses are defensive, and the configurations which evoke these defensive responses are threat stimuli. It is these threat stimuli and their defensive responses which I have chosen to use as the exemplars for my argument that reflexive responses create some of the emotional impact of art.

In Chapter 2, other ways by which art evokes emotion were discussed, but all these other ways are culturally bound. The way of evoking emotion discussed at length is biologically bound; that is, via unconditioned reflexive response to biologically relevant stimuli or releasers. These two ways in which art evokes emotion (culturally bound and biologically bound) are closely intertwined.

Some art may rely entirely on culturally derived associations and technique for its effect. For example, photographs of wrapped islands are probably devoid of any releasers. The monumentality (probably a releaser) of the wrapped islands is lost in the photographs and can only be imagined by the observer. A performance artist with a bag over his head standing motionless in a public place conceals possible releasers, such as eyes, and restrains movement, another possible releaser. He seems to be making a statement about isolation within a crowd and may rely solely on our associations about this situation. Craftwork is

sometimes elevated to artwork status on the basis of technical brilliance. A piece of handcrafted silver jewelry may contain no releasers or associations, yet will be valued as art for its fine craftsmanship.

On the other hand, the mere existence of releasers in a painting or piece of music does not guarantee its acceptance as art. If it does not meet the standards outlined in Chapter 2, it will not be accepted as art—at least by members of the art world.

Even though a work of art may be devoid of releasers, I contend that art was built on the emotional effect of releasers. Art is a behavior founded on co-opted naturally occurring responses to specific biologically important stimuli. While the peacock's tail appears to be mere ornament, we know that it is used to attract the attention of peahens; thus, the peacock's flamboyant tail helps perpetuate his species. Art, also, appears to be mere ornament, but, like the peacock's tail, art helps perpetuate the individuals who produce it. Releaser–response packages make possible the ability of art to attract our attention, just as the peahen is attracted by her suitor's tail. Releaser–response packages are necessary adaptations, vital for reactions to environmental dangers or desires, co-opted by art in order to manipulate the fears and pleasures of other human beings. Stephen Jay Gould writes, "Much of the fascination, the quirkiness, and the unpredictability of evolution lie in this principle of co-optation of structures initially evolved for other purposes or for no purpose at all. Feathers that evolved as thermoregulatory devices in small running dinosaurs are co-opted for flight in birds."[1] The difference with art co-opting orienting and defensive reflexes is that we, and not nature, are the co-optors. Driven by social manipulation to find new ways to socially manipulate, we put a giant step between us and other animals by co-opting this evolutionary adaption for our own use.

Perhaps, as Knight, Power, and Watts suggest, art began with early female *Homo sapiens* using red ochre to deceive their male counterparts into thinking they would soon be fertile as a bargaining tool for food.[2] Perhaps it began with the discovery that eye spots or zigzags would cause fear. At some point, early human beings discovered that they could reliably and consistently control the emotions, and, thereby, the actions of others of their kind by evoking the releasing effects of biologically relevant stimuli.

How art is used to control the behavior of others will be discussed at the end of this chapter. First, how releasers used in art can explain the seemingly universal quality of art will be discussed. Then we shall see how an alternate theory for the origins of art offers another perspective on this theory and how other theories, such as the notions promoted by Gestalt psychologist C. G. Jung, children's art specialist Rhoda Kellogg,

and animal art specialist Desmond Morris, fit into the puzzle of what art is. While these things are being discussed, answers to the "big questions" posed in Chapter 1 will be found. If art behavior arose because human beings respond to primitive cues (or releasers or biologically relevant stimuli) reliably and consistently and these responses could be used to manipulate other behaviors, then the answers to the big questions—Why do people make art? Why does art persist? Why do people enjoy art? What purpose does art serve?—become answerable.

## THE USE OF RELEASERS IN ART EXPLAINS
## ITS UNIVERSAL QUALITY

In 1757 David Hume argued that art appreciation is relative to one's own cultural background and personal taste.[3] Yet it cannot be denied that some artworks are valued across time and culture (e.g., Paleolithic cave paintings, African masks, the Sphinx, and the Taj Mahal). The question of relativity versus universality in art appreciation is still unsolved. If, however, the meaning of art appreciation is considered as suggested in Chapter 2, then it becomes possible to consider universality in terms of some emotional response to art. That is, if cultural and personal biases are stripped away, personal and cultural associations are taken into account, and only the reflexive response to particular line, mass, color, and sound are considered, then we are looking at a part of art appreciation which may be universal in nature. That is, the ability to respond in reflexive ways to particular configurations of line, mass, color, and sound would be a common trait in all human beings and could, therefore, account for a universal response to art.

As discussed in Chapter 2, anthropologist David Stout reached the conclusion that art appreciation was based universally on four criteria: technique, originality, awesomeness, and particular combinations of line, mass, color, and sound.[4] Note that the first three of the four are dependent on the cultural setting for their form. That is, what is unique to the New Guinea bushman may not be unique to the New York art critic. However, culture would not affect the reflexive response to particular combinations of line, mass, color, and sound.

Culture may, however, influence the interpretation of the response. Sometimes cultural biases can overcome the emotion evoked reflexively by the art object. Westerners who have not become acquainted with modern art may be so confused by *Les Demoiselles d'Avignon* that the effect is all but lost. An example of this situation from the Yoruba of Nigeria is discussed by Thompson. He compares the Nigerian response to an image of a distorted face filled with lumpy teeth, dubbed "Big Nose," with the response from Westerners. Westerners would find this

carving horrifying, he writes, but the Nigerians find it funny because it violates their aesthetic standards (i.e., it has many things "wrong" with it). Another example cited by Thompson is "Alakoro," a brass face mask that was intended to horrify enemies. The eyes on Big Nose are probably no less scary than are those of Alakoro, but the rest of the Big Nose carving does not contribute to the same effect for the Nigerians, who are concerned with the "mistakes." Though Alakoro also violates the culturally approved techniques of the Nigerians, it is not funny but horrifying. Thus, to the Nigerians, Big Nose is funny and Alakoro is terrifying. To Westerners, both faces are frightening (see Figure 9.1).[5]

It is possible to respond to art from other cultures and other times; we all know this. Of course, some of the response is based on the awesome quality associated with extreme age, as is the case with Paleolithic cave paintings, or the technical achievements of an ancient people, as is the case with Egyptian pyramids. However, some of the response is due to universal responses to particular combinations of line, mass, color, and sound; that is, a response to releasers. In an informal classroom setting I asked students to use words such as happy, sad, scary, and pleasant to describe slides of artworks and bits of taped music. They agreed as to which adjective could be used to describe works ranging from prehistoric stone figures to modern African tribal music to ancient Chinese sculpture to modern Western painting.

Consequently, though much of what we respond to in art is deeply embedded in our particular culture, some of the emotional impact of art comes from what appears to be reflexive responses to releasers (particular configurations of line, shape, mass, color, and sound) which are part of the artwork.

## OTHER THEORIES FOR THE ORIGINS OF ART WHICH SEEM TO FIT INTO THIS THEORY

### Hallucinations

Anthropology is now considering the possibility that ancient cave and rock art and the art of contemporary shamanistic societies may be the result of drug- or trance-induced hallucinations. J. D. Lewis-Williams and T. A. Dowson propose that it is these hallucinations that are copied onto the cave walls. Lewis-Williams and Dowson compared the images made by Upper Paleolithic people to the art of two shamanistic societies, the San of the Kalahari Desert and the Shoshonean Coso of the California Great Basin, and found remarkable similarities in the geometric shapes represented by all three groups. Altered states of consciousness is an important feature of shamanism. A contemporary example also supports the assumption that Paleolithic art resulted from

and animal art specialist Desmond Morris, fit into the puzzle of what art is. While these things are being discussed, answers to the "big questions" posed in Chapter 1 will be found. If art behavior arose because human beings respond to primitive cues (or releasers or biologically relevant stimuli) reliably and consistently and these responses could be used to manipulate other behaviors, then the answers to the big questions—Why do people make art? Why does art persist? Why do people enjoy art? What purpose does art serve?—become answerable.

## THE USE OF RELEASERS IN ART EXPLAINS
## ITS UNIVERSAL QUALITY

In 1757 David Hume argued that art appreciation is relative to one's own cultural background and personal taste.[3] Yet it cannot be denied that some artworks are valued across time and culture (e.g., Paleolithic cave paintings, African masks, the Sphinx, and the Taj Mahal). The question of relativity versus universality in art appreciation is still unsolved. If, however, the meaning of art appreciation is considered as suggested in Chapter 2, then it becomes possible to consider universality in terms of some emotional response to art. That is, if cultural and personal biases are stripped away, personal and cultural associations are taken into account, and only the reflexive response to particular line, mass, color, and sound are considered, then we are looking at a part of art appreciation which may be universal in nature. That is, the ability to respond in reflexive ways to particular configurations of line, mass, color, and sound would be a common trait in all human beings and could, therefore, account for a universal response to art.

As discussed in Chapter 2, anthropologist David Stout reached the conclusion that art appreciation was based universally on four criteria: technique, originality, awesomeness, and particular combinations of line, mass, color, and sound.[4] Note that the first three of the four are dependent on the cultural setting for their form. That is, what is unique to the New Guinea bushman may not be unique to the New York art critic. However, culture would not affect the reflexive response to particular combinations of line, mass, color, and sound.

Culture may, however, influence the interpretation of the response. Sometimes cultural biases can overcome the emotion evoked reflexively by the art object. Westerners who have not become acquainted with modern art may be so confused by *Les Demoiselles d'Avignon* that the effect is all but lost. An example of this situation from the Yoruba of Nigeria is discussed by Thompson. He compares the Nigerian response to an image of a distorted face filled with lumpy teeth, dubbed "Big Nose," with the response from Westerners. Westerners would find this

carving horrifying, he writes, but the Nigerians find it funny because it violates their aesthetic standards (i.e., it has many things "wrong" with it). Another example cited by Thompson is "Alakoro," a brass face mask that was intended to horrify enemies. The eyes on Big Nose are probably no less scary than are those of Alakoro, but the rest of the Big Nose carving does not contribute to the same effect for the Nigerians, who are concerned with the "mistakes." Though Alakoro also violates the culturally approved techniques of the Nigerians, it is not funny but horrifying. Thus, to the Nigerians, Big Nose is funny and Alakoro is terrifying. To Westerners, both faces are frightening (see Figure 9.1).[5]

It is possible to respond to art from other cultures and other times; we all know this. Of course, some of the response is based on the awesome quality associated with extreme age, as is the case with Paleolithic cave paintings, or the technical achievements of an ancient people, as is the case with Egyptian pyramids. However, some of the response is due to universal responses to particular combinations of line, mass, color, and sound; that is, a response to releasers. In an informal classroom setting I asked students to use words such as happy, sad, scary, and pleasant to describe slides of artworks and bits of taped music. They agreed as to which adjective could be used to describe works ranging from prehistoric stone figures to modern African tribal music to ancient Chinese sculpture to modern Western painting.

Consequently, though much of what we respond to in art is deeply embedded in our particular culture, some of the emotional impact of art comes from what appears to be reflexive responses to releasers (particular configurations of line, shape, mass, color, and sound) which are part of the artwork.

## OTHER THEORIES FOR THE ORIGINS OF ART WHICH SEEM TO FIT INTO THIS THEORY

### Hallucinations

Anthropology is now considering the possibility that ancient cave and rock art and the art of contemporary shamanistic societies may be the result of drug- or trance-induced hallucinations. J. D. Lewis-Williams and T. A. Dowson propose that it is these hallucinations that are copied onto the cave walls. Lewis-Williams and Dowson compared the images made by Upper Paleolithic people to the art of two shamanistic societies, the San of the Kalahari Desert and the Shoshonean Coso of the California Great Basin, and found remarkable similarities in the geometric shapes represented by all three groups. Altered states of consciousness is an important feature of shamanism. A contemporary example also supports the assumption that Paleolithic art resulted from

**Figure 9.1**
**Three Masks**

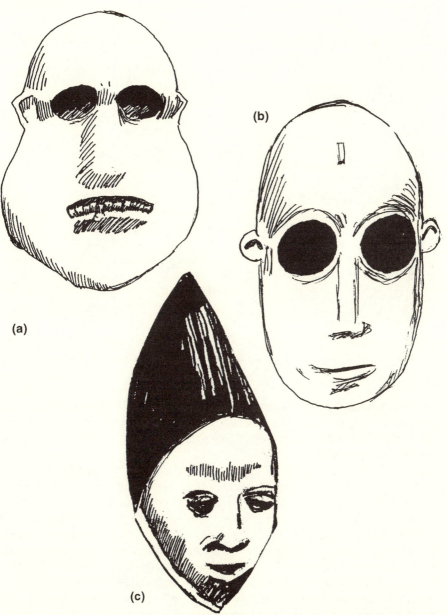

(b)

(a)

(c)

*Source*: Drawn from photographs in R. E. Thompson, "Aesthetics in Traditional Africa," in *Art and Aesthetics in Primitive Societies*, ed. Carol F. Jopling (New York: Dutton, 1971), 380.

*Note*: Traditional Yoruba aesthetic standards are violated in both "The Big Nose" (a) and "Alakoro" (b). "The Big Nose" is funny to the Yoruba, but "Alakoro" was used to frighten enemies. The face of the aesthetically correct sculpture "The Image of the Thundergod as Crowned Lord of the Yoruba" (c) displays the kind of image that pleases the Yoruba.

**Figure 9.2**
**Comparison of Images**

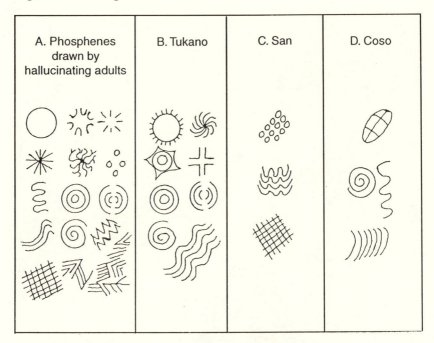

| A. Phosphenes drawn by hallucinating adults | B. Tukano | C. San | D. Coso |
|---|---|---|---|

shamanistic altered consciousness. G. Reichel-Dolmatoff studied the art produced from *yaje*-induced visions by the Tukano of the Columbian Amazon. Their images are repetitive of those seen in Paleolithic caves and on San and Coso rocks.[6]

Reichel-Dolmatoff recalled the work of Max Knoll who experimented with electric and chemical stimulation of the human nervous system to induce hallucinations. Knoll called the geometric configurations seen by all his subjects under stimulation "phosphenes." Included as phosphene patterns are circles, spirals, stars, curved lines, and zigzags. These patterns are similar to those seen in Paleolithic, San, Coso, and Tukano art (see Figure 9.2). Figurative hallucinations, which also occur if the trance goes deeper, include representations of figures, flowers, animals, man-made objects, scenery, and so on. These images tend to be culturally biased. Emotional response such as fear or anxiety may accompany the figurative images, but a feeling of transcendental wellness of being may also accompany these images.

Geometric entoptic phenomena or phosphenes and figurative hallucinations can be induced by electrical stimulation and chemical stimulation (in the form of drugs such as mescaline, psilocybin, LSD,

*Sources*: (A) Rhoda Kellogg, M. Knoll, and J. Kugler, "Form-Similarity between Phosphenes of Adults and Pre-School Children's Scribblings," *Nature* 208 (1965): 1129–1130; Mardi J. Horowitz, "Hallucinations: An Information-Processing Approach," in *Hallucinations: Behavior, Experience, and Theory*, ed. R. K. Siegel and L. J. West (New York: Wiley, 1975), 179; and R. K. Siegel, "Hallucinations," *Scientific American* 237 (1977): 138; (B) G. Reichel-Dolmatoff, *Beyond the Milky Way: Hallucinatory Imagery of the Tukano Indians* (Los Angeles: UCLA Latin American Center Publications, 1978), 45; (C), (D), and (E) J. D. Lewis-Williams and T. A. Dowson, "The Signs of All Times: Entoptic Phenomena in Upper Palaeolithic Art," *Current Anthropology* 29 (1988): 206–207; (F) Kellogg, Knoll, and Kugler, "Form-Similarity," 1129–1130; Rhoda Kellogg, *Children's Drawings/Children's Minds* (New York: Avon, 1979), 18–21; (G) Desmond Morris, *The Biology of Art* (New York: Knopf, 1962), 131, 133–136; (H) C. G. Jung, *The Archetypes and the Collective Unconscious*, 2d ed., trans. R. F. C. Hull (Princeton, N.J.: Princeton University Press, 1969), 368, 376.

*yaje*, etc.), fevers and migraines, falling asleep, waking up, insulin hypoglycemia, epilepsy, psychotic episodes, advanced syphilis, photostimulation, crystal gazing, dizziness, sensory deprivation,[7] and physical exhaustion.[8] Thus, hallucinations are pervasive in persons in "altered states of consciousness," they are accompanied by emotional response, and, in the geometric phase, are universal in content.

Phosphenes are thought to be manifestations of the nervous system.[9] West argues that visual phenomena occur when the images from memory traces are released from within the brain.[10] Halgren and associates find excitation of the hippocampus (seat of memory) and the amygdala (seat of emotion) to be heavily involved in the appearance

of figurative hallucinations (phosphenes were not considered).[11] Nervous system structures which are implicated in emotional memory, as discussed in Chapter 6, are implicated here in hallucinogenic behavior.

Phosphene patterns are similar in Paleolithic, San, Coso, and Tukano art. They are also similar to the drawings made by contemporary, hallucinating subjects who were asked to draw what they were seeing and to drawings made by children.[12] Thus, it is not unreasonable to conclude that phosphenes are the source for both ancient and modern primitive art and children's art. However, Desmond Morris noted that these same patterns which are found in the scribbles of children are also found in the scribbles of apes (see Figure 9.2).[13] They are also seen in the visual designs elephants make with their trunks in dirt or sand or on paper with chalk.[14]

It would be remarkable if phosphenes are also the source of animal art. Are animals attempting to show us what they see in hallucinations? Are human beings showing other human beings what they see in hallucinations? Why would that be necessary if all human beings are capable of hallucinating? It seems unlikely that art, in all its manifestations and in all its appearances in cultures across time and space—and species—would result from a simple sharing of hallucinations.

*A Critique of the Lewis-Williams Theory*    Though phosphenes appear to have a universal presence in art, no compelling reason has been suggested to account for this. Self-satisfying movement, as discussed in Chapter 8, would seem to account for these visual gestures across time, culture, and species better than a sharing of hallucinations. The animal studies, particularly, appeal to self-satisfying movement as the source of the visual patterns. However, this does not explain the similarity between the patterns made because it feels good and the patterns seen as phosphenes. Animals do hallucinate, but we do not know if their hallucinations match ours.[15] It is possible that the phosphene patterns match, by coincidence, the patterns resulting from self-satisfying movement, but it is more likely that they match each other because they represent similar Gestalts across modalities. Before discussing that point, however, I want to introduce it with Johanna Üher's critique of the Lewis-Williams and Dowson theory.

Johanna Üher focuses on the zigzag pattern for her critique of the Lewis-Williams and Dowson theory. She points out that "motor ability" (movement) and "structures of the mechanisms of visual perception" (phosphenes) are certainly not the only explanations for the frequency with which the zigzag is found in art.[16] She notes that zigzags are frequently combined with eye spots in amulets and masks. Since eye spots are used to threaten or protect, use of zigzags with eye spots suggests a comparable function. Masks or other objects often not only have ex-

aggerated eyes but also bared teeth. Showing the canines in anger elicits respectful behavior and depictions of the bite threat can be replaced by the zigzag. The apotropaic or warding-off context in which the zigzag universally appears suggests its threatening affective properties. It is often seen on weapons, and Üher mentions, specifically, the American "Flying Tiger" airplane from World War II which actually depicted the bite threat. Üher suggests that while zigzags are phosphenes, they carry specific emotional baggage. Because of their emotional salience, it seems that shamans, who are often involved in warding off evil, would be apt to choose the zigzag over less-meaningful phosphene patterns.[17]

*Art, Hallucinations, and Jung* Perhaps the form constants seen in hallucinations, children's art, "primitive" art, and, indeed, all art are, at least in part, visual images of releasers or biologically meaningful stimuli. That is, if, as research discussed in Chapter 6 indicates, certain neurons in the thalamus respond to biologically relevant stimuli such as eye spots and zigzags under normal circumstances, it may be the case that under conditions of altered consciousness these neurons are stimulated, releasing images of those biologically relevant stimuli as hallucinations. All phosphenes need not be visual images of releasers, but some certainly appear to be so. Curved and zigzag lines, which have been discussed as releasers, are prevalent as phosphenes. Eye spots, another releaser, do not appear as such in the phosphene patterns, but circles and dots do, and these basic forms can be endlessly enhanced and combined. Also, some phosphene patterns may have biologically important meanings that are as yet undiscovered.

An example of a phosphene pattern that may have biologically important meaning is the mandala as described by Rhoda Kellogg and C. G. Jung. According to Kellogg's analysis of children's art, the mandala appears first as a combination of a circle and two or more crossed lines. Mandalas can also be squares or rectangles with crossed lines inside.[18] Jung describes the basic mandala as a circle. Tibetan Buddhism makes significant use of mandalas as *yantras* or instruments of contemplation. Usually, the *yantra* contains three circles.[19] Circular mandalas have a spiral or tunnel quality, so that their source could be the spiral phosphene. Jung described the mandala as an archetype which is shared by all. Jung's collective unconscious is probably the instincts or reflexes common to all, and "archetypes are the unconscious images of the instincts themselves." Jung further noted that the archetypes are "found in the delusions of paranoiacs, the fantasies observed in trance-state, and the dreams of early childhood from the third to the fifth year."[20] Kellogg states that the basic scribbles and diagrams of children's art are Gestalts and archetypes in the sense used by Jung.[21] Jung further noted the following:

There must be a transconscious disposition in every individual which is able to produce the same or very similar symbols at all times and in all places. Since this disposition is usually not a conscious possession of the individual, I have called it the *collective unconscious*, and, as the bases of its symbolical products, I postulate the existence of primordial images, the *archetypes*. I need hardly add that the identity of unconscious individual contents . . . is expressed not merely in their form but in their meaning. Knowledge of the common origin of these unconsciously preformed symbols has been totally lost to us. . . . When we penetrate . . . below the surface of the psyche, we come upon historical layers which are not just dead dust, but alive and continuously active in everyone—maybe to a degree that we cannot imagine in the present state of our knowledge.[22]

The present state of our knowledge has advanced a bit since Jung. It is now possible to postulate that Jung's archetypes appear as phosphenes and in the drawings of apes, elephants, and children and adult human beings. At least some of these images are infused with emotional meaning. They are likely the internal templates for biologically significant stimuli. As Jung put it, they are the "images of instincts."

Rhoda Kellogg referred to mandalas as Gestalts. Köhler's maluma and takete, discussed in Chapter 7, might be called Gestalts. According to Gestalt psychology, perception occurs as wholes. That is, a tiger is perceived as a tiger, not as color and form bites which are then conceived as "tiger." This concept of wholes is important, because releasers or biologically relevant stimuli are responded to as wholes and not as parts. Also important is the notion of the affective meaning which is part of the whole. For example, Kluver writes, "A live bull snake, a boa constrictor in a motion picture, and a wavy black line of certain dimensions may lead to reactions of 'fear,' . . . whereas a live garter snake and a boa constrictor in a film running at a higher speed may not. It is not a certain size, color, shape, or speed of movement that leads to the manifestation of 'fear' . . . but a specific form of 'togetherness' of these properties that constitutes the behaviorally effective stimulus."[23] I interpret Kluver's remark to mean that if a curved line (such as d, e, or f in Figure 7.3), which was described by Poffenberger and Barrows' subjects as "merry" and "playful," is made to undulate in a snake-like way, this same line would be described as scary or as frightening.[24] Also, it is not just two black circles placed a particular distance horizontally apart that evoke a defense response (see Figure 6.3); various similar circular configurations which have the eye-spot quality can also evoke a defense response (see the various eye-spot patterns on the moths in Figure 7.1). Therefore, the form constants described as phosphenes could evoke different affective responses depending on their "togetherness" or Gestalt.

One more point from Gestalt psychology seems pertinent. C. C. Pratt, in an introduction to the writings of Wolfgang Köhler, one of the

founders of Gestalt psychology, discusses the notion which Köhler called "tertiary qualities." Pratt gives as an example the friendliness of expression on a familiar face. This friendliness of a face is more likely to be remembered than the physical aspects of the face, such as the color of the eyes or the shape of the nose, and is generally described in terms that are usually used for moods or feelings. The friendly face is gay or happy or playful. These qualities, Pratt notes, are generally regarded as the very essence of the appeal of art. Köhler asked where these emotions come from and answered that "the moods and feelings of mankind are capable of iconic *presentation* in visual and auditory patterns," which is not unlike saying that patterns or configurations of line, shape, color, or sound mean fear or comfort or happiness. Moreover, Köhler makes it clear that tertiary qualities work across modalities, so the same rhythm can be visual, tactual, and auditory while expressing or making felt the same mood. Köhler's notion is that the greatness of a work of art is contained within its own formal structure, and it is the task of "psychophysics to find out what the stimulus conditions are that produce those qualities, and what it is the artist does with his tones and colors to give them the sound of gaiety or the look of serenity."[25] I think Köhler was correct, and I have tried to do as he requested: find out what the stimulus conditions are that produce the emotional qualities in a work of art and describe how the artist gives them "the sound of gaiety or the look of serenity." To do so, I have concentrated on how the artist creates uneasiness by evoking the defense reaction.[26]

### THE USE OF RELEASERS IN ART MIGHT HELP EXPLAIN WHY ART EXISTS

The use of releasers, which evoke emotional response in art, might account for the appearance of art in virtually every known culture and in every known age, because reflexive response to releasers would be inherent in every human being. Art is certainly one of mankind's great inventions, but it is not an invention of technical progress, such as the wheel. Releasers used in art are definitely the result of biological adaptation to environmental pressures. For example, the visceral alerting response is a behavior which aids in the organism's survival by preparing it for fight or flight. Since the visceral alerting response is evoked by works of art, works of art could be important to survival.

How can art be important to survival? Ellen Dissanayake has written a compelling argument answering that question. Her thesis is that art bound groups of our ancestors together, cementing societies into unified wholes as a means of providing better insurance for survival of the individuals within the groups.[27] During the course of her argu-

ment, Dissanayake alludes to a couple of points. First, she mentions that the manufacture of art is "based on a universal inherited propensity in human nature to make some objects and activities special."[28] She supports this statement with discussions of such activities as the decoration of tools early in human prehistory and even, as discussed in Chapter 7, the apparent appreciation or acknowledgment of the specialness of a peculiar red stone by our predecessor, *Homo erectus*. Second, she writes that, while making things special is at the root of making art, at the root of aesthetic experience are "reflexive general responses to biological significant stimuli," as I have argued throughout this book.[29] While she has pursued the notion of art as a means of social unification, I have pursued the idea of the emotional experience evoked by art as the key to the ultimate purpose and origin of art. As will be seen, our two lines of reasoning merge and form an idea of what and why art was and what and why art is.

### What Art Was

Dissanayake carefully divides our modern Western version of art, as exemplified by Leonardo, Wagner, Picasso, John Cage, Andy Warhol, and so on, from what art was, as exemplified by ritualized ceremonies, body decoration, costumes, cave painting, and the like. Ritual ceremony and its attendant decoration (masks, costumes, rhythms, etc.), which she suggests probably grew from elaborations of simple ritualized behaviors, "became an activity that had significant adaptive value to the groups that practiced it. A society that performed communal rites that bound its members in common beliefs and values would presumably have been more cohesive and therefore more equipped for survival than one that did not."[30]

An apparent purpose accorded art by our ancient ancestors, according to Dissanayake, was that making some objects special, by decorating them or perhaps, even, by sacrificing them, would separate these objects from other ordinary objects. They would be made sacred or magical and would be infused with special meaning which could, perhaps, affect the outcome of hunts or what happened in an afterlife. It was, in effect, Dissanayake writes, a way for our ancestors to attempt to exercise some control over their world and their lives. It may be that this "control property" of art may have been extended beyond objects and prey animals to other humans, a notion pursued later in this chapter.

Dissanayake asks the question that ethology asks of most ritualized behavior: Why continue the ritual to extreme length and elaboration with exhausting dances and the like? Would this not prove fatal to groups of human beings caught in a state of exhaustion by predators or warring tribes of other members of our species? Her answer is that

the elaborate ceremony was effective for promoting group solidarity and was, therefore, worth the risk. Moreover, "redundant, memorable experiences would better teach and express and reinforce the values and beliefs of the society and perpetuate knowledge that was essential for group maintenance and survival."[31] Dissanayake credits John Pfeiffer for this last idea.

Of course, our ancient ancestors did not, in all probability, say to themselves, "We will dance until we fall down because that will promote group solidarity." Nor did they likely remark that these redundant, exhausting, emotional experiences would teach their children needed information better than would rote memorization. What, then, would make people perform these elaborate ceremonies to the point of physical and mental exhaustion? Dissanayake's answer is that the pleasure derived from the reflexive response to biologically meaningful stimuli.[32] That is, the pleasure found in the excitement of the dance made them whirl and twirl to the point of falling down. Group solidarity and the mnemonic benefits were incidental to the pleasure derived from the dance and ritual, but proved to be of adaptive significance. Thus, she has pinpointed what all art turns on: biological response to ethological releasers.

### Why Art Was

Dissanayake suggests that art bound early humans together into closely knit groups, which aided their chances for survival. Elaborate ceremonies also made early humans feel as though they had some control over their destinies. In addition, elaborate ceremonies could be used to transmit knowledge. John Pfeiffer pulls all three of these threads together in his discussion of Upper Paleolithic cave art.

Pfeiffer begins by asserting that Plato did not want poets in his ideal society, as described in the *Republic*, because the poets of preliterate Greece, of which Homer was the most powerful, were guardians of law, order, and morality. They were members of the elite and used their rank and their artistic abilities to teach people how to behave and to tell people how to think. Thus, art was doing what Dissanayake has proposed it did: unified, educated, and controlled. Plato thought that reason and logic should rule; instead, he wrote, base instinct ruled. He objected to poets because their poetry appealed to pleasure and pain and lust and anger. Plato wrote that poetry makes these base instincts our rulers, whereas we should control them. Plato, notes Pfeiffer, failed to recognize the mnemonic significance of the arousal of these base instincts.

The tradition of poetry that Plato so disliked belonged, according to Pfeiffer, to prehistory and represented the last of Western civilization's oral tradition. Pfeiffer suggests that the people of the Upper Paleolithic

began the oral traditions that ended with Homer, and the remains of Upper Paleolithic myth and ceremony suggest a social, political, and intellectual unity that directly opposes the fragmentation of today. For people of the Upper Paleolithic, the only way to exist was to have a body of "conforming and obeying people."[33] Modern individualism would have proved fatal, and it was the poet or shaman who kept the group unified. Pfeiffer writes this about the poet/artist/shaman of Upper Paleolithic times:

As masters of illusion, specialists in the evolving art of social control, they held exalted positions. It could not be otherwise. As equals, they could never have done what they had to do, indoctrinate people for survival in groups, devise and implant the shared memories that would make for widening allegiances, common causes, communities solid enough to endure generation after generation. Learning in our sense of a continuing search for new knowledge and new insights would have been a disaster. Learning by ritual, was dedicated to the inhibition of innovation. The ceremonial life promoted, not inquiry, but unbending belief and obedience.[34]

Pfeiffer argues that the shaman or those in charge of ceremonies expected and received absolute and unquestioning obedience, and the first step in overcoming what we feel today is a normal resistance to the indoctrination necessary for absolute and unquestioning obedience is to get and hold the audience's complete attention. The next step is to ensure that the message will be remembered. The final step is to make sure the message is believed and obeyed. Pfeiffer illustrates how the evidence found in Paleolithic caves indicates how shamans of the Upper Paleolithic accomplished these three steps of indoctrination.

First, the brain could be prepared for indoctrination by sheer monotony. The less information it receives, the more likely it is to go into a trancelike state akin to the state just before sleep. Caves, Pfeiffer purports, are extremely effective settings for sensory deprivation of the sort needed to induce this twilight state (note that sensory deprivation is one of the methods used for inducing hallucinations). Pfeiffer reports that university students each spent up to forty-eight hours alone in a cave in order to study the effects on the mind. They found that in the twilight state induced by sensory deprivation in a cave they developed an inclination toward supernatural interpretations of any unexplained occurrences.

Second, Pfeiffer suggests that at that point Upper Paleolithic indoctrination would have begun. Noises and lights would suddenly come out of the quiet and the dark. Sounds and lights in a silent, dark, isolated cave would raise heart rate, blood pressure, and the hair on the back of your neck. Odd noises after forty-eight hours alone in a cave would get your attention, to say the least. Releasers could be used

alone, or they might be paired with information to be learned so that emotional memories would be formed. As discussed in Chapter 6, these memories would be indelible.

Inducing the twilight, trancelike state was necessary for indoctrination or, as we might say today, brainwashing. The twilight state, Pfeiffer writes, lowers the ability to doubt, ask questions, and criticize. It leaves one open to any suggestion. Along with the inability to doubt comes a feeling of well-being. This is what Pfeiffer refers to as "belief beyond belief" or the religious revelation or seeing the profound truth (recall the transcendental feeling of well-being described by persons who were hallucinating). The profound truth could be whatever the shaman wanted the audience to believe. In the case of Upper Paleolithic audiences, the profound truth probably had to do with survival tactics and group unification (see Figure 9.3).[35]

Pfeiffer suggests that Paleolithic cave art was designed to control the attention of children so that necessary survival lessons could be learned rapidly and completely. Pfeiffer compares the ancient cave art in Western Europe to today's art and music rituals of the Australian Aborigines, who use their art to control the attention of their youngsters in order to teach them survival in the Australian desert. The lessons must be learned rapidly and completely, and the attention-getting, mood-provoking releasers found in the cave art and the Aborigine art indicate that these are used to provide quick and complete learning. Aborigine children are literally brainwashed by hours of dancing and forced solitude in small dark enclosures. Then they are confronted by sudden sounds or lights and frightening visual configurations and sounds combined with needed information. The results are crucial to the Aborigine children's survival in the desert; they must learn where all of the water holes and shelters are or die of thirst or exposure. Pfeiffer suggests that Paleolithic cave art was produced for the same purpose; the survival skills taught in this instance are, however, lost to us now.

Thus, why art was, Dissanayake asserts, was to indoctrinate group members with vital information necessary for individual survival and/ or group unification. Releasers or biologically relevant stimuli made this possible. Sounds, rhythms, light, movement, color, and forms, all presented at optimum times, gained and held attention and served as mnemonic aides to retention of vital information. Today's Australian Aborigines teach their children facts necessary for survival by combining frightening visual configurations and sounds with the facts. This method of classical conditioning, Pfeiffer asserts, was probably also used by Cro-Magnon cave painters 30 thousand years ago.[36] As Stephen Jay Gould points out, our ancestors, the Cro-Magnon cave painters, were physically and mentally like us. As he puts it, "There but for the grace of 30,000 years go I."[37] The Cro-Magnon painters of

**Figure 9.3**
**How Art Can Be Used to Control Behavior**

**Mind Is Prepared for Indoctrination**

A trancelike state is induced via monotony
and/or sensory deprivation, rhythm,
rhythmic dancing or chanting, darkness,
solitude, or diminishment of individuality
by being part of a crowd; drugs enhance

**Attention Is Attracted**

Shaman/leader/artist rivets attention
with releasers (such as loud sounds, bright lights,
sudden movement) which, when paired with
the information to be remembered
(goals of the group, survival skills, who is the enemy),
make emotional memories or use
previously conditioned stimuli (likeness of gods or
leaders or enemies) to revive emotional memories.

**Beliefs and Behavior Are Influenced**

- Information is traced indelibly in memory via
  classical conditoning
- A feeling of rightness occurs
- No realization of how thoughts have been manipulated

Chauvet Cave (32,410 years ago) overlapped the Neanderthal people in Europe, but, as far as is known, the Neanderthals made no representational art. Gould notes that this "striking cultural difference reinforces the opinion that Neanderthal and Cro-Magnon were two separate, albeit closely related species. . . . Neanderthal died out, while Cro-Magnon continues as modern humanity."[38] While no evidence exists to document why the Neanderthal died out or even why there is today only one species of *Homo* extant, it might be because our Cro-Magnon ancestors used art to solidify their groups into survival machines and the other species, lacking this great advantage, were unable to keep a step ahead of changing environments or were simply unable to compete with Cro-Magnon for the same resources.[39]

### Why Art Is

Dissanayake does not think art is used to bind societies together anymore, except as used by Australian Aborigines and other so-called primitive groups. She does not think that we, as literate, rational, sophisticated individuals, are receptive to the twilight state experience or that we are capable of being indoctrinated in the same way that our preliterate ancestors probably were. However, I think enough vestiges remain of the old tendencies to make things special, to experience the twilight state, to be subjectable to indoctrination, and to respond reflexively to relevant biological stimuli or releasers to make it possible to track traces of the old purpose of art in the art of literate societies. For example, Gothic cathedrals of Western Europe are certainly awe inspiring. In our little American churches one hears about God; in the great churches of the middle ages and early Renaissance one feels God. Individuals are reduced to parts in a crowd. The music thunders and soars. Dim lights induce the quality of twilight. The priest is the leader and tells the group what to believe, what to think, and how to behave. Granted, the indoctrination is not complete, but it has all of the old attributes, and it works well enough.

The mnemonic qualities of art are commonly known. Public television's "Sesame Street" uses bright colors, movement, song, dance, and odd creatures to help little children learn the alphabet. Television is not as effective a means of indoctrination as being isolated in a cave with sounds and lights, but, in relative terms, the purpose is the same. Today we prefer to use the term "teach" rather than "indoctrinate."

Art in Western society is frequently reduced to making "statements" (see Chapter 2). Most frequently, the messages in the artists' statements fail to reach the masses, generally being noticed by a small audience of people either in or on the periphery of the art world. Generally, these statements are obtuse and unattended by the kind of mnemonic

and attention-getting devices that apparently make Australian Aborigine or made Upper Paleolithic messages so memorable. That is, releasers, if used, may be subdued in intensity. The appeal is often, but certainly not always, intellectual rather than emotional. For example, Andy Warhol's *Sleep* could create murmurs among members of the art world, but barely a whisper could be heard from America's working class. Art critic Robert Hughes argues that modern Western visual artists made antiwar statements to no avail between the world wars. He reasoned that their work was seen and appreciated only by those people who already held the same views; therefore, no learning took place, but only support for already held beliefs. The art had to reach more people if it were to make a difference. Hughes concluded that art, or at least modern art, has no influence on people's thinking and beliefs.[40] This may be true if one thinks of art only in terms of museum pieces accepted as art by a few members of the Western world.

However, if that narrow view of art is expanded, it can be seen that even art in our modern fragmented individualized society can influence what people think and believe and how they behave. Artists who hope to do this today must, however, if they are to influence the masses, work in a media that has mass appeal. As Hughes pointed out, modern painting has a limited appeal, and at its most exciting is appreciated by a relatively small audience. Moreover, it cannot be appreciated by many people in its original form, since it must come directly to the people or they must travel to see it. Reproductions of, for example, Jasper John's flag paintings barely capture a small portion of the impact of the original paintings.

However, a media exists which reproduces originals with practically the same impact, is available in multiple copies at the same time to most of the earth's population, and is broadcast over radio waves to those without access to the recordings of the original. This media is popular music. It is, by definition, music of the masses. Popular music was used by artists during the Vietnam War to change people's thinking, beliefs, and behavior. Around 1965, popular music became filled with releasers and antiwar and antiestablishment messages. Popular music (rock and roll) became so loud as to be monumental in effect (monumentality is probably a releaser). Guitars no longer were simply strummed; they were tortured, and they shrieked and wailed and cried in response (these are probably auditory releasers). Singers no longer crooned; they screamed. Rhythms and melodies no longer were pleasant; they grated, they pounded, they were insistent. Lyrics no longer conveyed just messages of love and desire; they contained messages about peace and asked important questions about making war. Concerts became trance inducing, with disconcerting flashing

lights and images and bone-jarring sound, and were often attended by huge crowds in which individuals were reduced to minuscule parts of the throng. Drugs were often available which, if used, further influenced the twilight state. Musicians became leaders. Some were demons and some were gods. What they said, did, and wore became standards to follow. Art influenced not one small group but huge groups of people worldwide. Today's artists use essentially the same methods employed by the artists of the Upper Paleolithic. They cannot isolate individuals in caves, but they can isolate huge groups of people in football stadiums to be mesmerized by rhythm and ear-ringing sound. They can still pair releasers with information to be burned into memory. The technical capabilities have changed, but our biology has not changed enough to be impervious to biologically relevant stimuli. Art can still change thinking, beliefs, and behavior.

Art is a subtle and effective teacher. By subtle, I mean that one does not realize that learning is taking place. By effective, I mean that the learning is often complete. Chapter 6 discussed the research of Joseph LeDoux, which demonstrates how emotional memories can be formed by classical conditioning and how these memories are indelible. Artistic behavior (making ordinary things special) often makes use of unconditioned stimuli which evoke emotional responses and sometimes pairs unconditioned stimuli with items which would not ordinarily evoke emotional response, thus giving these items the properties of the unconditioned stimuli. Since response to unconditioned stimuli and classical conditioning takes place below the level of consciousness, art is capable of forming and shaping the thoughts and behaviors of people without their conscious awareness.

This ability of art to make ideas salient and thereby memorable may have provided rulers with a means to control their subjects. Subjugation through fear is a means of retaining power. For example, the population of Easter Island may have been subjugated in part by fear induced by the releasing effects of the island's monumental statues, which still evoke awe. The Easter Island heads had eyes at one time. The upright statues with eyes intact would be very effective releasers of at least the visceral alerting response, and quite possibly a nearly full defense reaction. It is possible to imagine ceremonies involving these statues that would provide the indoctrination necessary for control of the people of the island. It is possible that the monumental likenesses of the Egyptian pharaohs and the enormous expanse and upward soar of Gothic cathedrals may have served similar purposes. It seems appropriate to restate here what Picasso said concerning his first encounter with African masks: "I understood what the Negroes used their sculpture for. . . . They were weapons."[41]

### Why Artists Use "Weapons"

Even though Dissanayake argues that art is adaptive in the sense that it is used to unify groups to provide strength (and I agree with her), this argument does not imply group selection.[42] Group unification can be beneficial to individuals within the group (as is observed in herding animals, for instance), but it is the individual making the art who must benefit for art-making behavior to be evolutionarily adaptive. Why would anyone expend time making ordinary objects special? Why dance when walking takes so much less energy. The answer is that walking does not attract the attention of others. Attracting attention can be the starting point for a way of obtaining reproductive advantage, just as the peacock's tail attracts the peahen. Individual reproductive advantage drives artistic behavior, but the route to success can be circuitous, winding through status, leadership, control, and power. Ultimately, art can serve as a means of acquiring and maintaining power, which, in the end, should lead to increased access to resources and increased chances for reproductive success.

*How Art Is Used to Obtain Power*   Human beings operate within social hierarchies. Some individuals are dominant, with the others submitting power to them. Power is sometimes handed to individuals voluntarily by the group when those individuals have the knowledge and skills to accomplish the mission of the group. For example, if a fire threatens to destroy homes, residents turn power over to firefighters. Officials are often elected because they want the jobs and they appear to be capable. Dominance can also be achieved through brute force, however. Playground bullies are dominant because they have beaten up or have threatened to beat up the other children on the playground. Hoodlums run their crime organizations based on the same premise. The bully rules by threat and fear.

There are at least two drawbacks to this latter method of acquiring power. First, everyone understands how the bully's power was acquired and knows how it can be lost; he who rules by force must forever watch his back. Second, the larger the group, the more individuals there are to be bullied and the more chances there are for uprisings. A large group is very difficult to maintain and control by sheer force alone.

A successful alternative to becoming a bully to obtain power is to be a leader. A leader makes the group's goals his or her goals and, thus, is followed voluntarily. Barbara Hold-Cavell differentiates between dominate individuals (those who gain high status via intimidation) and leaders who gain prestige by way of attention-getting behaviors.[43] Some people are natural leaders, and some need to make themselves into leaders. Their methods are similar. Generally, the leader focuses on a goal which is either already a goal of the group (e.g., political freedom,

social equality, increased monetary returns), or the leader focuses on a goal which the group can be made to take as its own (e.g., minority rights, animal welfare, concern for those not members of the group; an example is sending money and supplies to another group struck by famine). The leader encourages group focus on the goal by using such devices as stirring oratory, public rallies (the bigger, the better—being diminished by the crowd is one of the methods of indoctrination), catchy slogans, symbols with which the group can identify (such as the flag or huge photographs of heros), anthems, and parades.

Elements of all these devices are likely to include rhythm, cultural associations, and releasers which evoke common emotions in the group, thus uniting the group behind the leader. It is possible that artistic behavior evolved as a clever alternative or adjunct to brute force to acquire and maintain power. Art's secret weapon, the weapon that is so superior to the bully's methods and the weapon that Picasso recognized in the African masks, is that it provides a means of control without the group knowing it is being controlled. Because of the nature of classical conditioning, art can evoke threat and fear without the group knowing it is being threatened (see Figure 9.3). Since the group is unaware it is being controlled, it is unlikely to rise up against those in power unless they abuse their power. Moreover, art, using a popular media such as music, can reach people worldwide. Leaders can manipulate people with oratory, slogans, patriotic music, and fanfare on television, reaching millions. The size of the group is not a limiting factor, as it is with brute force.

Art is not propaganda. Propaganda can be recognized as lies. Art works by classical conditioning to control thoughts and behavior. Only now that we can understand how it works can we be aware of its power. The German people did not understand its power and allowed Hitler to take over their country between the world wars. As a youth, Adolf Hitler wanted to be an artist. He became a great artist, but not in the European tradition. He was a master of Pavlovian or classical conditioning, placing himself and symbols of his ideas and goals next to powerful releasers in order to obtain the backing of the German people. Keep in mind Pfieffer's description of shamanistic indoctrination as discussed earlier in this chapter while I recount a description of Hitler's methods from an old encyclopedia: Hitler staged huge gatherings, commissioned monumental architecture, and used stirring oratory to arouse emotions and create unification toward his goals. He used "great masses of uniformed men as displays of his armed might. Troops and spectators alike hypnotized themselves by chanting 'Heil Hitler!' They came to believe that Hitler alone could lead Germany to greatness." Using spectacle, rhythm, symbols of national pride, and chanting, Hitler unified the German people toward the goal of national great-

ness. Hitler delivered speeches from balconies overlooking the crowd, which set him physically and symbolically above them. He surrounded himself with massive architecture and huge swastikas, which would create awe. He made crowds of thousands wait for hours before he appeared, intensifying the importance of his speech and appearance. He took speech lessons from an actor; the content of his speeches was mediocre and even his command of the language was bad, but he used "dramatic cries and gestures" to sway the audience.[44]

A dramatic example of how Hitler used classical or Pavlovian conditioning to control the behavior of the German people is his use of the famous *Graf Zeppelin* in the late 1930s. Hitler had giant swastikas painted on the tail fins of the giant air ship and used it for display, flying at low altitudes all over Germany. The *Graf Zeppelin* was 800 feet long and 100 feet in diameter. Imagine the Chrysler Building hovering overhead. Hitler paired what probably are releasers for monumental size and an object flying overhead with his symbol of Nazi might, which would most likely condition fear of the symbol itself.

### What Art Is

Art is not icing on the cake of culture. Art is an intrinsic part of human behavior; we can call human kind not only *Homo sapiens* but, as Ellen Dissanayake has it, *Homo aestheticus*. Probably quite by accident and without understanding what they had done, our remote ancestors co-opted some adaptive behaviors to add to their elaboration of ordinary things. These behaviors, such as fear at the sight of predator eyes and teeth, turned a previously ordinary thing, such as a covering for the head, into a frightful mask.

Art can be made by any of us. It need not result in museum-quality work; it can be only an elaboration of an ordinary object: a hair style rather than plain hair, fashion rather than a simple covering to keep warm, decorating rather than a room with furniture. We can all dance, sing, and doodle; some just do these better than others.

Art is appreciated by all of us. We need no special knowledge or sensory apparatus or experience to respond to a rhythm, a tune, a series of bright colors, a monumental building, or a parade. We can all be thrilled and soothed by art.

Art is a species-specific behavior which can be used for social manipulation. All of us are subject to art's whim. Art can direct thinking, beliefs, and behavior. Art is a means to educate, subjugate, subvert, and convert. Art has this power because it can tap into and use our reflexive responses to natural, biologically relevant stimuli. We are unable to control these responses. We do not even realize what is happening.

## NOTES

1. Stephen Jay Gould, "A Lesson from the Old Masters," *Natural History* 105, no. 8 (1996): 58.

2. C. Knight, C. Power, and I. Watts, "The Human Symbolic Revolution: A Darwinian Account," *Cambridge Archaeological Journal* 5 (1995): 75–114; see Chapter 7 for further discussion. It is theorized that red, being the color of menstruation, was used to mimic menstruation (imminent fertility) by female ancestors of our species in order to coerce the males into provisioning them. The increasing appearance of red ochre at archeological sites approaching and including the appearance of *Homo sapiens* led Knight, Power, and Watts to adopt this theory. Perhaps this represents the first instance of a releaser being co-opted by our ancestors to manipulate others.

3. David Hume, "Of the Standard of Taste," in *Aesthetic Theories: Studies in the Philosophy of Art*, ed. K. Ascshenbrenner and A. Isenberg (1757; reprint, Englewood Cliffs, N.J.: Prentice-Hall, 1965).

4. David B. Stout, "Aesthetics in 'Primitive Societies,'" in *Art and Aesthetics in Primitive Societies*, ed. C. F. Jopling (New York: Dutton, 1971), 30–34.

5. R. F. Thompson, "Aesthetics in Traditional Africa," in *Art and Aesthetics in Primitive Societies*, ed. C. F. Jopling (New York: Dutton, 1971), 374–380.

6. J. D. Lewis-Williams and T. A. Dowson, "The Signs of All Times: Entoptic Phenomena in Upper Palaeolithic Art," *Current Anthropology* 29 (1988): 201–245; G. Reichel-Dolmatoff, *Beyond the Milky Way: Hallucinatory Imagery of the Tukano Indians* (Los Angeles: UCLA Latin American Center Publications, 1978). See also Bruce Bower, "Visions on the Rocks," *Science News* 150 (1996): 216–217, for a brief review of the literature.

7. Reichel-Dolmatoff, *Beyond the Milky Way*; M. Knoll and J. Kugler, "Subjective Light Pattern Spectroscopy in the Encephalographic Frequency Range," *Nature* 184 (1959): 1823–1824; Ronald K. Siegel and Murray E. Jarvik, "Drug-Induced Hallucinations in Animals and Man," in *Hallucinations: Behavior, Experience, and Theory*, ed. R. K. Siegel and L. J. West (New York: Wiley, 1975), 81–162; and R. K. Siegel, "Hallucinations," *Scientific American* 237 (1977): 132–140.

8. E. R. Jaensch, *Eidetic Imagery and Typological Methods of Investigation*, trans. Oscar Oeser (New York: Harcourt Brace, 1930).

9. Reichel-Dolmatoff, *Beyond the Milky Way*.

10. Louis Jolyon West, "A Clinical and Theoretical Overview of Hallucinatory Phenomena," in *Hallucinations: Behavior, Experience, and Theory*, ed. R. K. Siegel and L. J. West (New York: Wiley, 1975), 287–312.

11. E. Halgren, R. D. Walter, D. G. Cherlow, and P. H. Crandall, "Mental Phenomena Evoked by Electrical Stimulation of the Human Hippocampal Formation and Amygdala," *Brain* 101 (1978): 83–117; J. Bancaud, F. Brunet-Bourgin, P. Chauvel, and E. Halgren, "Anatomical Origin of *Déjà Vu* and Vivid 'Memories' in Human Temporal Lobe Epilepsy," *Brain* 117 (1994): 71–90.

12. See Knoll and Kugler, "Subjective Light Pattern Spectroscopy"; Heinrich Kluver, "Mechanisms of Hallucinations," in *Studies in Personality*, ed. J. F. Dashiel (New York and London: McGraw Hill, 1942), 175–207; Mardi J. Horowitz, "Hallucinations: An Information-Processing Approach," in *Hallucinations: Behavior, Experience, and Theory*, ed. R. K. Siegel and L. J. West (New

York: Wiley, 1975), 163–196; R. Kellogg, M. Knoll, and J. Kugler, "Form-Similarity between Phosphenes of Adults and Pre-School Children's Scribblings," *Nature* 208 (1965): 1129–1130; and Martin Krampen, "Grapheme Development in Handicapped Children's Drawings," *Perceptual and Motor Skills* 60 (1985): 231–238.

13. Desmond Morris, *The Biology of Art* (New York: Knopf, 1962). Admittedly, the patterns are not so refined as in *Homo sapiens'* drawings, but they are very similar.

14. J. Ehmann, "The Elephant as Artist," *National Wildlife* 25 (1987): 26–28.

15. See Wallace D. Winters, "The Continuum of CNS Excitatory States and Hallucinosis," in *Hallucinations: Behavior, Experience, and Theory*, ed. R. K. Siegel and L. J. West (New York: Wiley, 1975), 53–70, for an example. Winters stimulated hallucinations in cats.

16. Johanna Üher, "On Zigzag Designs: Three Levels of Meaning," *Current Anthropology* 32 (1991): 437.

17. Ibid., 438.

18. R. Kellogg, *Analyzing Children's Art* (Palo Alto, Calif.: National Press Books, 1969), 64–73.

19. C. G. Jung, *The Archetypes and the Collective Unconscious*, 2d ed., trans. R. F. C. Hull (Princeton, N.J.: Princeton University Press, 1969), 355.

20. Ibid., 42–44, 50.

21. R. Kellogg, *Analyzing Children's Art*, 215.

22. Jung, *Archetypes and the Collective Unconscious*, 384.

23. Kluver, "Mechanisms of Hallucinations," 190.

24. A. T. Poffenberger and B. E. Barrows, "The Feeling Value of Lines," *Journal of Applied Psychology* 8 (1924): 187–205. These adjectives were extracted from Poffenberger and Barrows's Table 3, which showed the percentage of subjects matching lines d, e, and f (see Figure 7.3) with the thirteen adjectives offered them. Merry and playful received the highest percentages: 46.1 percent and 42.5 percent, respectively. This was the highest percentage accorded either adjective without a vertical directional element to the line.

25. Carroll C. Pratt, introduction to *The Task of Gestalt Psychology*, by Wolfgang Köhler (Princeton, N.J.: Princeton University Press, 1969), 22–28.

26. This is not to say that the artist selects threat stimuli consciously. Artists are also not fully conscious of the effects of the stimuli used in art. The most effective artists have a sensitivity to the releasers which they are able to translate in their art, but, with the possible exception of Picasso, they do not fully realize what they are doing.

27. Ellen Dissanayake, *What Is Art For?* (Seattle: University of Washington Press, 1988); Ellen Dissanayake, *Homo Aesthetics: Where Art Comes From and Why* (New York: The Free Press, 1992).

28. Dissanayake, *What Is Art For?*, 107.

29. Ibid., 150.

30. Ibid., 151.

31. Ibid., 153.

32. Ibid., 152.

33. John E. Pfeiffer, *The Creative Explosion: An Inquiry into the Origins of Art and Religion* (Ithaca: Cornell University Press, 1982), 190.

34. Ibid., 207.
35. Ibid., 213.
36. See Chapter 6 for a discussion of the neurobiology that makes this classical conditioning possible.
37. Stephen Jay Gould, "Up Against a Wall," *Natural History* 105, no. 7 (1996): 73.
38. Ibid., 18, 22.
39. For an interesting commentary on the demise of the Neanderthals, see Johan M. G. van der Dennen, "The Continuing Story of Neanderthal Man," *Human Ethology Bulletin* 12, no. 1 (1997): 4–8.
40. Robert Hughes, *The Shock of the New* (New York: Knopf, 1981). Hughes's commentary extends only to art of the Western art world, which we sometimes call "fine art." In the big picture of art, which covers other cultures and times, our Western notion of fine art is an anomaly. It is narrow in focus to the point of almost being cut off from the rest of art, which is one reason why we have a difficult time defining art.
41. P. Leighten, *Re-Ordering the Universe: Picasso and Anarchism, 1897–1914* (Princeton, N.J.: Princeton University Press, 1989), 82.
42. Selection, in the Darwinian sense, is generally accepted to take place at the individual level. According to group selectionist theory, individuals within the group will work toward the good of the group. However, it is the individual whose genes are passed down to offspring. It seems, rather, that the group works toward the good of the individuals in the group.
43. Barbara Hold-Cavell, "What Is the Best Index for Status?" *Human Ethology Newsletter* 8, no. 2 (1993): 4.
44. *The World Book Encyclopedia*, 1956 ed., s.v. "Adolf Hitler."

## SELECTED BIBLIOGRAPHY

Coe, Kathryn. "Art: The Replicable Unit—An Inquiry into the Possible Origin of Art As a Social Behavior." *Journal of Social and Evolutionary Systems* 15 (1992): 217–234.

Lewis-Williams, J. D., and T. A. Dowson. "The Signs of All Times: Entoptic Phenomena in Upper Palaeolithic Art." *Current Anthropology* 29 (1988): 201–245.

Pfeiffer, John E. *The Creative Explosion: An Inquiry into the Origins of Art and Religion*. Ithaca: Cornell University Press, 1982.

Siegel, R. K., and L. J. West, eds. *Hallucinations: Behavior, Experience, and Theory*. New York: Wiley, 1975.

Üher, Johanna. "On Zigzag Designs: Three Levels of Meaning." *Current Anthropology* 32 (1991): 437–439.

# Index

**ABOUT THE AUTHOR**

NANCY E. AIKEN is Adjunct Professor in the Department of Philosophy at Ohio University. She is an artist as well as a teacher. She has written numerous articles on art and evolution.

ISBN 0-275-95901-5

EAN

9 780275 959012

HARDCOVER BAR CODE